THE
COLOUR *of* IRELAND
COUNTY *by* COUNTY 1860–1960

First published 2021
by Black & White Publishing Ltd
Nautical House, 104 Commercial Street, Edinburgh, EH6 6NF

1 3 5 7 9 10 8 6 4 2 21 22 23 24

ISBN: 978 1 78530 364 7

A CIP catalogue record for this book is available from the British Library.

Layout by Black & White Publishing
Printed and bound in Turkey by Imago

THE
COLOUR *of* IRELAND
COUNTY *by* COUNTY 1860–1960

ROB CROSS

BLACK & WHITE PUBLISHING

*To my mother and father Noreen and Pat, my sisters
Sinéad, Mary and Siobhán, and my brother Brian,
for their continued support and encouragement
throughout my life.*

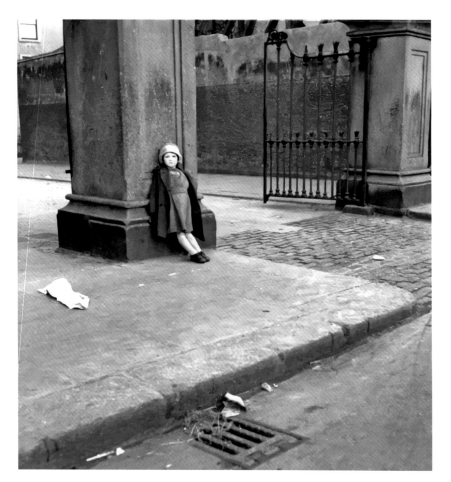

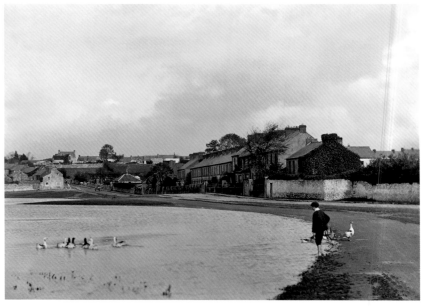

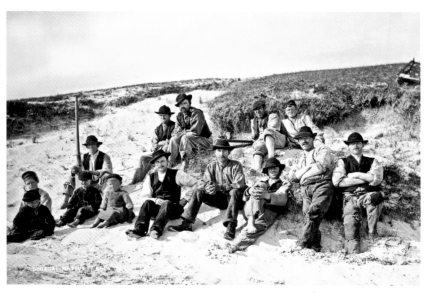

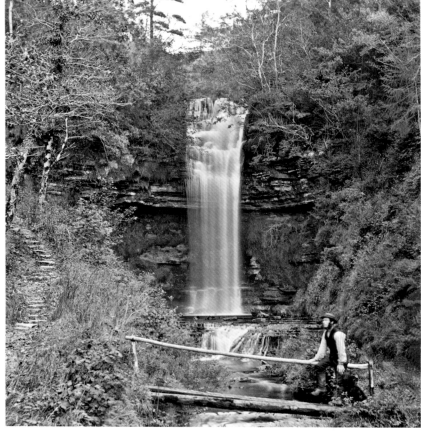

CONTENTS

Do the originals not speak more powerfully than any subsequent colourisation can?

It is evident that computer programmes and historical context can make uncomfortable bedfellows.

NOT THE SAME LIFE

Diarmaid Ferriter

In 1995 the great Irish novelist John McGahern made clear his admiration for an art that had brought to light and preserved the lives and looks of a whole variety of nineteenth century people in his native Leitrim. McGahern wrote glowingly about the photographs taken by Leland Lewis Duncan between 1889 and 1894. They were discovered by McGahern's cousin Liam Kelly who noted that they:

'Ranged from the big house and the mud cabin to the well-dressed landlord's daughter and the impoverished peasant. Through his camera lens, we view the meitheal of men drinking Guinness after the rick of hay is finished, the straw-boy dressed for the wedding party, the woman at her spinning wheel, the bare-footed postboy and the big-boned blacksmith.'

At that point in time the subjects of the photographs knew little of the process of photography. As a result, 'they have the fascination of nearly all old photographs,' McGahern wrote. 'Time that is still our element has already washed over these lives and they seem to look at us out of a depth of time or waters in fashions that have ceased . . . they could not imagine how they would look in a photograph . . . they speak to us out of a world that has disappeared; but such is the magic and mystery of art that they do so with a richness and depth that life rarely gives . . . what an added pleasure it is to see how unselfconscious these people are . . . their mute presence is more eloquent than any idea of self.'

And what of the photographer? McGahern tells us that Duncan 'had to be able to see the picture in his mind's eye beforehand; he could not add or subtract anything later in the darkroom so that whatever he saw in his viewfinder before the shutter clicked was the final picture'. The pioneering photographers of that era understood the potential and limitations of their medium and engaged with it accordingly, but we now live in an age, as underlined by this rich, fascinating – but for me, troubling – book, where the photographs of history are no longer 'the final picture'.

Of course, Duncan's Leitrim subjects lived their lives in colour. Liam Kelly's overview of their activities suggests a vividness, energy and engagement with the possibilities and responsibilities that surrounded them while, as McGahern observed, 'the moment and the day were everything'. They inhabited the immediacy of their lives, but now, thanks to advances in technology, these photographs – taken well over a century ago – can be colourised. How might we think about the colour versions? Are the moment and the day in which they were taken still 'everything'? Or does what is essentially a form of interference with evidence – albeit interference that is well-intentioned and sometimes the result of assiduous research of context – undermine their essence?

In thinking about these questions, my mind tilts from side to side, but the reservations I have are never

quashed. As a historian, I am uncomfortable with the colourisation of black and white photographs while also being aware of the popularity of the process, its ability to democratise history and the generosity of people like Rob Cross who devote so much time and effort to satisfy those who want their black and white past brought to a new life. But I am not convinced that it is the same life.

Whether colourisers spend minutes or hours working on a photo, there is an element of guesswork; there will usually be doubt that they have succeeded fully; many faces and bodies become more like waxworks, and it is evident that computer programmes and historical context can make uncomfortable bedfellows. The pictures that were taken at any moment in time were the pictures as the takers saw them; what they saw, in colour, is not the exact same as what a colourised photograph becomes.

Do the black and white family images we hold dear become, after colourisation, more about the colour than the subjects? What about the memories the originals hold or generate – why do we have to interfere with them? And why do some contemporary photographers, who have access to colour, prefer to take black and white photos? Is it because black and white is, for them, more penetrative?

Do iconic, renowned images become something else after colourisation? Do we really need to see the colour of President John F. Kennedy's blood on his wife Jackie's dress the day he was assassinated? Do the originals not speak more powerfully than any subsequent colourisation can? We need to think, too, about the photographer's craft. Do the photographers who worked in black and white deserve this act of colouring to be done to their work or is the essence of their art – and its sureness and decisiveness – being unfairly compromised?

I do not have answers to all these questions, but they do need to be asked and discussed. When, in 2020, a highly popular book of colourised photographs was published, the authors noted that the debate about colourisation had been going on for decades but claimed they did not want to engage in that debate. Why not? They also said they were aware of the ethical concerns raised by altering primary sources, so surely a more robust engagement with those concerns is merited, an engagement that this book, helpfully and crucially, enables by including the originals alongside the colour versions.

Peter Jackson's ground-breaking 2018 documentary *They Shall Not Grow Old*, involving modernised and colourised footage of the First World War, understandably stirred deep, emotional responses. The scale of the technical challenge met and the resources and efforts that went into its making were lauded. As the soldiers arrive on the Western Front and the footage moves to colour the impact is mesmeric, but are we really seeing the war, for the first time, as they

saw it? Are the methods that were used at the time to capture these men not themselves an intrinsic part of that era? They knew as they stared into cameras that they were gazing into devices that would produce black and white images. So why alter them?

The *Observer*'s film critic Mark Kermode celebrated Jackson's approach as 'using 21st century technology to put the humanity back into old movie stock', but that is a problematic assertion as it implies the original footage lacks humanity, which is simply not true. The original images possess a uniqueness that was subsequently interfered with. It is true that the originals remain to be viewed, but the increasing momentum behind colourisation and the unending quest to 'improve' on things or make them easier for us to relate to, also holds out the danger of the originals becoming marginalised.

A crucial point here is about the textures of the time. As the American photographers William Eggleston, Joel Meyerowitz and William Christenberry brought colour to the centre of photographic practice in the 1960s and 1970s, colour was seen as an intrinsic quality of the visual world. In the words of John Szarkowski, director of photography at the New York Museum of Modern Art, and renowned historian of photography, they were 'working not as though colour were a separate issue, a problem to be solved in isolation, but rather as though the world itself existed in colour'.

But colour was not an intrinsic quality of the world of photography during an older era. The celebrated German critic Walter Benjamin wrote an essay on photography in 1931:

'No matter how artful the photographer, no matter how carefully he posed his subject, the beholder feels an irresistible urge to search such a picture for the tiny spark of contingency, of the Here and Now, with which reality has, so to speak, seared the subject, to find the inconspicuous spot where in the immediacy of that long-forgotten moment the future subsists so eloquently that we, looking back, may rediscover it … For it is another nature that speaks to the camera than to the eye … What is aura, actually? A strange weave of space and time: the unique appearance or semblance of distance, no matter how close the object may be.'

Yes, the people in this book were photographed in black and white as they lived their lives in colour. But they also lived those lives before colour photography and, for me, there is a strong argument to be made that we should leave them there without interference.

As I see it, colourisation assaults the aura.

Diarmaid Ferriter
Professor of Modern Irish History,
University College Dublin

If we divide photography into two ages, before and after the arrival of colour photography, some will ask — should the two meet?

The images presented here do not attempt to replace their original sources. Rather, they may serve as a fascinating engagement with the past.

IMAGES OF THE EVERYDAY

Donal Fallon

With the end of the First World War, a large victory parade made its way through the streets of the Irish capital, the flag of the Empire flying over many of Dublin's most prestigious buildings. It was an uncomfortable reminder that not all in Dublin felt they were on the side of what the 1916 Proclamation had termed 'gallant allies in Europe' only a few short years earlier. George Joseph Dwyer, a member of the Dublin Brigade of the IRA, recalled decades later that, 'We were to open fire on the parade but at the last moment this instruction was cancelled. On our way home we observed a cameraman who had taken pictures of the parade. We took the camera off him and destroyed it.'

Other accounts of the day place the unfortunate photographer himself in the River Liffey after the altercation. The story matters here, as it tells us something significant: the Republican movement was deeply conscious of the potential power of press photography – and images of that day in particular – to disrupt or reshape the narrative of the Irish question elsewhere.

Our understanding of the revolutionary period comes from a multitude of sources, of course. Primary source recollections, such as the excellent Bureau of Military History and published memoirs – including *Guerrilla Days in Ireland* and *My Fight For Irish Freedom* – are joined by an ever-growing body of research by historians and others. But who could deny that the cameras of photographers such as W. D. Hogan, present at events like the aftermath of the burning of Cork City and the destruction of Dublin's Custom House, have influenced how we view the period too?

Images shaped our understanding of key events in Irish history even before photography. James Mahony's haunting illustrations for the *Illustrated London News* of the Great Hunger, in particular that depicting a mother and her two starving children, are indeed more familiar to Irish eyes than any written account of the crisis. Yet photography makes suffering all the more real – how much more charitable might the British public have been if they were confronted not by Mahony's sketches, but by photographic evidence of human suffering? Haunting photos of the concentration camps of the Second Boer War (1899–1902) graphically brought home the horrific realities of conflict, and ensured the place of photography in our understanding of international news and development.

Many historians will recall a moment when the

power of photography, as a source, first became apparent to them. For me, it occurred against the backdrop of the centenary of the 1913 Lockout. Amid the harrowing housing inquiry and press reports on Dublin's worsening tenement crisis were the images of John Cooke, Honorary Treasurer of the National Society for the Prevention of Cruelty to Children, who travelled into the heart of slumdom with a camera to show the desperate realities of life in parts of the city. His pictures shocked in ways beyond words. In teaching on the period, I utilise Cooke's images – the work of a man who insisted the tenement system 'breeds misery – and worse' – to ask students to reflect on photography's power to impact upon and move public opinion.

Some of the images in this collection relate to conflict; for example, W. D. Hogan's iconic image of cheery Auxiliaries and Black and Tans at the London and North Western Hotel on Dublin's dockside, following an attack in April 1921, or the destruction of Henry Street in the aftermath of the Easter Rising. But many more relate to so-called ordinary life, or everyday life, depicting survival, labour and recreation in the nineteenth and twentieth centuries. It is in these images that a multitude of sometimes surprising things are revealed – from the architecture of our towns and cities, to changing fashions.

Even with the widespread arrival of colour photography in the mid-twentieth century, some photographers continued to shoot in black and white, perhaps influenced by the great Henri Cartier-Bresson's insistence that 'color negates all of photography's three-dimensional values'. In an Irish context, it is near impossible to picture the photography of John Minihan – who so skilfully captured Samuel Beckett – in colour. Who could disagree with the assessment that 'there's a theatricality with colour that doesn't work with Beckett'? Yet there are iconic images of Ireland from the second half of the twentieth century onwards which are equally difficult to imagine in black and white, such as Evelyn Hofer's contributions to *Dublin: A Portrait* (1967), where the brown and green leaves of Stephen's Green and the red brick buildings of the Liberties breathe new life into the images before us.

If we divide photography into two ages, before and after the arrival of colour photography, some will ask – should the two meet? To my mind, at the heart of the debate around colourisation is a question of presentation. The journalist Matt Novak, in an interesting piece for tech website Gizmodo (which sports the tagline *'we come from the future'*), raised the intriguing case of an image of the Golden Gate Bridge, tweeted by the ever-popular @HistoryInPics account (3.4 million followers on Twitter at the time of writing). The image, which pops from the screen in vivid colour, was presented to followers with the simple caption 'Golden Gate Bridge, 1940'. With no mention of its colourisation, it could readily be presumed to be an

unadjusted primary source. Viewed by millions – and shared by thousands – could such an image surpass its original in search engine algorithms, thus becoming the 'authentic' and more familiar image?

Yet when images are presented to us alongside their black and white originals – and it is made clear to us we are viewing a colourised reimagining of the past – these concerns around confusion fade, and instead such images move to the realm of entertainment. A simple search of Rob Cross's Twitter hashtag, #TheColourofIreland, and we can see the possibilities of these images to spark reflection, discussion, even debate.

The images presented here do not attempt to replace their original sources. Rather, they may serve as a fascinating engagement with the past which could lead the viewer to explore the rich archival collections from which Rob has selected them. They also serve a very useful purpose in making us think about images more broadly – if colourisation is a manipulation, what of looking closer at historical images in other ways? In recent times, more are familiar with the story of the 'Battle of Tralee', a fictitious battle that was 'recreated' on Vico Road in Killiney. These images, which not alone made it to the front of the *Illustrated London News* during the War of Independence but have since been reproduced in endless secondary sources, did not tell the story they purported to – but another fascinating tale entirely. Clearly, black and white images don't always tell the truth either.

There is a real beauty in the images of the everyday presented to us in *The Colour of Ireland*. I find that they recall the words of writer and philosopher Susan Sontag: 'to take a photograph is to participate in another person's mortality, vulnerability, mutability. Precisely by slicing out this moment and freezing it, all photographs testify to time's relentless melt.' These moments in the lives of others, those people now gone, are images in which we see the familiar and the curiously unfamiliar. Rob Cross has presented us with an ever-growing project that captures transformation and change on the island of Ireland through time, and which challenges us to think about the past and how we view and interpret it.

Donal Fallon
Author and former Historian in
Residence to Dublin City Council

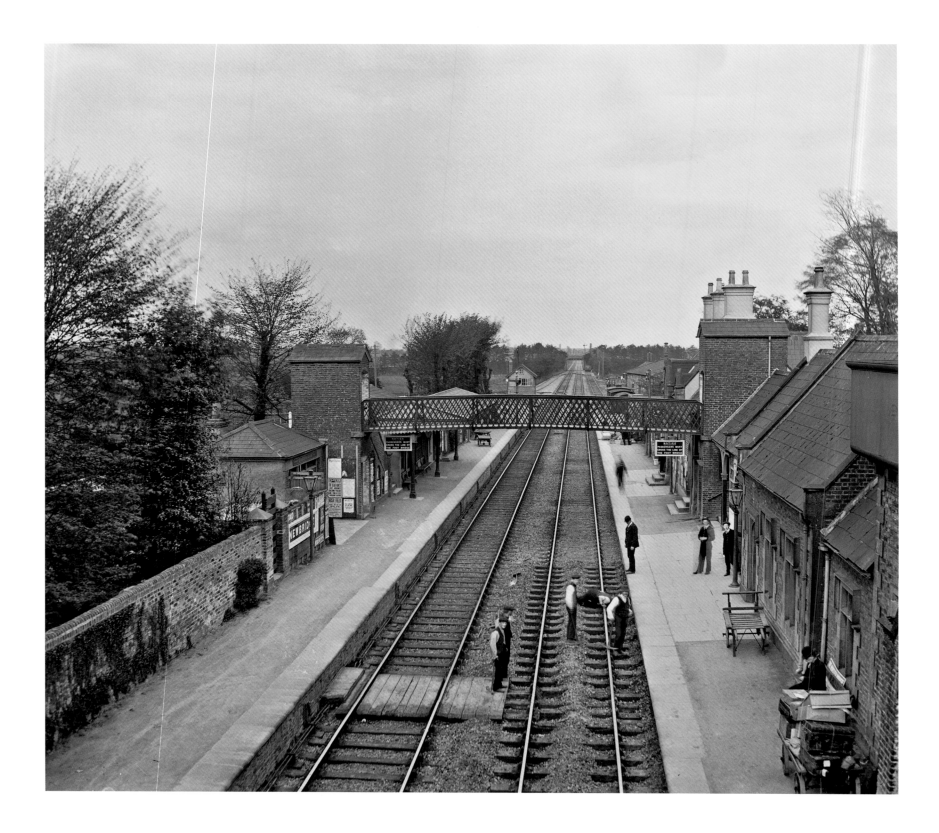

LEINSTER

or Laighin *in Irish*

*is one of the four traditional provinces of Ireland situated
in the southeast and east of Ireland.*

Wexford | Meath | Kilkenny | Wicklow

Offaly | Westmeath | Laois | Kildare | Longford

Dublin | Carlow | Louth

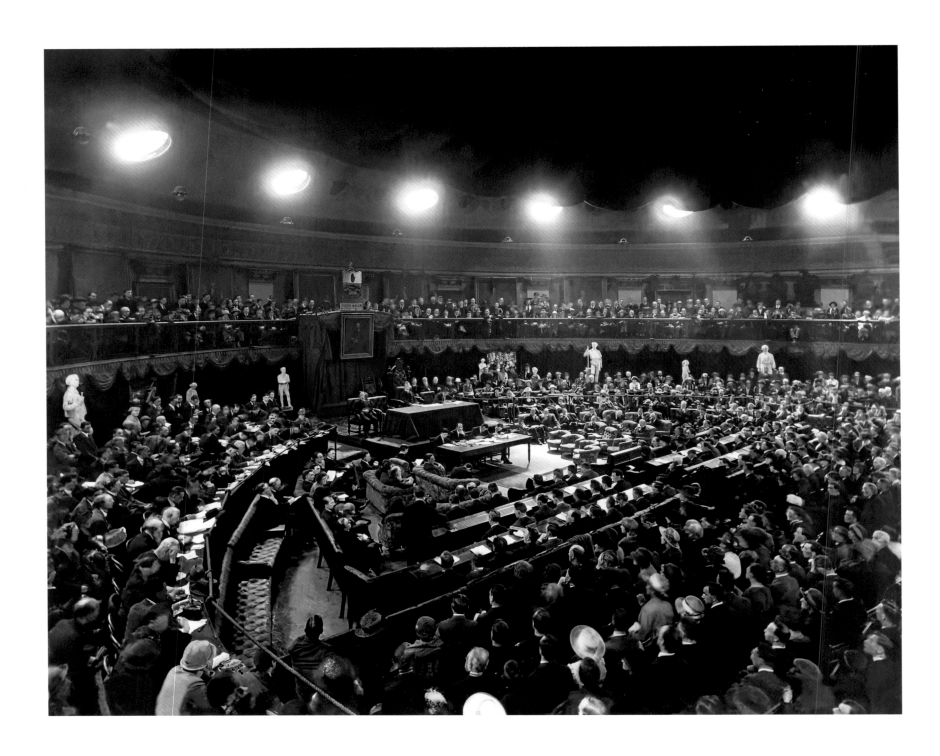

MY
FAVOURITE
PHOTO *to* COLOURISE

(FEATURED ON PAGE 54)

One of my favourite photos that I've colourised is a 1921 image featuring the second-ever sitting of Dáil Éireann, which took place in the Mansion House Round Room on Dawson Street in Dublin City. During the research process into verifying the colours, I used as a colour reference a painting by Thomas Ryan, which currently hangs over the entrance to the Dáil Chamber in Leinster House on Kildare Street. From the Thomas Ryan painting, I could verify the colours of key elements. For example, the tablecloth in the photo was green and the cloth hanging from the Round Room balconies in the background was bright red.

Once you start adding colour to the finer detail of the photo, such as the people and the furniture, you begin to discover new objects that you wouldn't have recognised in the original black and white photo. This uncovering of new elements from those visual stories of the past is surely one of my favourite aspects of colourising photos.

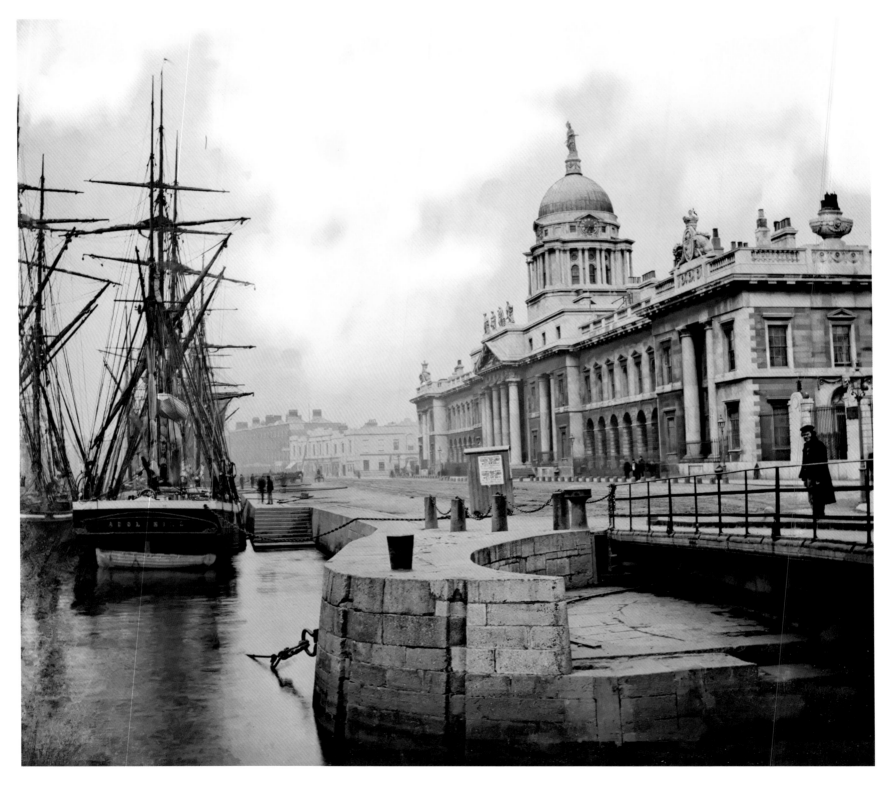

DUBLIN
Custom House
c.1880

The majestic sailing ship *Adolphine* moored at the Custom House in Dublin City with a swivel bridge in the foreground. The two-storey building beyond the 1791 Custom House designed by architect James Gandon is the original Liberty Hall which was formerly the Northumberland Hotel. Interestingly, on the red-painted kiosk there is a poster advertising 'Pleasure Trips to Lambay Island', which is the largest island off the east coast of Ireland.

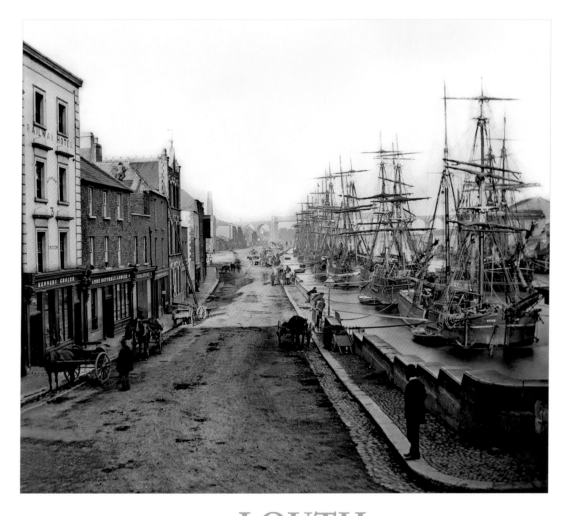

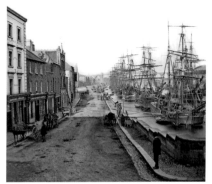

LOUTH
North Quay, Drogheda
c.1865

North Quay in Drogheda, County Louth featuring Kennedy's and Anne Butterly grocers and the Railway Hotel and the railway viaduct in the distance.

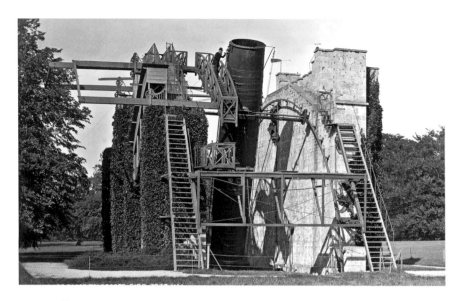

Lord Ross's Telescope

OFFALY
1885

Birr Castle, Parsonstown in County Offaly. In the early 1840s, William Parsons, the 3rd Earl of Rosse, designed and built the largest telescope in the world. The Leviathan of Parsonstown telescope was completed in 1845 and, at the time, was the world's largest mirror telescope. In use until 1917, the original mirror, made by Lord Rosse in his laboratory and measuring 1.8 metres, can now be seen at the Science Museum in London.

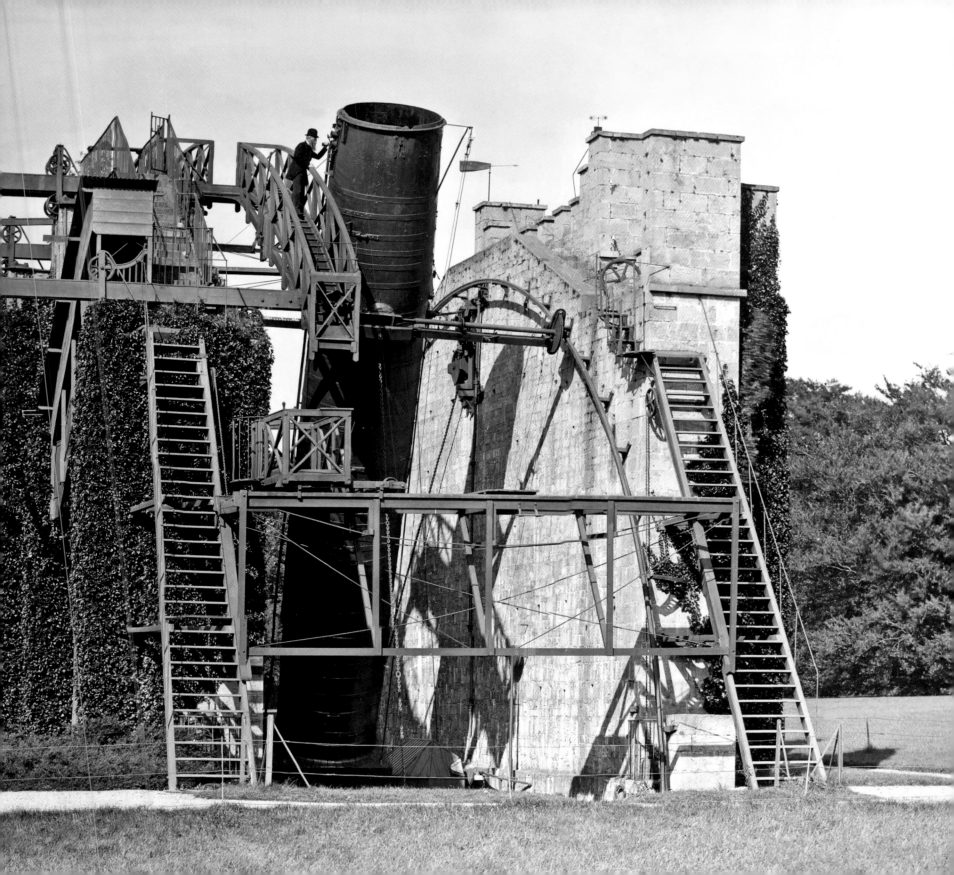

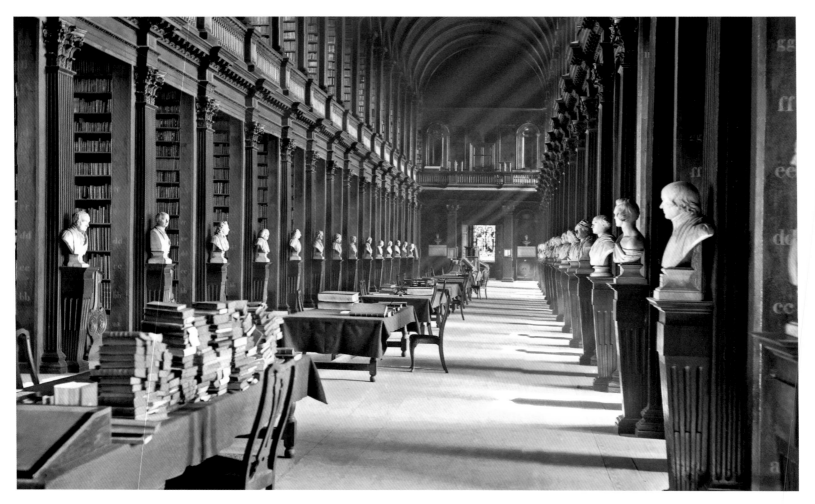

DUBLIN
Trinity College Long Room
1885

The world-famous Long Room Library at Trinity College Dublin. Built between 1712 and 1732, it is nearly 65 metres in length and filled with over 200,000 of the library's oldest books.

DUBLIN

Strand Road, Sandymount

c.1900

Dublin Tramways Company Tram Car no.196 on Strand Road in Sandymount in Dublin City with the old Merrion Pier, Promenade, Baths, and the Martello Tower in the background.

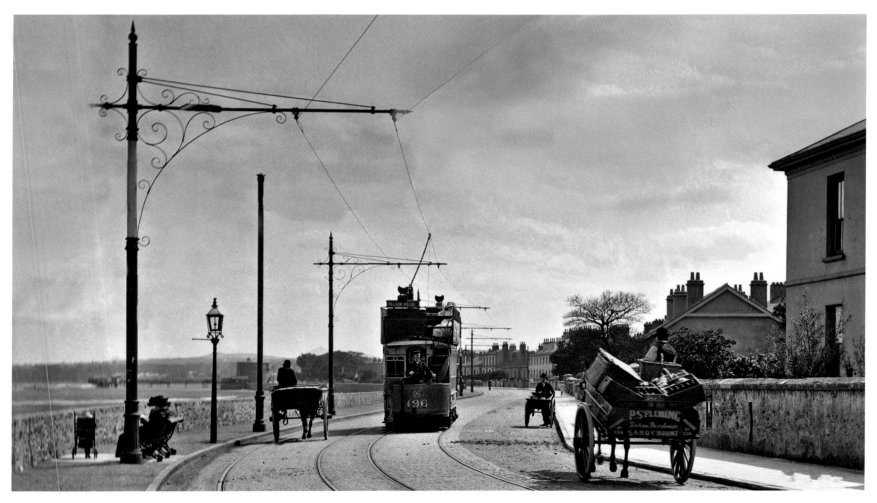

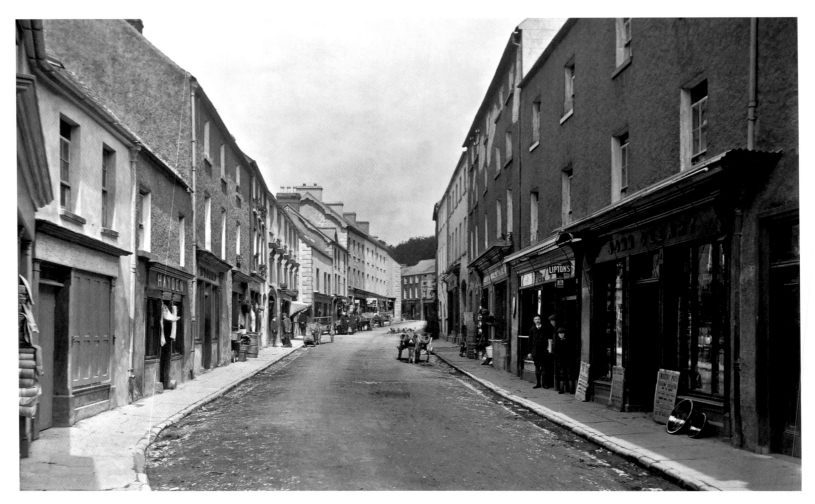

KILKENNY
High Street, Graiguenamanagh
c.1890s

High Street in Graiguenamanagh (Gráig na Manach, 'village of the monks'), which is located on the River Barrow in County Kilkenny.

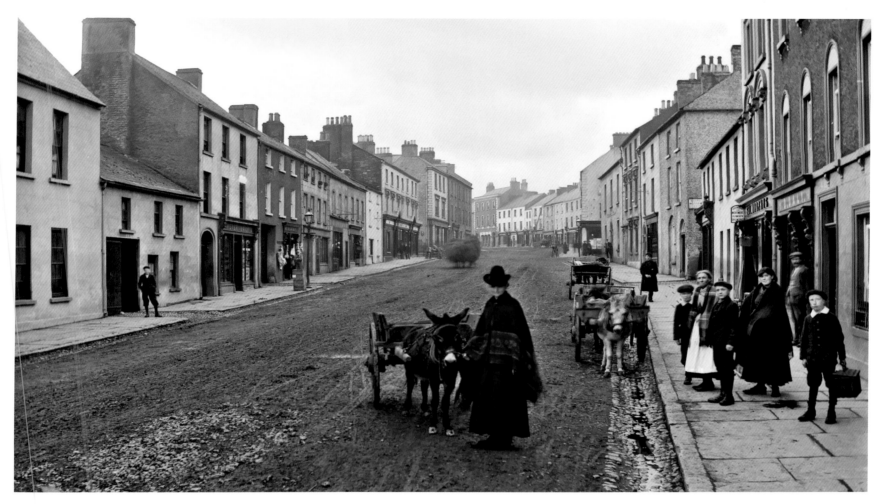

WESTMEATH
Earl Street (now Pearse Street), Mullingar
c.1890s

A Robert French photograph of Earl Street in Mullingar, County Westmeath. Earl Street was named in honour of the new Landlord of Mullingar, Colonel Greville, who had purchased the town in 1858.

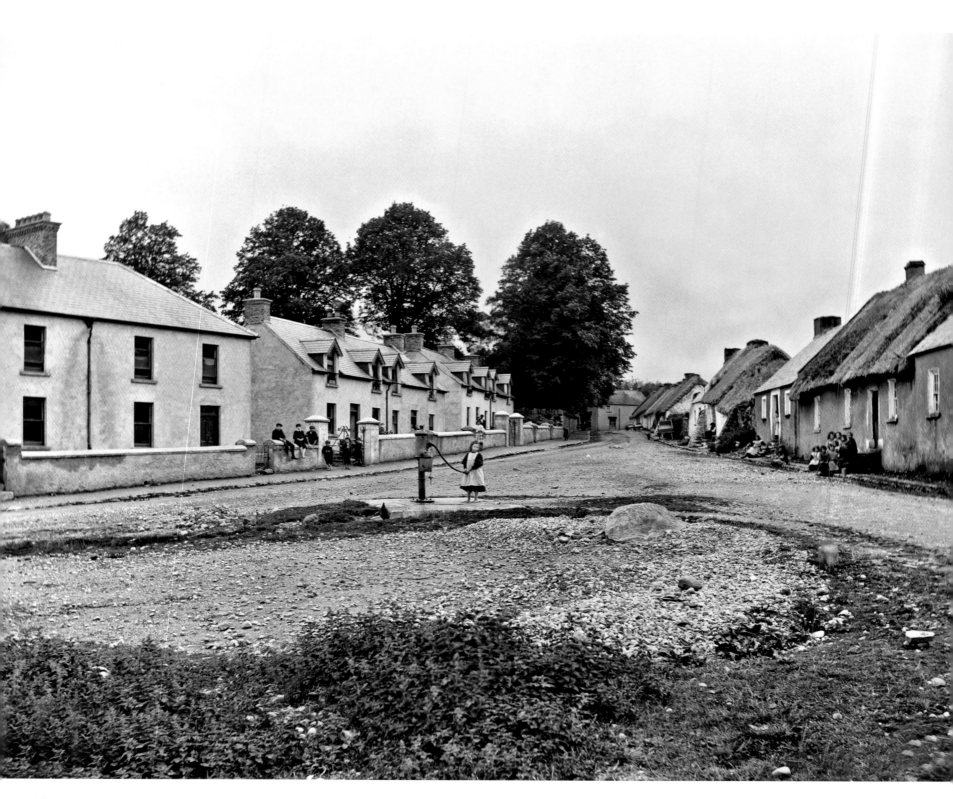

KILKENNY
High Street, Graiguenamanagh
c.1890

Graiguenamanagh is a small town located on the River Barrow in County Kilkenny.

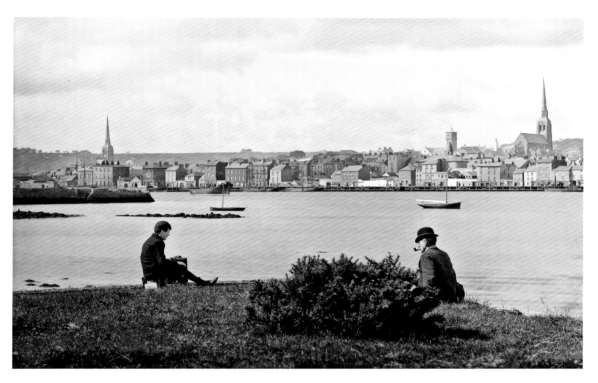

WEXFORD
Wexford Harbour
c.1890

Wexford Harbour, with the steeples of the Church of the Assumption designed by architects Pugin & Ashlin in 1864. On the left is the Church of the Immaculate Conception designed by architects Richard Pierce and J. J. McCarthy in 1860.

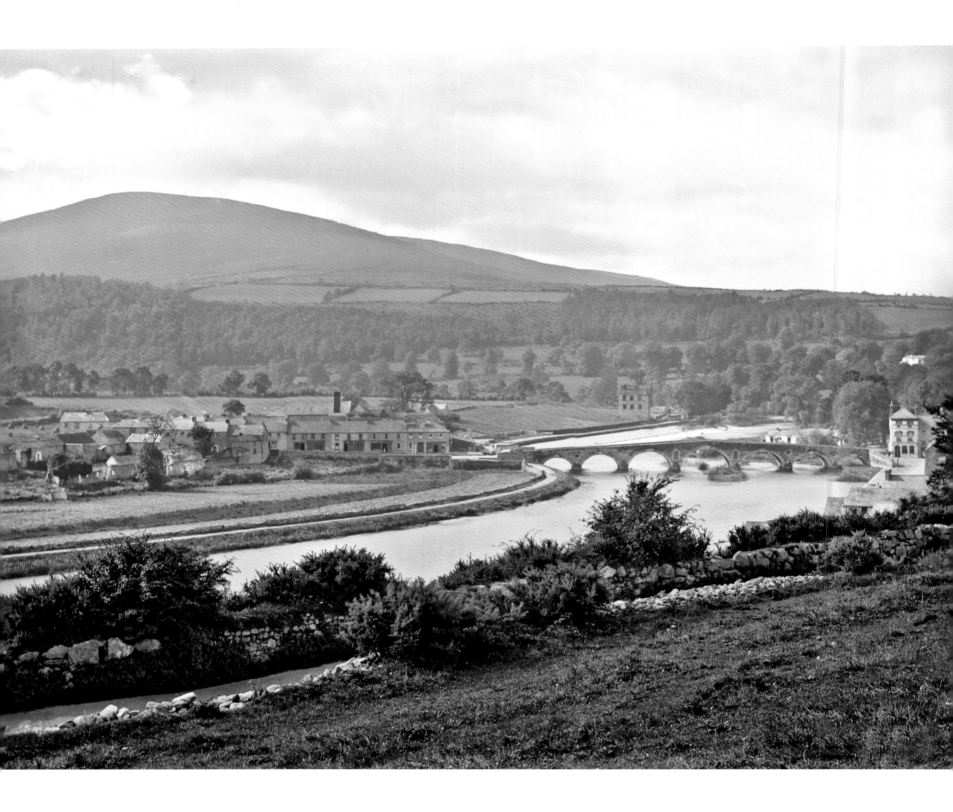

KILKENNY & CARLOW

Graiguenamanagh Bridge

c.1890s

The seven arches humpbacked bridge seen here was erected in 1764 by engineer George Semple as a replacement for the fifteenth century stone bridge. Graiguenamanagh is home to Duiske Abbey, which originated in the thirteenth century as the church of a Cistercian monastery.

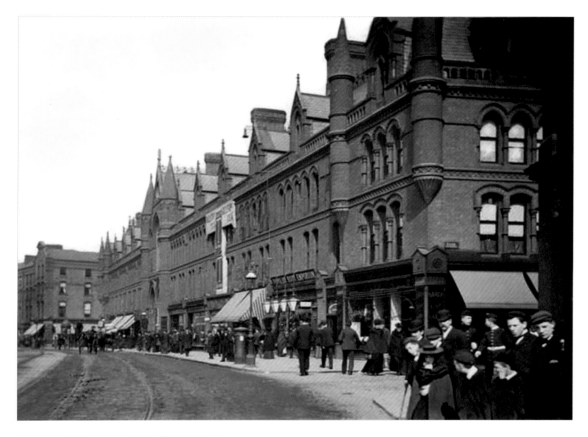

DUBLIN

South City Market, George's Street

1897

The stunning red brick turrets and towers of the Victorian-style South City Market (now known as George's Street Arcade) were designed by Lockwood and Mawson Architects and opened in 1881. The market was destroyed by a fire in 1892 and was rebuilt in 1894 with a remodelled interior designed by William Henry Byrne.

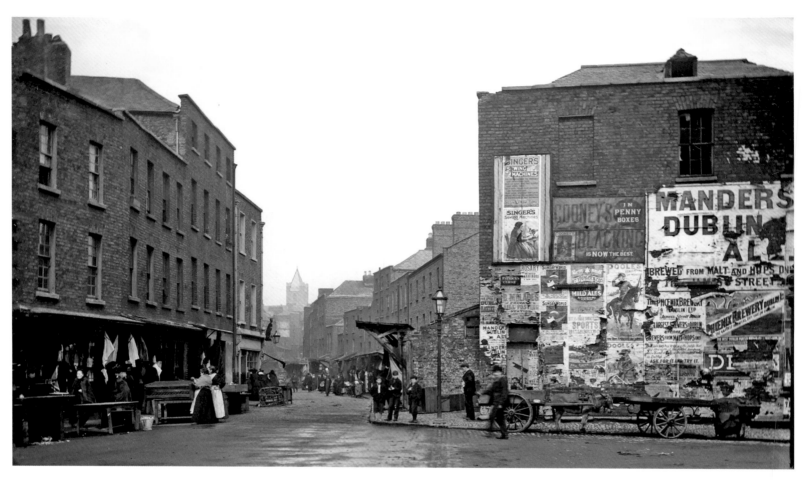

DUBLIN

Patrick Street

1898

Bustling Patrick Street, before it was widened, in the Dublin Liberties with the tower of Christ Church Cathedral in the distance. The road to the right is Patrick's Close North, which no longer exists, and the building with all the posters was demolished to make way for the Lord Iveagh's St Patrick's Park, which was completed in 1902.

SINGER'S
SEWING
MACHINES

ARE SO SIMPLE THAT THE YOUNGEST
CAN UNDERSTAND THEM.
AND SO EASY, THAT THE OLDEST
CAN WORK THEM.
SUCH EASY TERMS, THAT ANYBODY
CAN PURCHASE ONE.
VERY GOOD DISCOUNT FOR CASH
AND AS MUCH AS 20/- ALLOWED FOR
AN OLD MACHINE IN PART EXCHANGE.

THE SINGER MANF. COMP?
BRANCH OFFICES EVERYWHERE.

SINGER'S
Sewing Machines

106 Years Old. (Taken from Life)

COONEY'S
IN PENNY BOXES

COONEY'S
BLACKING
IS NOW THE BEST.

Blacking

MANDERS
DUBLIN
ALE

BREWED FROM MALT AND HOPS O
STREET

ROSARY
MIXED
MARRIAGES
A SICK CALL

SUNDAY WORLD

POOLES
REALIZATIONS
UP TO DATE

PATRICKS
CLOSE

THE ONLY SUNDAY PAPER
PRINTED AND PUBLISHED IN IRELAND

Wm YOUNGER & CO'S
CELEBRATED

B. McGLADES
DUBLIN
PRIVATE
BILL POSTING
STATION

THE NEW
SUNDAY WORLD

MILD ALES

THE PHŒNIX BREWERY
(DUBLIN) LTD
James Street Dublin
LARGEST BREWERS IN DUBLIN

PHŒNIX BREWERY DUBLIN

Wm Younger Co.

THE ONLY SUNDAY PAPER
PRINTED AND PUBLISHED IN IRELAND

ROYAL IRISH
SPORTS
BALLSBRIDGE

MANDERS
DUBLIN
ALE
JAMES'S STREET

BREWERS FROM MALT & HOPS ONLY

MANDERS
DUBLIN
ALE

POOLES

ASK FOR IT AND TRY IT.

DU

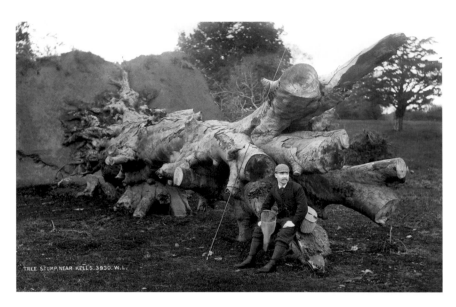

TREE STUMP. NEAR KELLS. 3930. W.L.

MEATH
Kells

c.1897

A fisherman in Kells, County Meath. The Kells Anglers Association was established in 1893 and owns fishing rights of fourteen miles on Blackwater River, the largest tributary of the River Boyne.

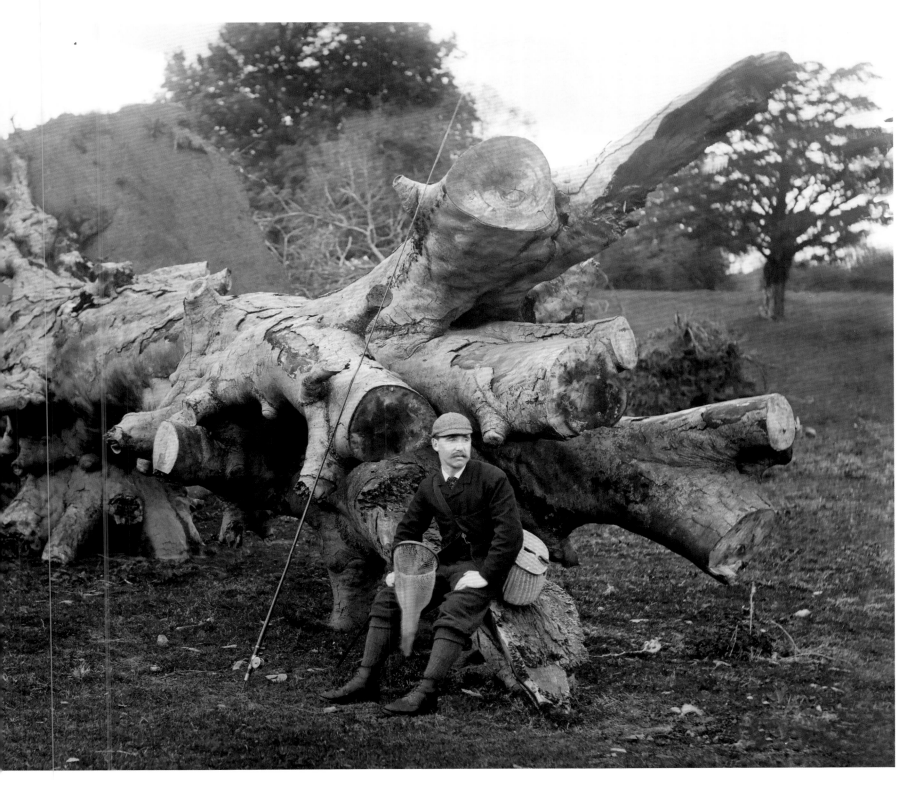

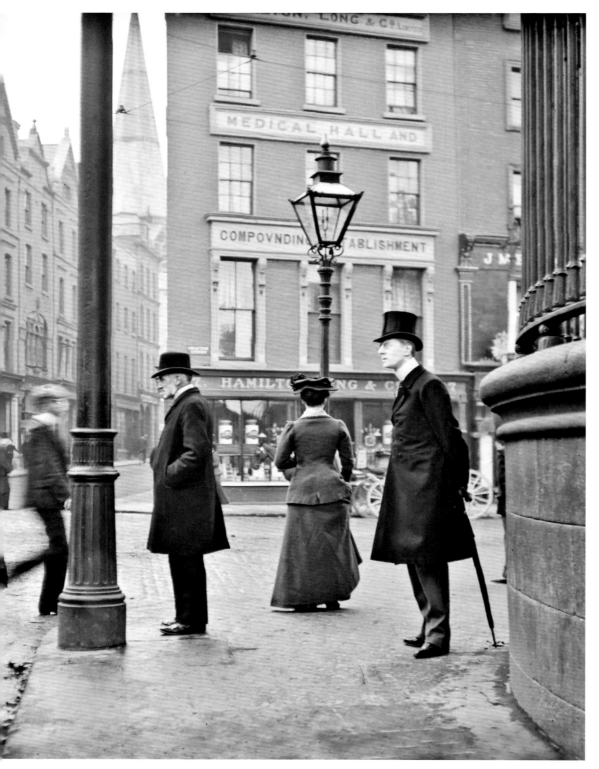

DUBLIN
Junction of Nassau Street, Grafton Street and Suffolk Street
c.1900

A John J. Clarke photograph of the junction of Nassau Street, Grafton Street and Suffolk Street in Dublin City with the spire of St Andrew's Church in the background, which was designed by architects Lanyon, Lynn & Lanyon in 1860.

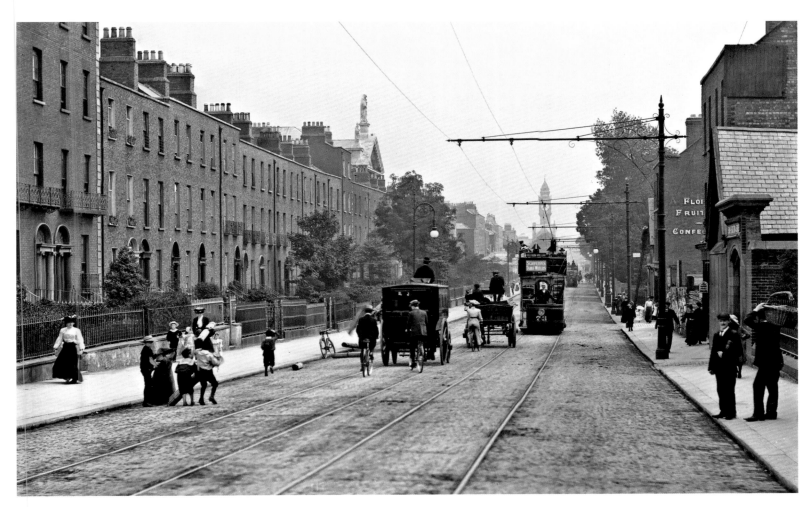

DUBLIN
Rathmines Road
c.1900

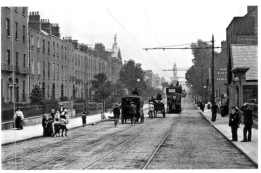

Rathmines Road in Dublin City featuring a dome-less Church of Mary Immaculate designed by architects Patrick Byrne & W. H. Byrne in 1854. In the background is the red sandstone four-faced clock tower of Rathmines Town Hall designed by architect Sir Thomas Drew in 1895.

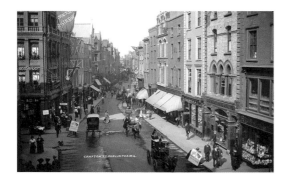

DUBLIN
Grafton Street
c.1900

A bustling Grafton Street featuring the Trocadero restaurant and a host of flags, most likely there for Queen Victoria's visit on 4 April 1900.

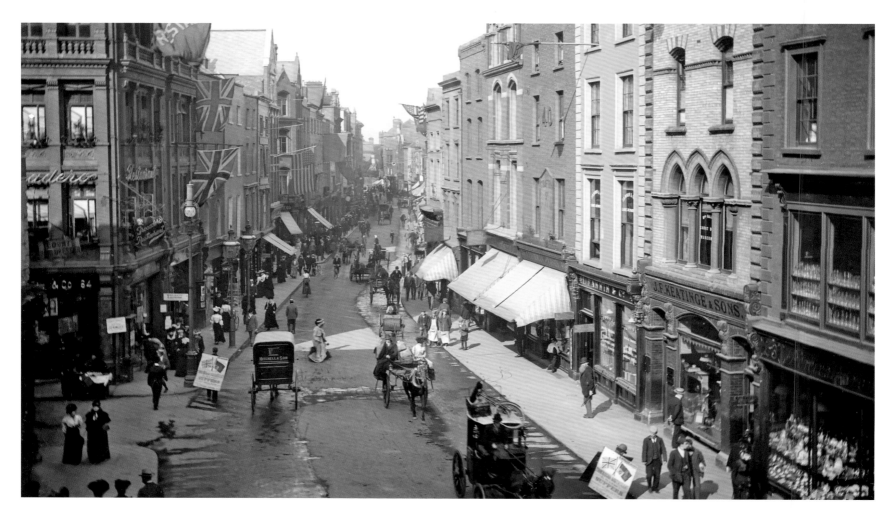

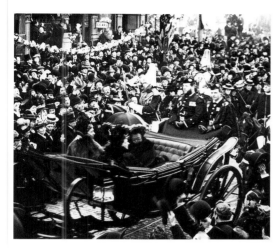

Queen Victoria
DUBLIN
Grafton Street
4 April 1900

This Thomas H. Mason photograph was taken on 4 April 1900. It shows Queen Victoria in her carriage on Grafton Street with her daughters, Princess Christian of Schleswig-Holstein and Princess Beatrice.

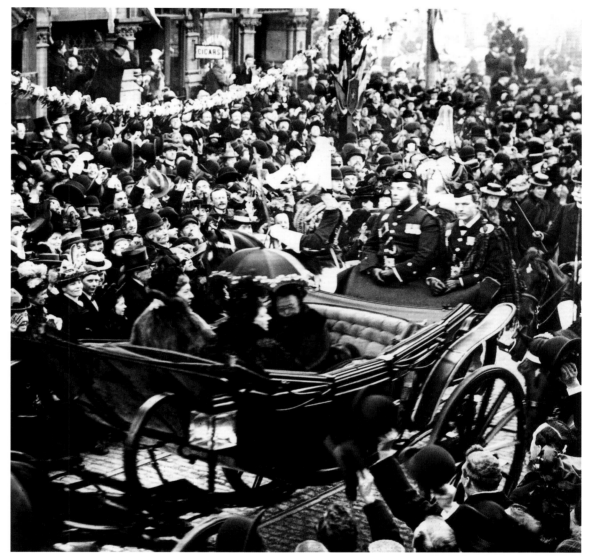

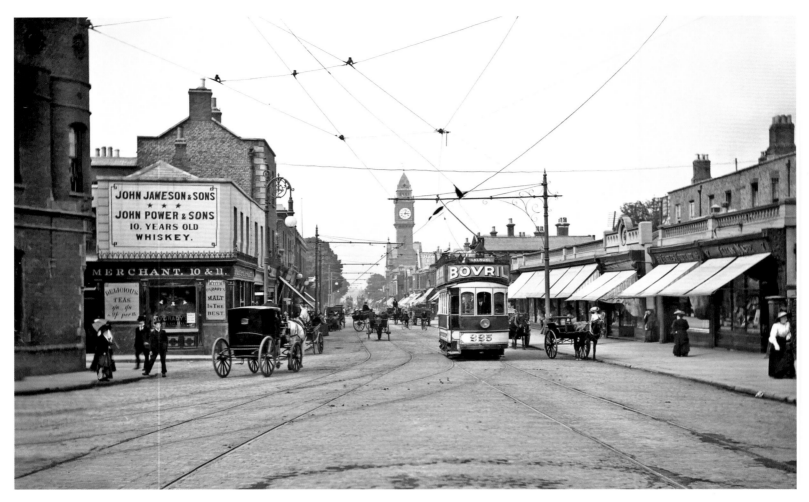

DUBLIN
Rathmines Road
c.1900

A busy Rathmines Road in Dublin, featuring the red sandstone four-faced clock tower of Rathmines Town Hall.

DUBLIN

Junction of Grafton Street and South King Street

c.1900

A woman with her birdcage at the junction of Grafton Street and South King Street in Dublin City with the canopy of the Gaiety Theatre featured in the background.

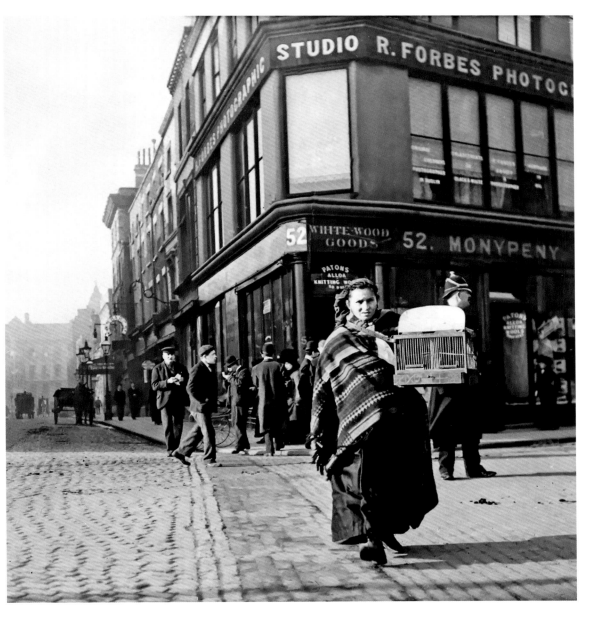

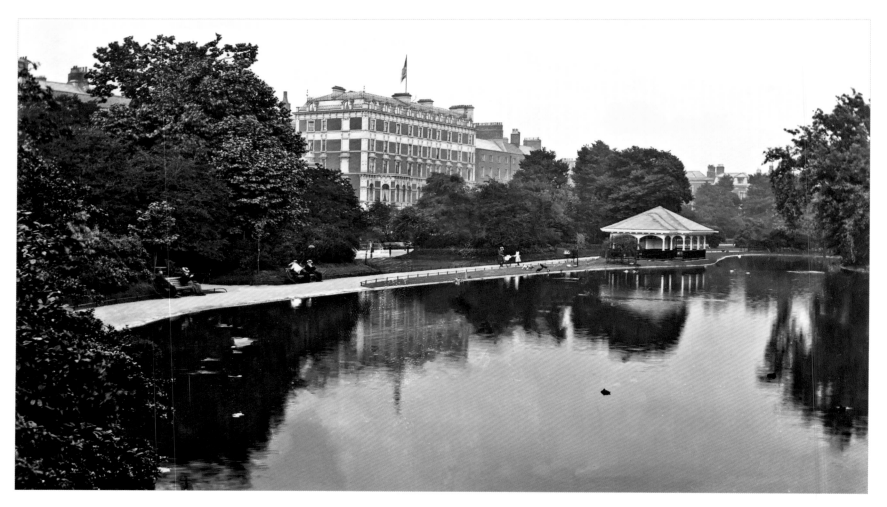

DUBLIN
St Stephen's Park
c.1890s

Dublin's St Stephen's Green Park. The name St Stephen's Green originates in the thirteenth century when a church called St Stephen's, with a leper hospital attached, was situated in that area. In the background is the Shelbourne Hotel, designed by architect John McCurdy in 1867, where the Constitution of the Irish Free State was drafted in room 112 in 1922, now known as the Constitution Room.

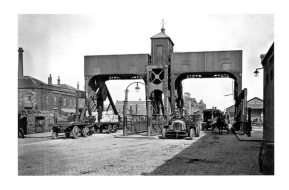

DUBLIN
Spencer Dock Bridge
1914

The Scherzer rolling lift bridge at the entrance to Spencer Dock (beside Dublin's Convention Centre), North Wall Quay, constructed in 1911 for the Dublin Port and Docks Board. The bridge is a form of bascule bridge, that uses a counterweight to balance the movement of the bridge as it opens.

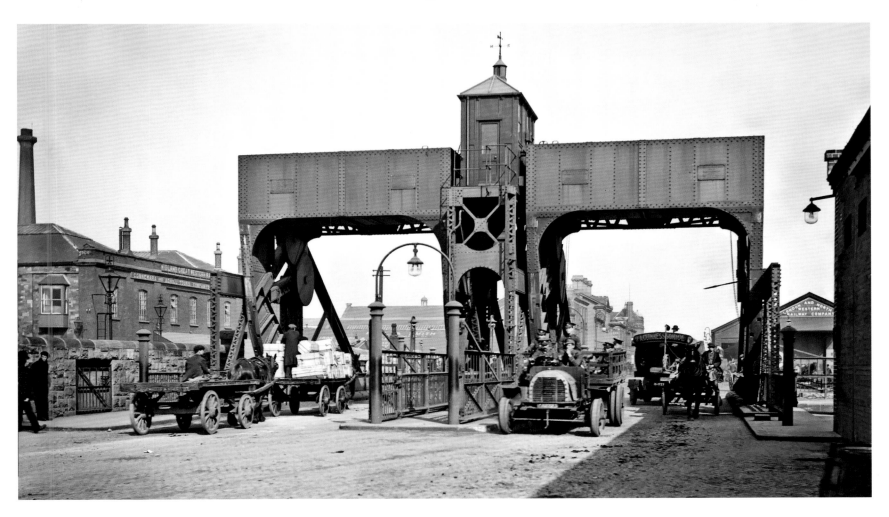

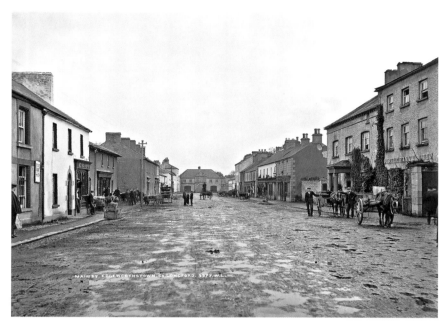

LONGFORD
Main Street, Edgeworthstown
c.1900

This Main Street in Edgeworthstown features the Ulster Bank Ltd and, in the background, the original entrance to the Edgeworth Estate owned by Richard Lovell Edgeworth. The area was named Edgeworthstown in the nineteenth century after the Anglo-Irish Edgeworth family.

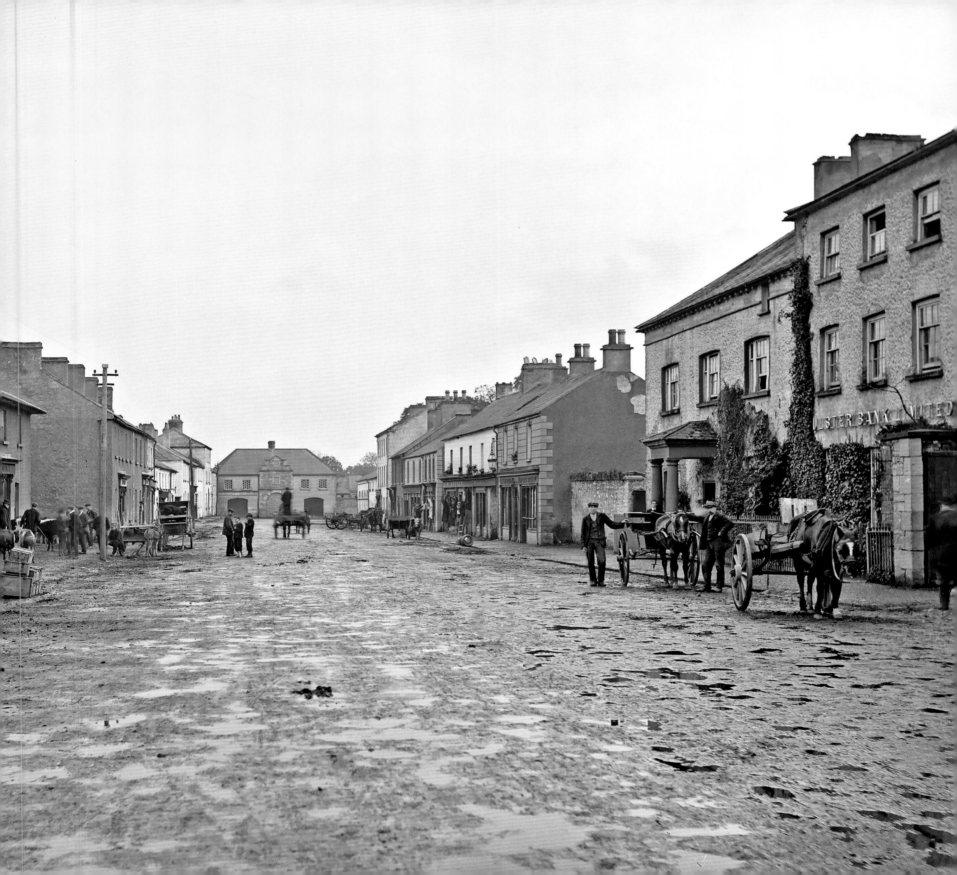

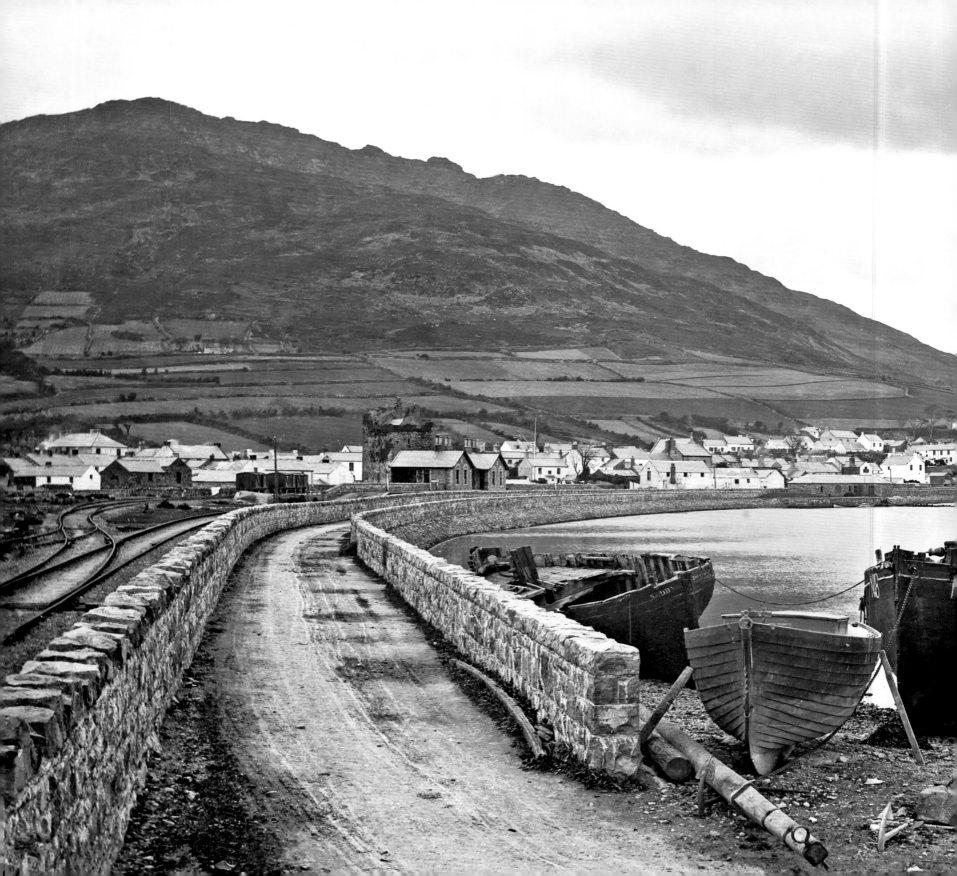

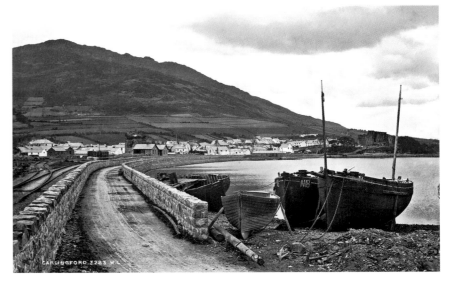

LOUTH
Carlingford
c.1900

Carlingford Harbour on the Cooley Peninsula in County Louth featuring the twelfth century King John's Castle and the 1876 Carlingford train station situated next to the sixteenth century Taaffe's Castle tower house.

LOUTH
The Square, Dundalk
c.1900

The Square in Dundalk, County Louth, featuring the red brick upper floor of Ulster Bank Ltd. Dundalk has a long history as a market town and travellers have come from all over Ireland to trade and shop here for 300 years. After the start of the Northern Ireland peace process in December 2000 the then American president, Bill Clinton, gave a speech to 60,000 people in the Market Square.

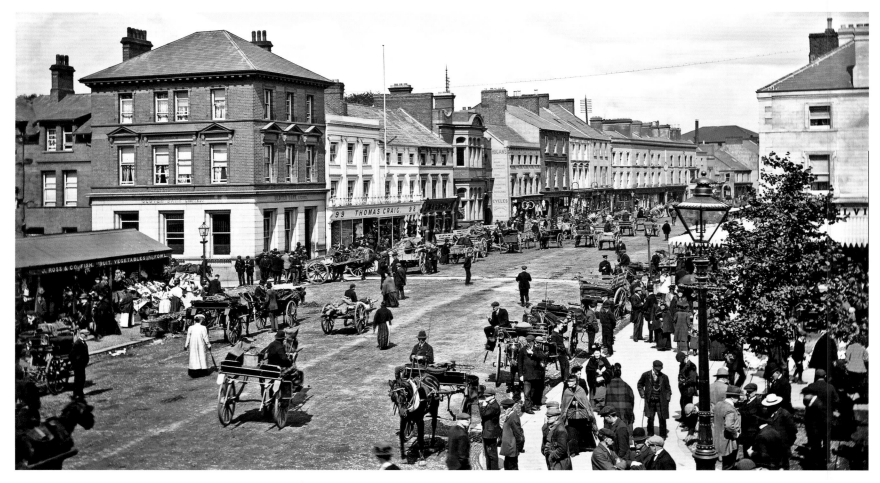

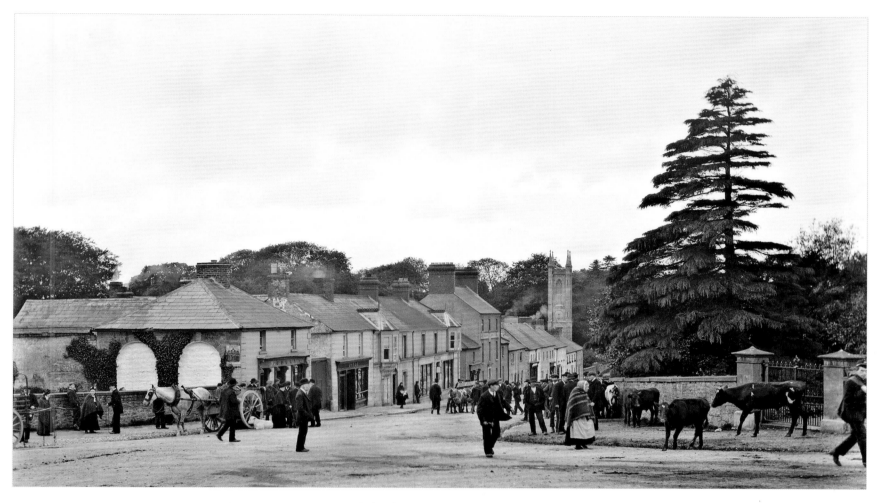

MEATH

Slane

c.1900

An Eason & Son photograph of market day in Slane. In the background is the clock tower of St Patrick's Church designed by Francis Johnston in 1795, minus its clock faces, which were added a few years later. If you look closely there is a recruitment poster on the gable wall for the Edwardian British Army Foot Guards, which is titled 'His Majesty's Foot Guards'.

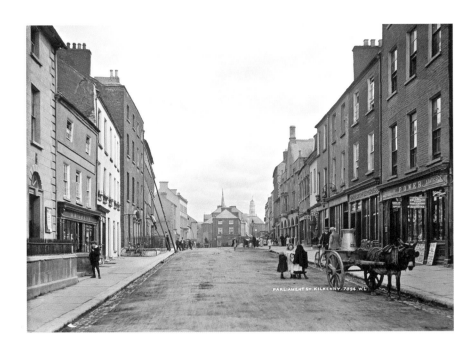

KILKENNY

Parliament Street

c.1905

Parliament Street in County Kilkenny with the Tholsel building in the background. This was built in 1761 by Alderman William Colles as a place for collecting tolls.

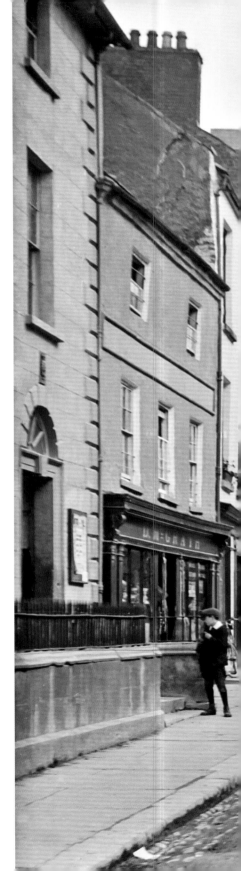

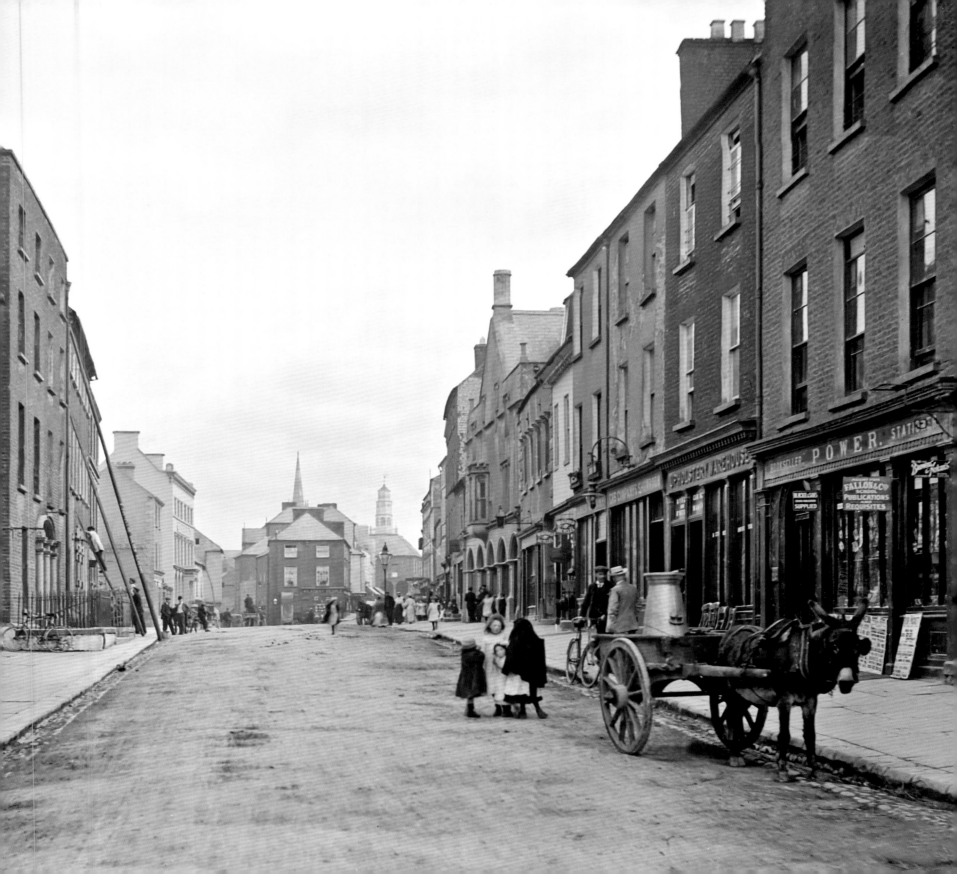

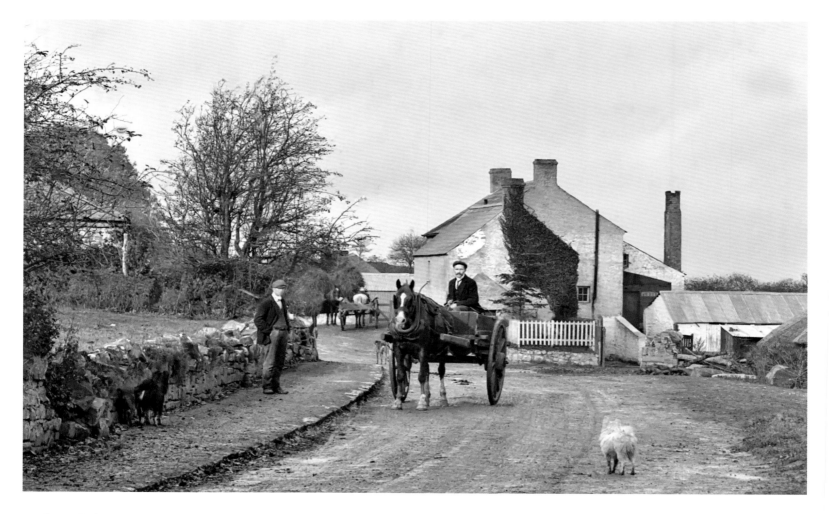

MEATH

Kilmessan

c.1900

The Main Street in Kilmessan Village (Cill Mheasáin, 'Church of Messan'), in County Meath. In the medieval period, Kilmessan parish was part of Skreen (Skryne), an area of land granted to Adam de Feipo by Hugh de Lacy after 1186, following the Anglo-Norman invasion in 1169.

MEATH

Newgrange

1905

A girl at the entrance of Newgrange's 5,200-year-old passage tomb in the Boyne Valley in County Meath. Newgrange was built by Stone Age farmers and is now a World Heritage Site. The passage and chamber are aligned with the sun as it rises on the morning of the winter solstice.

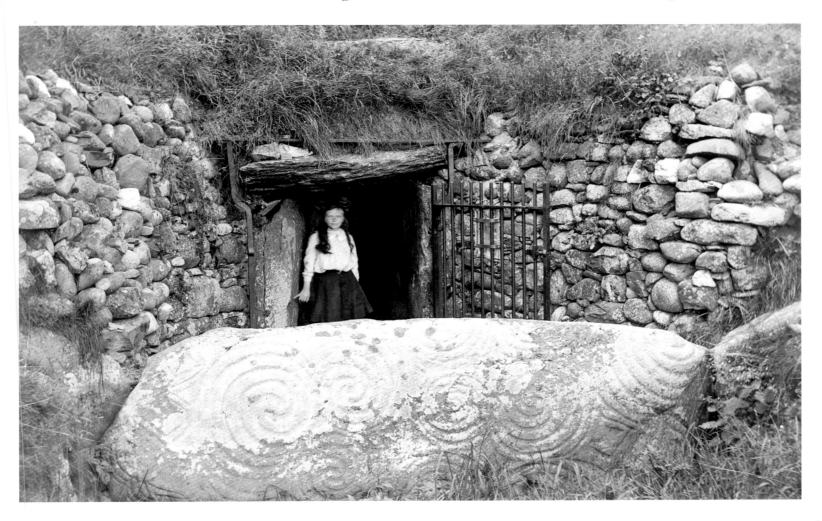

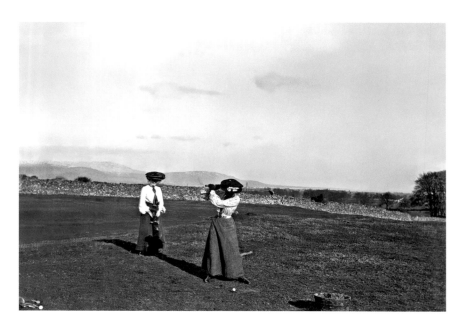

LOUTH
The Links
c.1907

Two women play golf on the links in County Louth. The first documented Irish lady golfer was Mrs Wright, the wife of a Captain Wright, of the Scottish Light Infantry Gordon Highlander. They were stationed in Belfast and played at Royal Belfast Club in 1887.

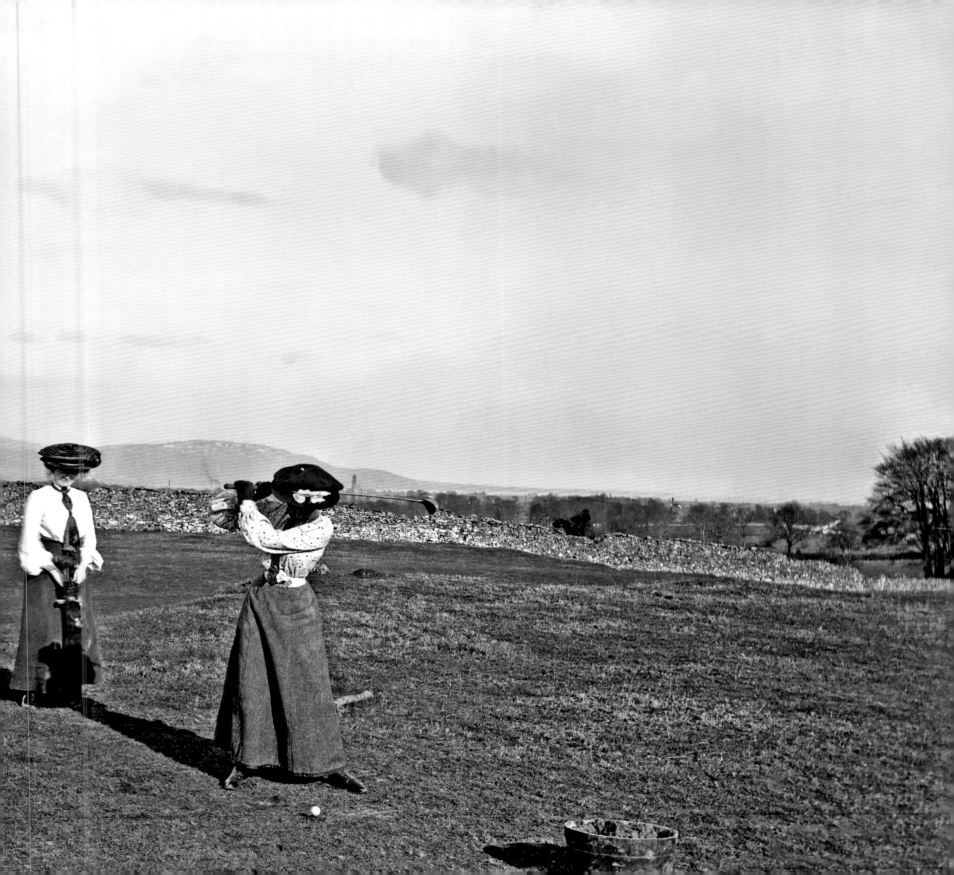

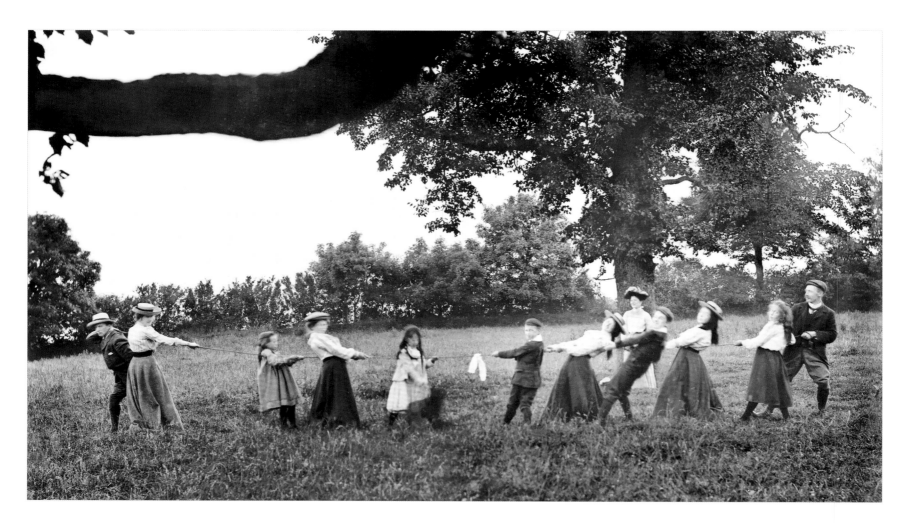

LOUTH
Drumleck
c.1907

Adults and children play tug of war in Drumleck in County Louth. The sport of tug of war was part of the Olympic Games from 1900 until 1920, but has not been included since.

CARLOW
Main Street, Bagenalstown
c.1910

Main Street, Bagenalstown, featuring the steeple of St Andrew's Church, which opened for Christmas Day 1820. The street features many traders such as Connolly, Lawler, Barry and Doran and, midway on the left-hand side of the street, is the entrance to the Bagenalstown Courthouse.

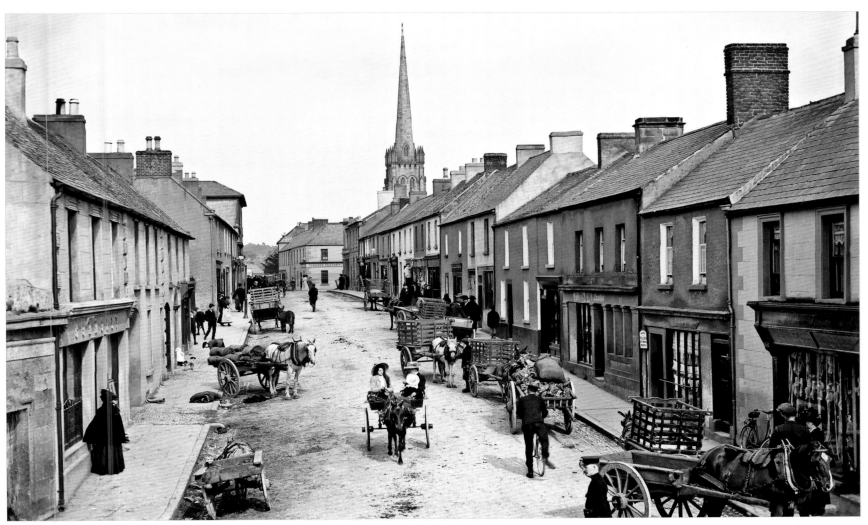

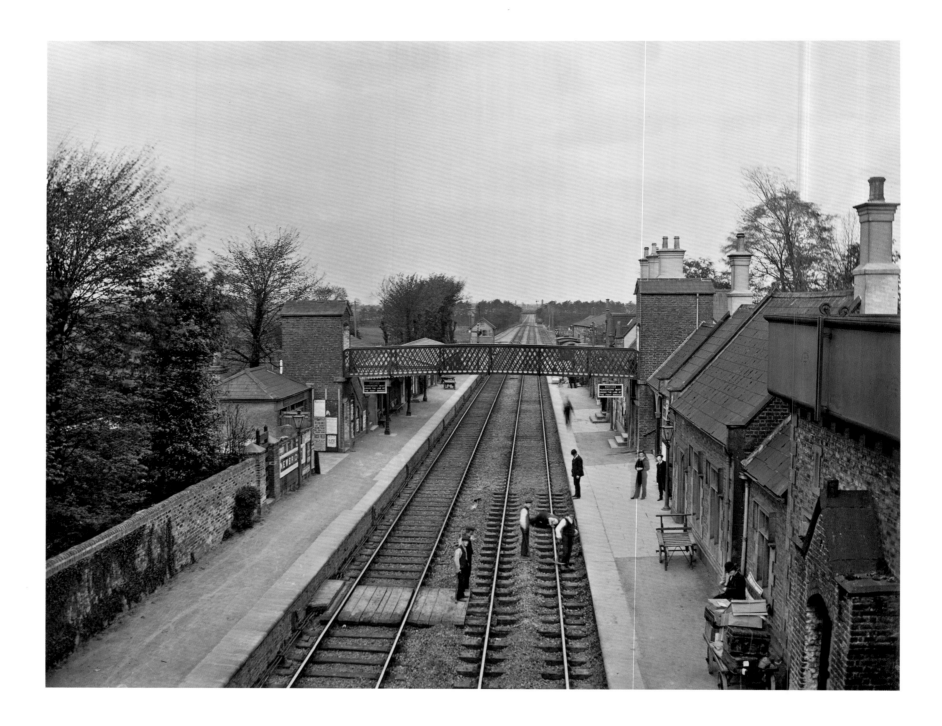

KILDARE
Newbridge railway station
1910

Newbridge railway station in County Kildare, featuring the station master observing rail workers spreading track ballast on the tracks. On the left-hand side, there is an Eason & Son newsagent kiosk.

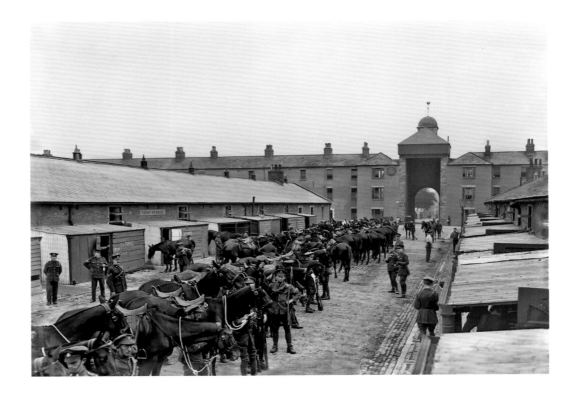

KILDARE
Newbridge
1910

British cavalry troops get ready at Newbridge Barracks stables.

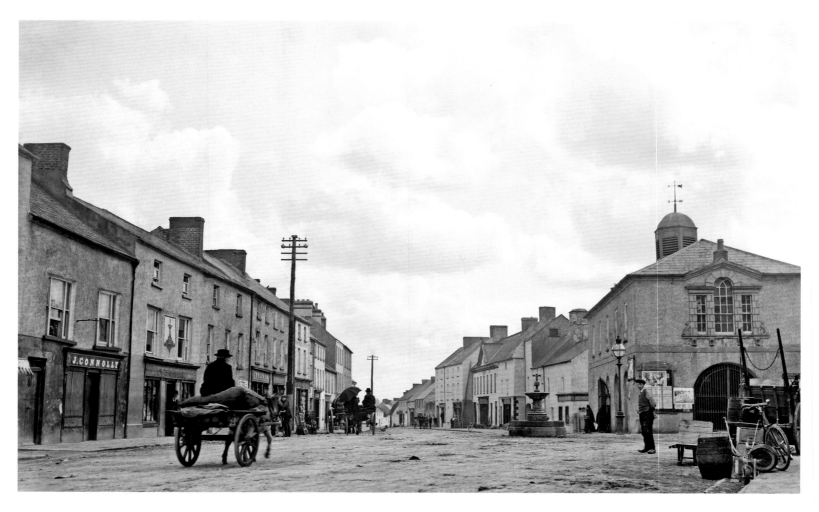

LAOIS
Main Street, Mountrath
1912

The Market Square in Mountrath, County Laois, featuring Fountain House on the left and Market House on the right, the latter designed by architect Richard Castle in 1748.

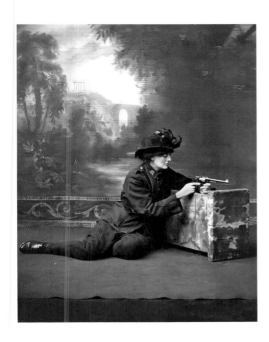

Countess Constance Markievicz
DUBLIN
1915

Countess Markievicz fought in
St Stephen's Green during the
1916 Easter Rising and was elected
Minister for Labour in the First Dáil,
becoming the first female cabinet
minister in Europe.

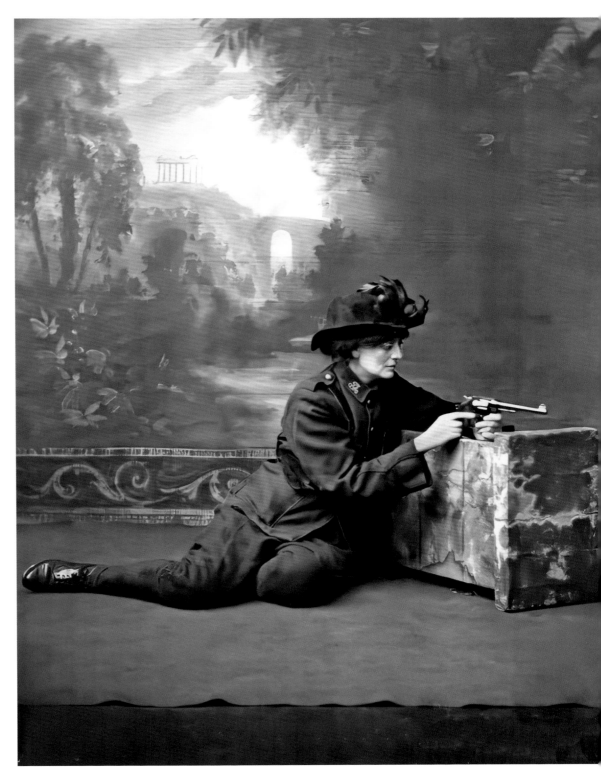

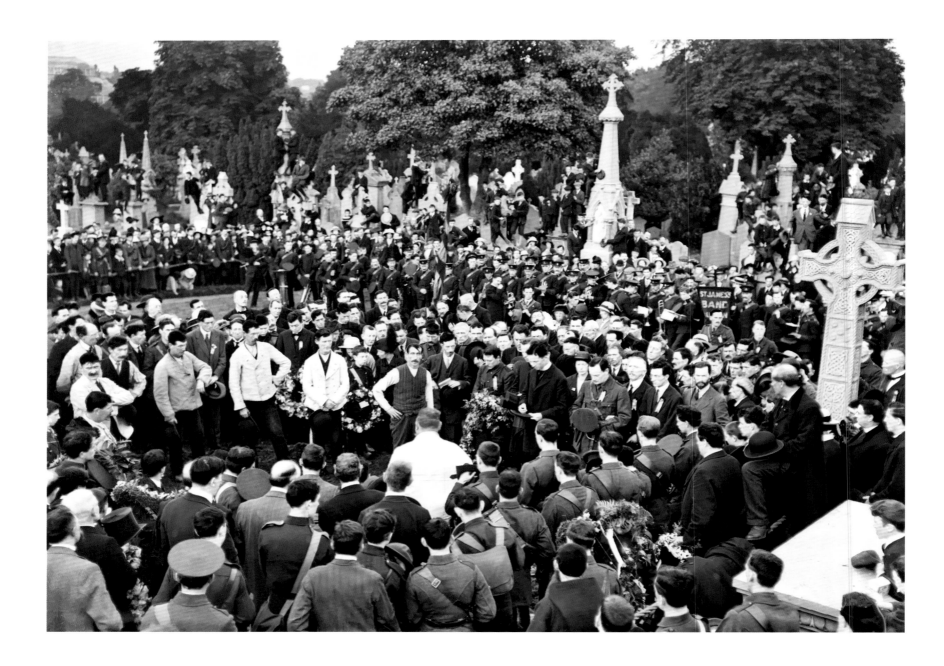

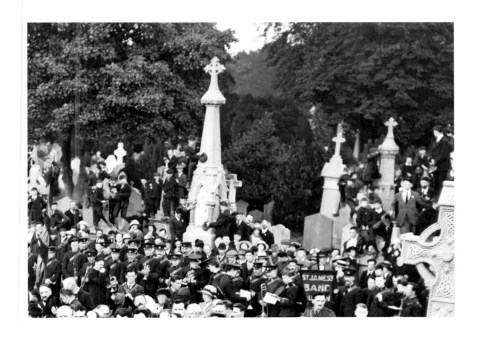

"The Fools, the Fools, the Fools! they have left us our Fenian dead – And while Ireland holds these graves, Ireland unfree shall never be at peace." Pádraig Pearse

Funeral of O'Donovan Rossa

DUBLIN

Glasnevan Cemetery

1 August 1915

The burial of the Irish Fenian leader Jeremiah O'Donovan Rossa in Glasnevin Cemetery on 1 August 1915, with the St James's band in the background. The photo features Pádraig Pearse, one of the leaders of the 1916 Easter Rising, who gave the famous graveside oration that roused Irish republican feeling and was a significant element in the lead-up to the Easter Rising.

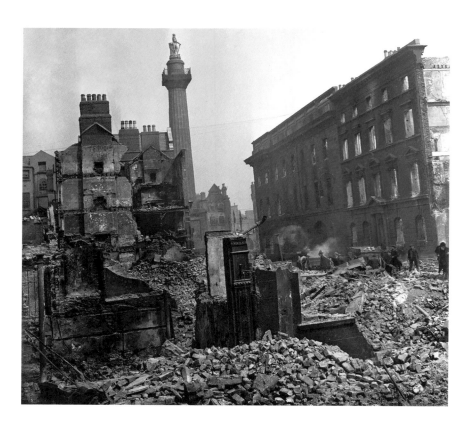

DUBLIN
Nelson's Pillar
1916

The 1809 Nelson's Pillar and the shell of the GPO
on Sackville Street (now O'Connell Street). In the
foreground is the smouldering rubble of Henry Street
in the aftermath of the 1916 Easter Rising. Also, in
the background, workers can be seen starting the huge
effort to clean up the city as Dubliners go about their
daily lives against the backdrop of rubble and ruins.

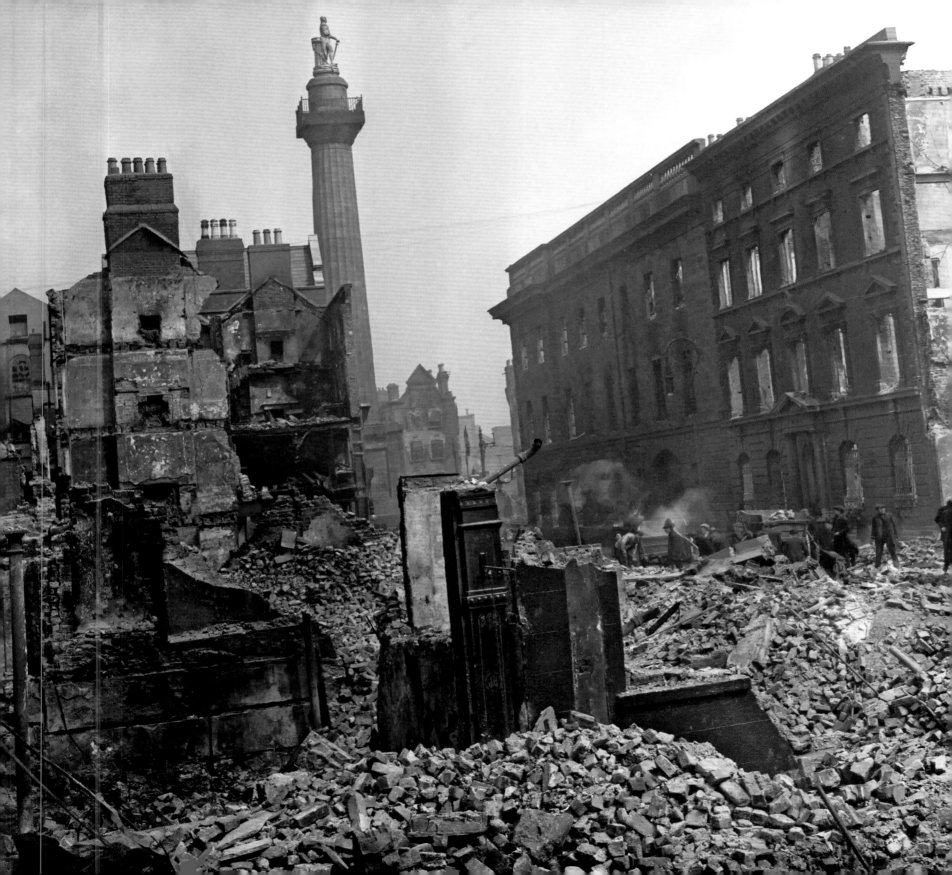

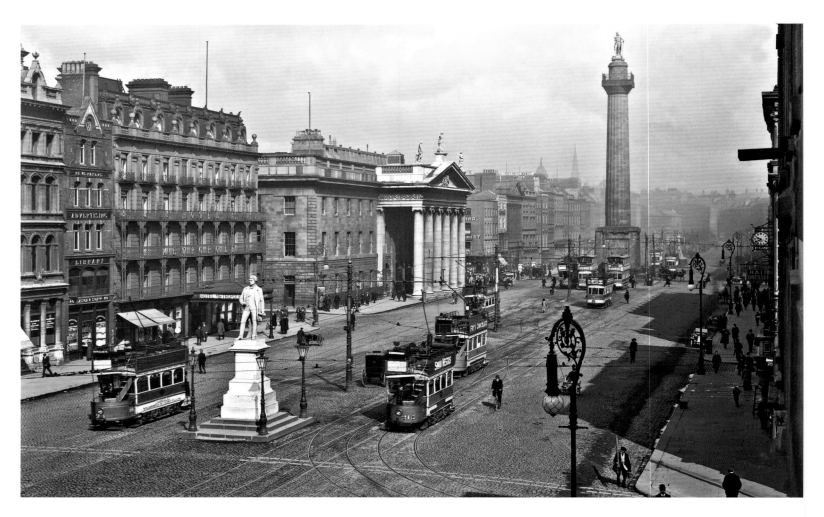

DUBLIN
Sackville Street (now O'Connell Street)
c.1910

An Eason & Son photograph of Sackville Street in Dublin City. It features the monument of Sir John Gray, the GPO and Nelson's Pillar, and on the left-hand side are the retail news, advertising and library signs of Eason & Son.

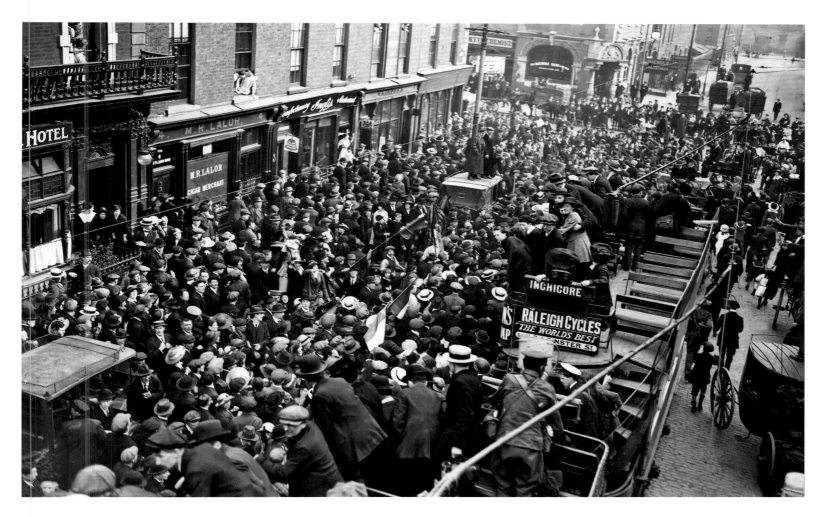

DUBLIN
Westland Row
18 June 1917

A 1917 Keogh Brothers' photograph featuring huge crowds on Westland Row in Dublin City waiting to welcome back Irish Republican prisoners. Among the prisoners was Countess Markievicz who was released under a general amnesty.

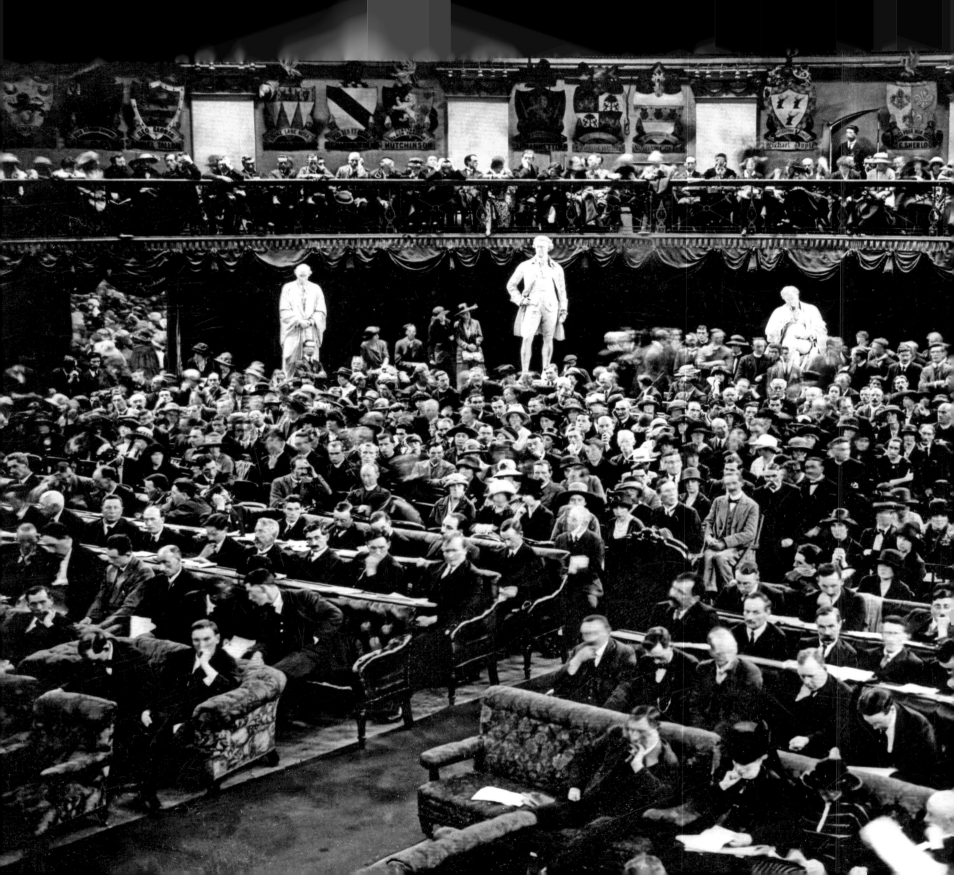

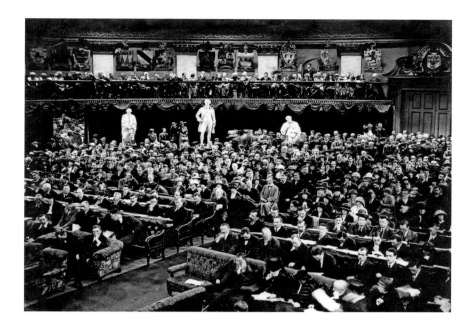

Dáil Éireann meeting for the Declaration of Independence

DUBLIN

16 August 1921

A Dáil Éireann meeting in the Mansion House on Dawson Street, Dublin City. The August sessions centred around negotiating a framework for the meetings in London which eventually delivered the Treaty. The armorial bearings of past Lord Mayors of Dublin hang on the walls at the back of the gallery and the statues are by Irish sculptor John Henry Folan. They represent Science, Industry, Agriculture and Arts, and now stand in the foyer of Technological University Dublin on Bolton Street.

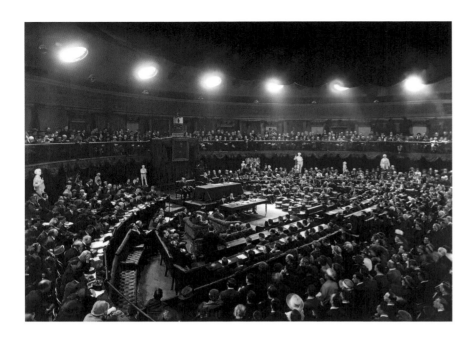

Dáil Éireann meeting for the Declaration of Independence

DUBLIN
16 August 1921

A Dáil Éireann meeting in the Mansion House on Dawson Street, Dublin City, to discuss the British peace proposals. The Speaker's chair is on a dais with a green baize cover in front of it. On the floor, immediately below the Speaker, is the Clerk's table. Éamon de Valera can be seen sitting on a settee to the left of the Clerk's table and on the red leather upholstered bench one can see Erskine Childers (hand to chin), and next to him is James Douglas. In the next row in front is Constance Markievicz and Gavan Duffy.

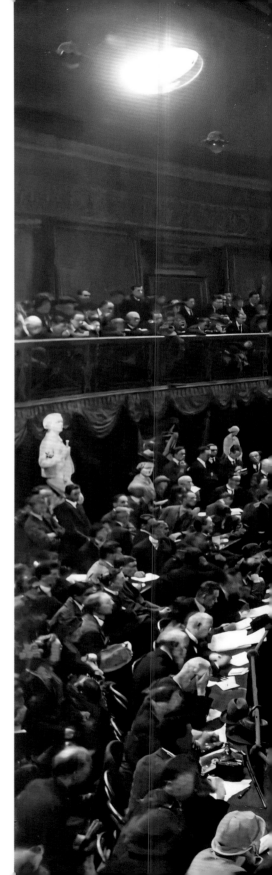

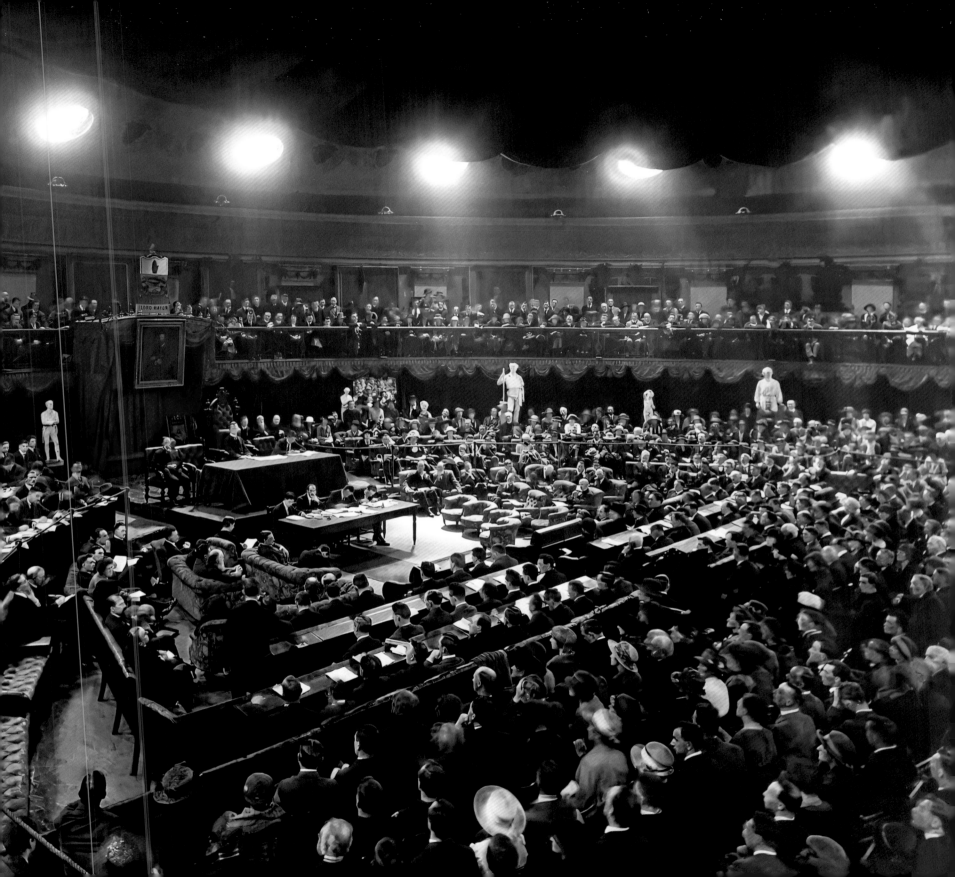

DUBLIN
Jervis Street Hospital
24 November 1920

The grounds of Jervis Street Hospital (now the Jervis Street Shopping Centre) in Dublin City during the military enquiry into the Croke Park shootings known as 'Bloody Sunday'. On Sunday 21 November 1920, during the Irish War of Independence, more than thirty people were killed or fatally wounded by British Royal Irish Constabulary members called the 'Black and Tans', made up of Auxiliaries and British soldiers.

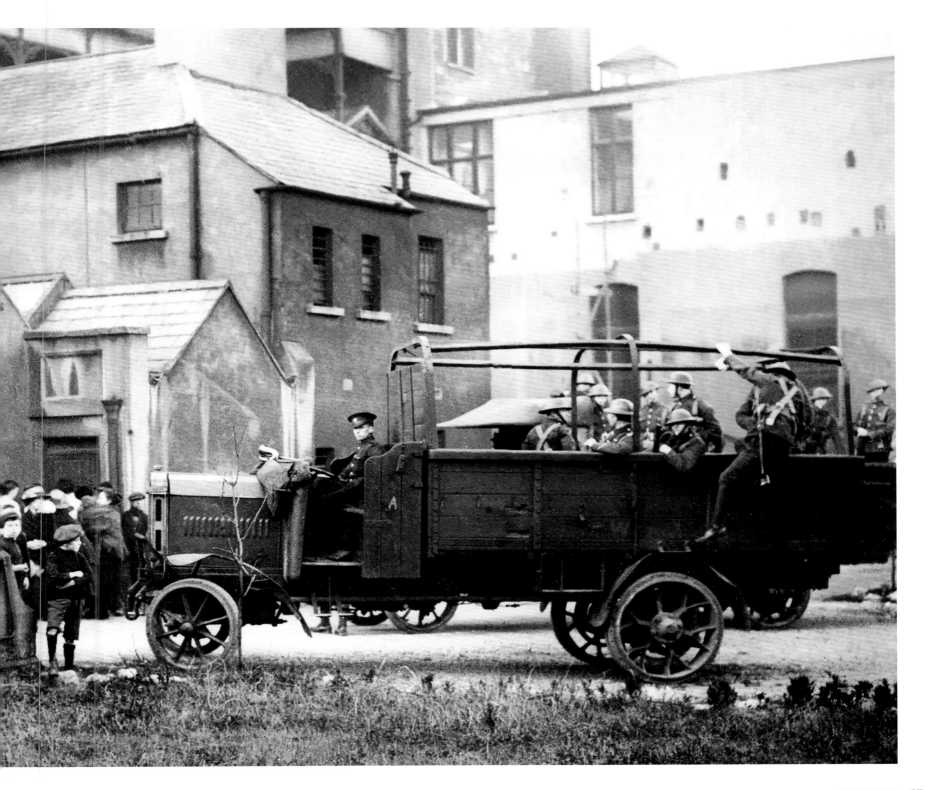

DUBLIN
London and North Western Hotel
1921

Black and Tans and Auxiliaries outside the London and North Western Hotel, North Wall in Dublin City after an Irish Republican Army raid in which twelve bombs were thrown at the windows of the hotel and one man was killed in the act of throwing a bomb.

DUBLIN

Custom House

May 1921

Irish Republican Army prisoners outside the Custom House, Dublin. On 25 May 1921, during the Irish War of Independence, the IRA occupied then burned down the building.

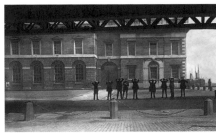

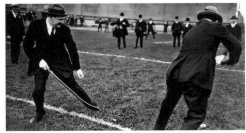

DUBLIN

Croke Park

11 September 1921

Michael Collins and Harry Boland hurling in Croke Park, Dublin City, before the 1921 Leinster Senior Hurling Championship final, in which Dublin beat Kilkenny 4-4 to 1-5.

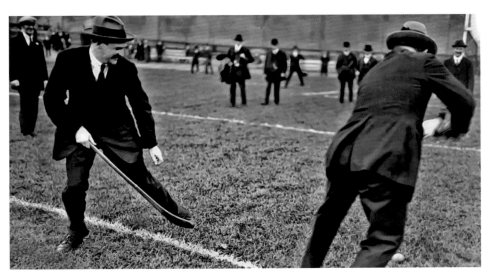

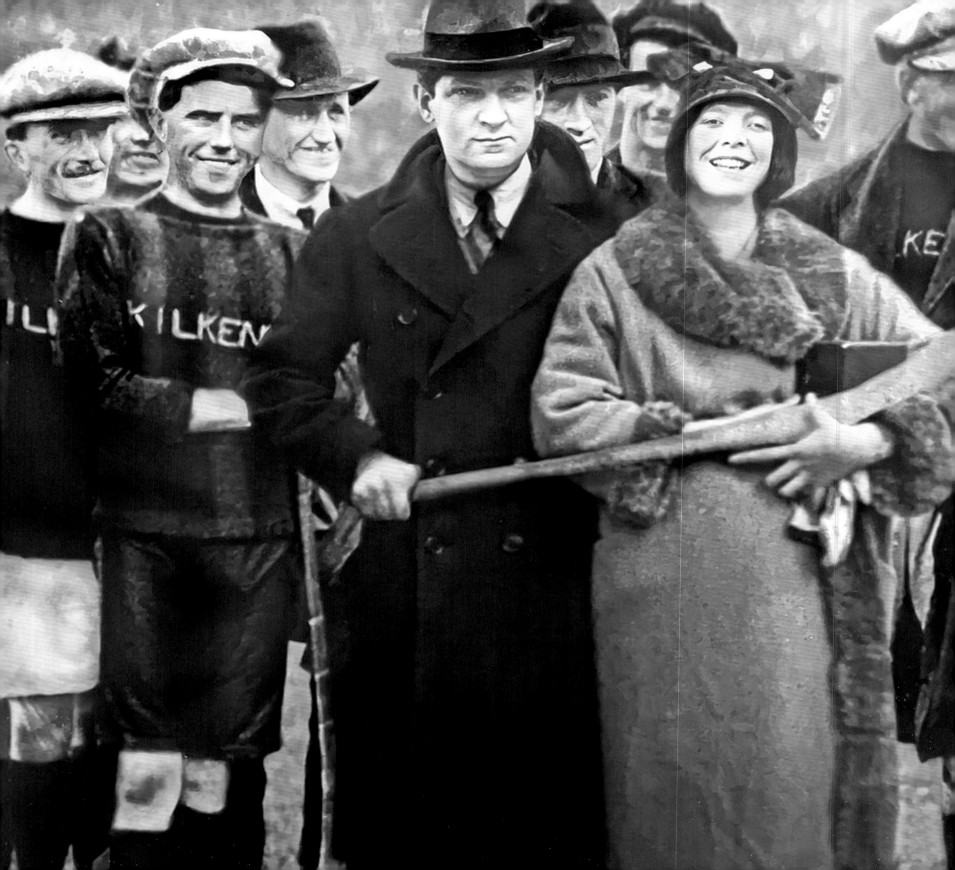

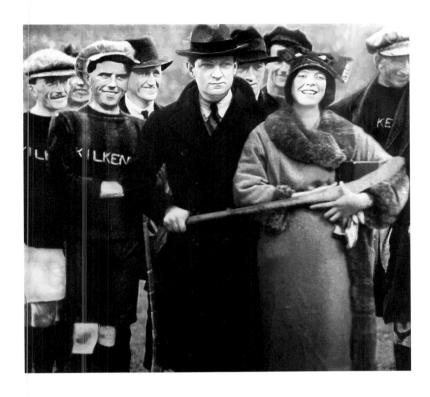

DUBLIN
Croke Park
1921

Michael Collins and his fiancée Kitty Kiernan with the Kilkenny hurlers before the 1921 Senior Hurling Championship at Croke Park in Dublin City. This image was created for a calendar. It is not real, but as a distortion of history it demonstrates how vigilance is needed when examining photographic evidence (see page 216 for more on the altering of historical images).

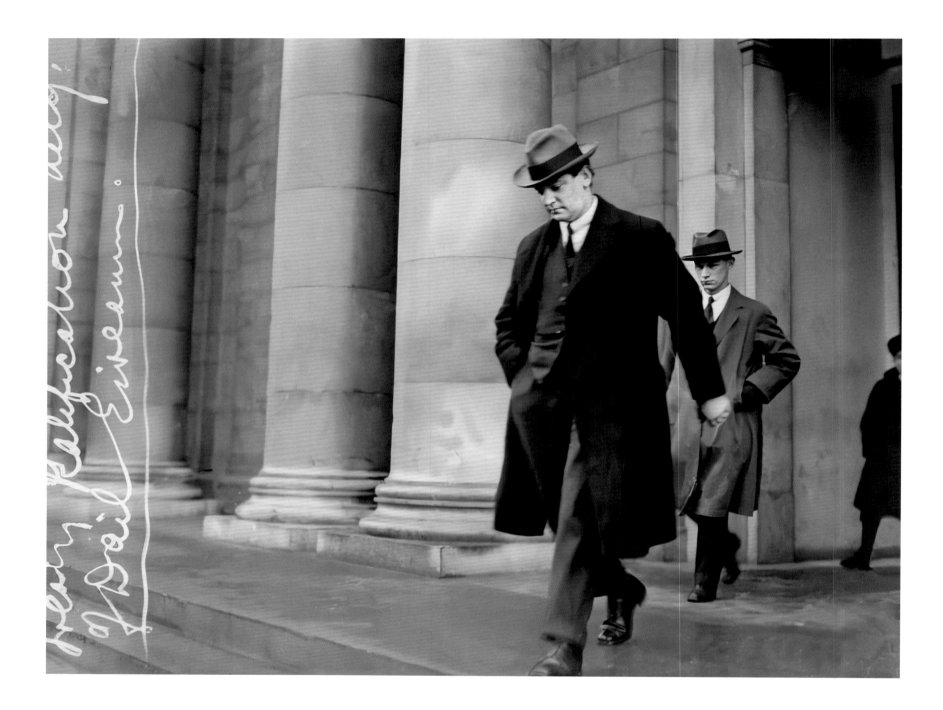

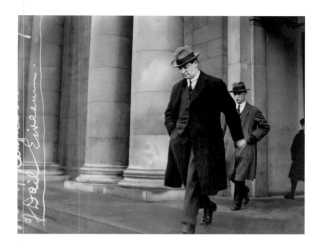

DUBLIN
Earlsfort Terrace
7 January 1922

Michael Collins with his bodyguard Joe O'Reilly leaving Earlsfort Terrace where the Second Dáil ratified the Anglo-Irish Treaty on 7 January 1922. Joe O'Reilly, from Bantry in County Cork, had been friends with Collins since the Irish War of Independence, serving in his Irish Republican Army hit squad in Dublin. It was said that he was the only person in Dublin who knew of Collins' whereabouts at any given time.

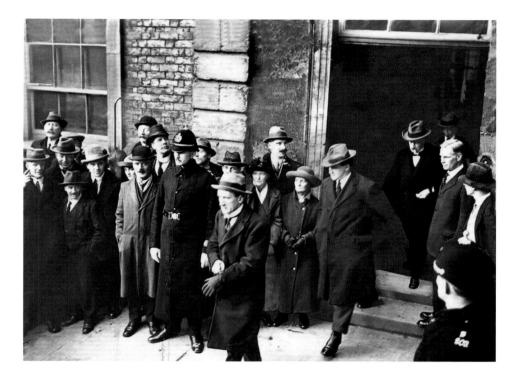

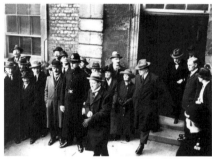

Kevin O'Higgins &
Michael Collins
DUBLIN
Dublin Castle
16 January 1922

Kevin O'Higgins and Michael Collins leaving out through the Chief Secretary's door in Dublin Castle on 16 January 1922 after the formal transfer of power from the British government.

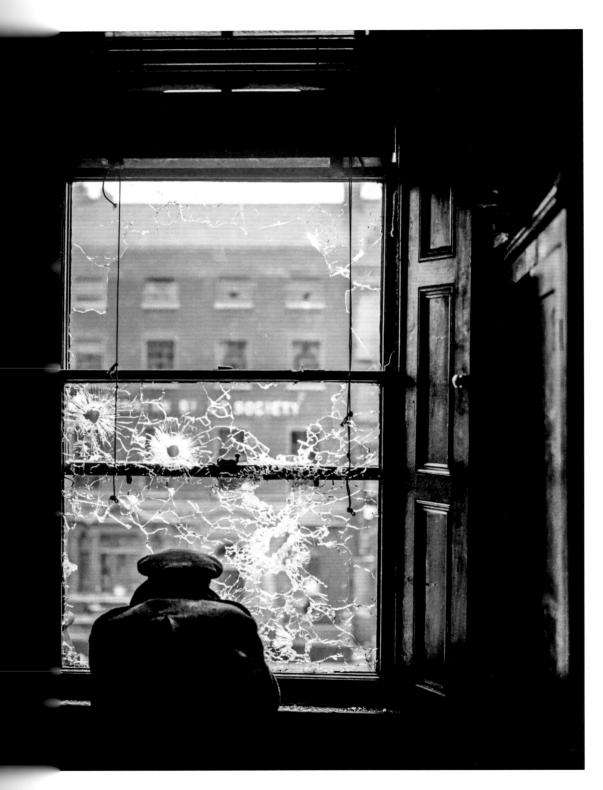

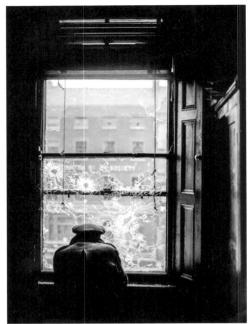

DUBLIN
*Upper Sackville Street
(now O'Connell Street)*
July 1922

A soldier looks out of a window
shattered by bullets on Sackville
Street in Dublin City during the Irish
Civil War. In the background is the
Hibernian Bible Society at 10 Upper
Sackville Street.

DUBLIN
College Street
1922

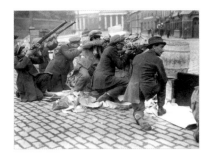

Anti-Treaty IRA men take up positions behind a barricade on College Street at Dublin Trinity College. The Bank of Ireland can be seen in the background.

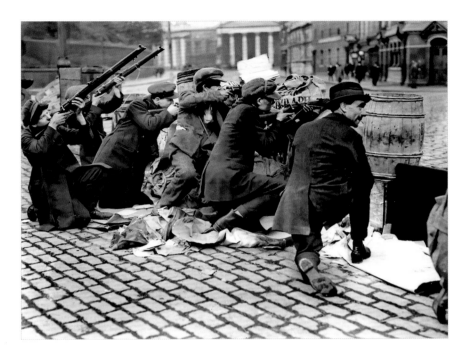

DUBLIN
College Street
1922

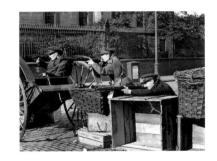

Pro-Treaty national army troops take up positions behind a barricade on College Street, Dublin City, during the Irish Civil War. Trinity College can be seen in the background.

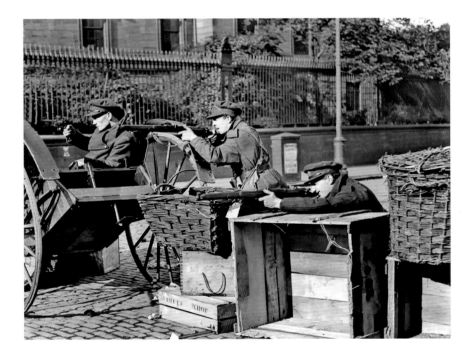

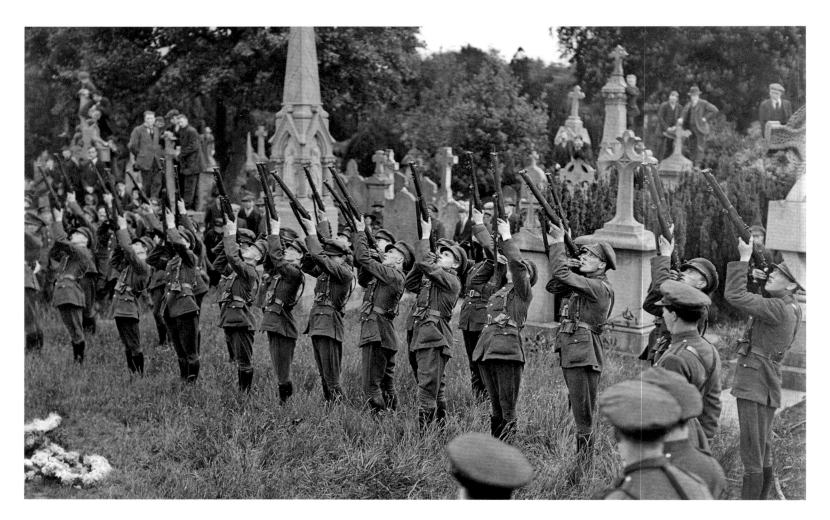

DUBLIN
Glasnevin Cemetery
2 June 1922

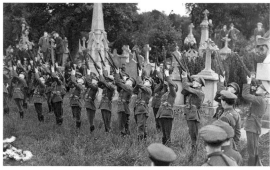

The firing party giving three volleys over the grave of Joseph McGuinness T. D. at Glasnevin Cemetery on 2 June 1922. McGuinness took part in fighting in the Four Courts during the Easter Rising in 1916.

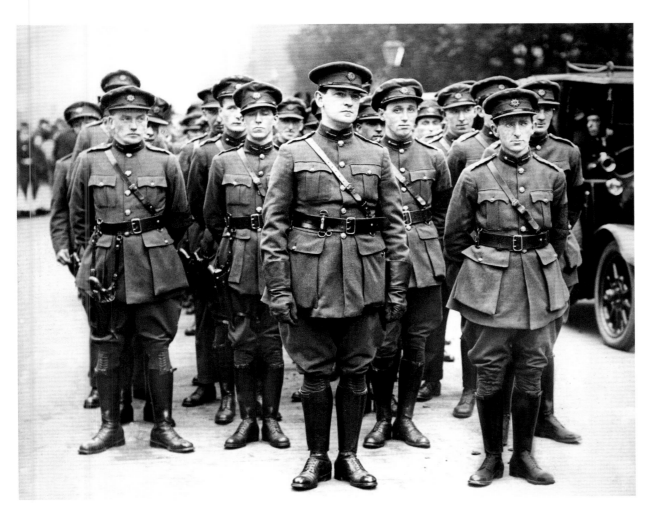

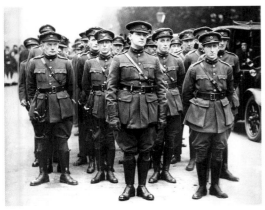

Arthur Griffith's funeral

DUBLIN
August 1922

Michael Collins with Richard Mulcahy in the funeral procession of Arthur Griffith who died on 12 August 1922. Just ten days later Collins himself would be assassinated in an ambush at Béal na mBláth in County Cork.

Outside the funeral service of Arthur Griffith

DUBLIN
Marlborough Street
August 1922

Michael Collins and admirers about to enter St Mary's
Pro-Cathedral on Marlborough Street, Dublin City, for
the funeral service of Arthur Griffith.

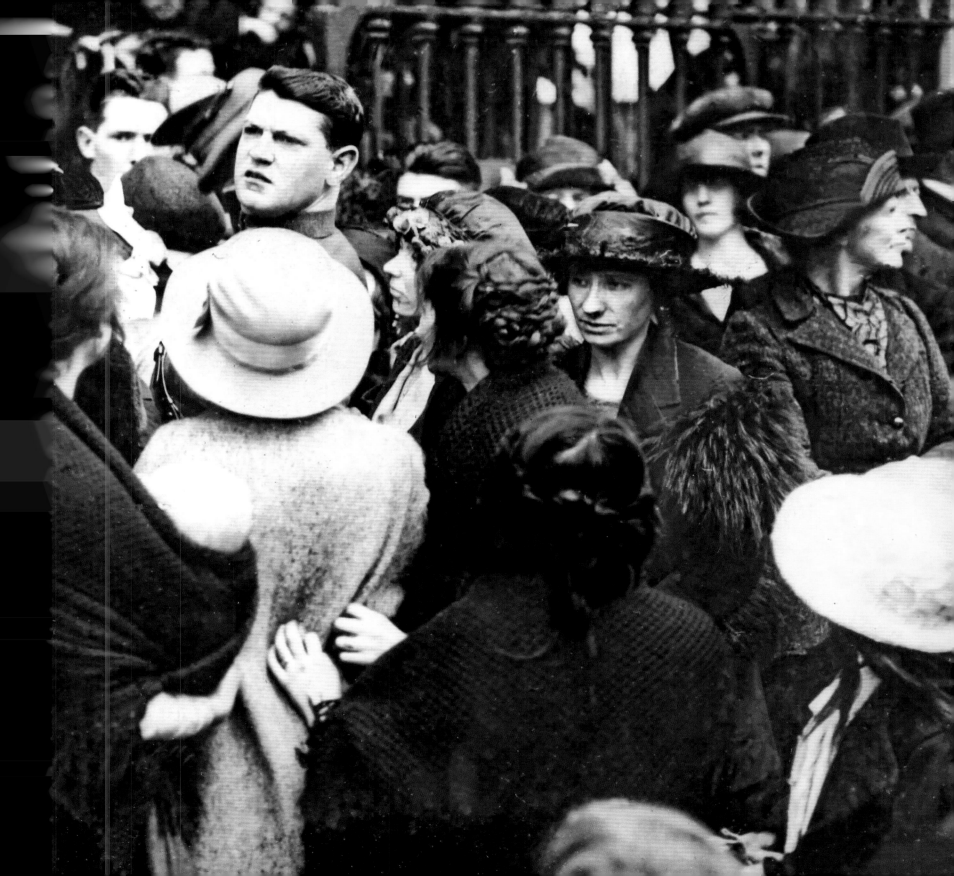

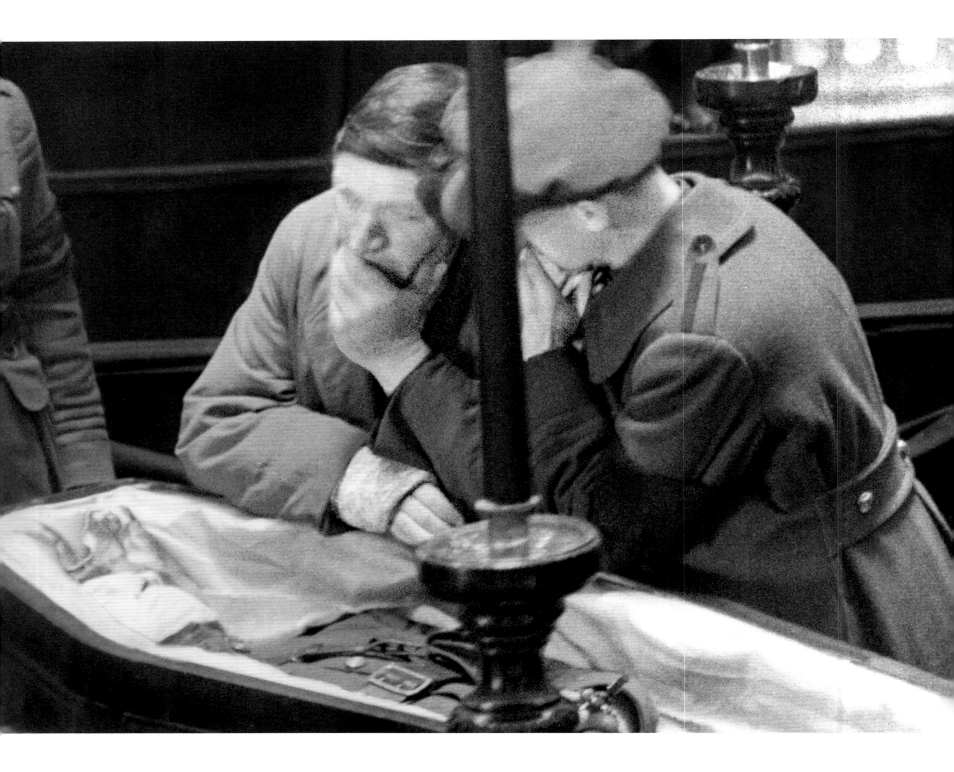

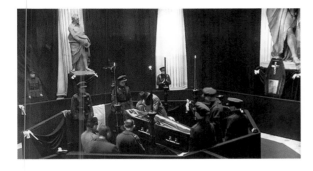

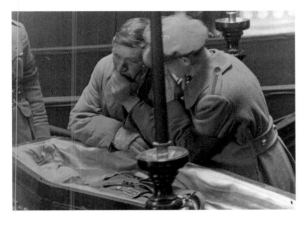

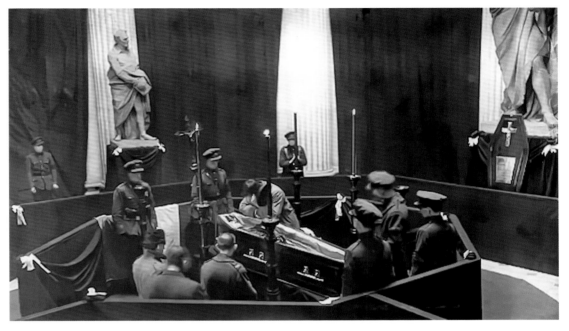

DUBLIN
City Hall
27 August 1922

Seán Collins beside the coffin of his brother, Michael, in Dublin's City Hall. Michael Collins' body lay in state for three days following his death.

DUBLIN
City Hall
27 August 1922

The bandage that can be seen here on Séan Collins' hand is from an accident while working on the family's farm at Woodfield, Sam's Cross, outside Clonakilty in County Cork.

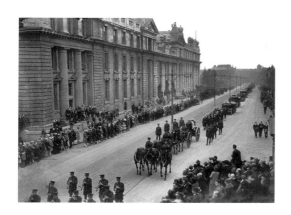

DUBLIN
Merrion Square Upper
28 August 1922

The funeral cortège of Michael Collins passes Government Buildings on Merrion Square Upper in Dublin City en route to Glasnevin Cemetery. It is estimated that the cortège was three miles long and 500,000 people lined the streets, which at the time was one fifth of the population of Ireland.

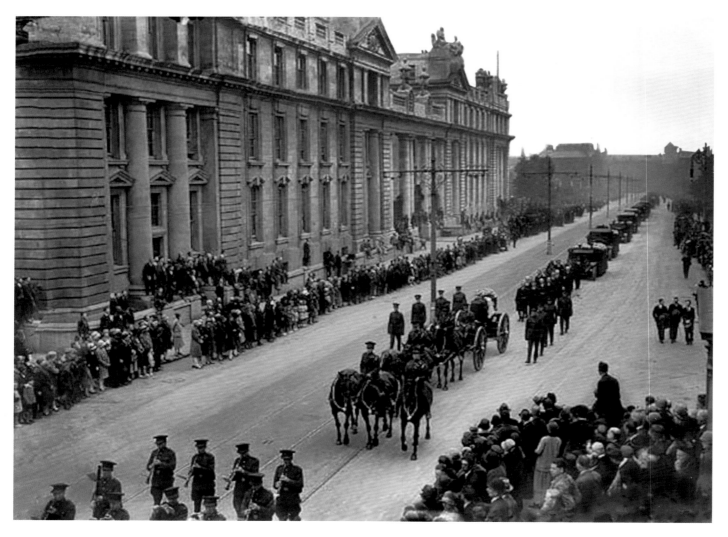

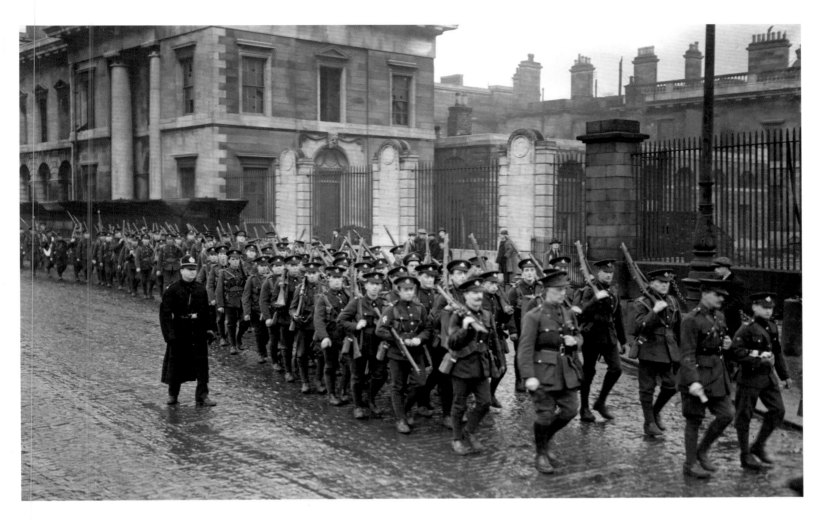

DUBLIN
17 December 1922

British Troops pass the Custom House as they leave Dublin for the last time after Ireland was declared a free state following the Irish War of Independence. Thousands lined the quays to watch the 3,500 troops, mostly from the Leicester, Worcester and Border regiments, march to the port where the admiralty steamer TSS *Arvonia* waited at anchor. In the background is the burnt-out shell of the Custom House, occupied by the Irish Republican Army and set on fire on 25 May 1921.

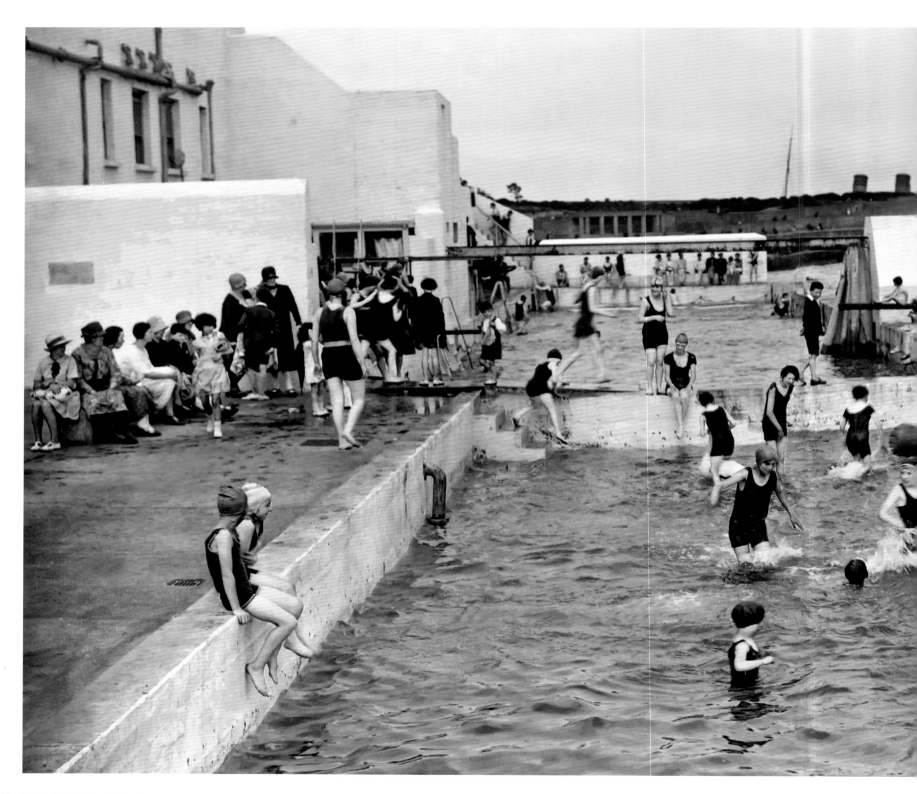

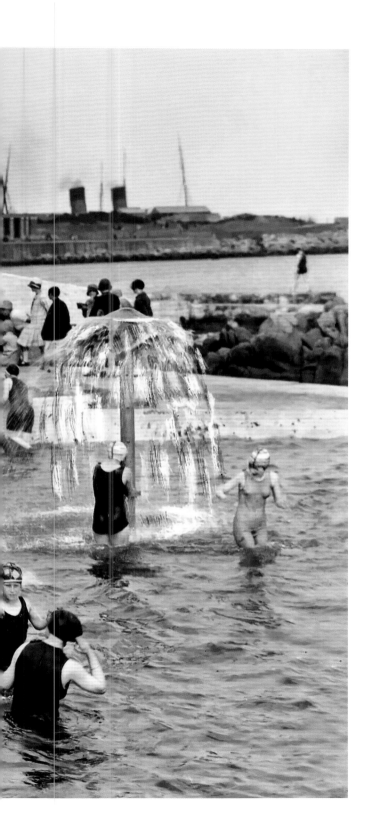

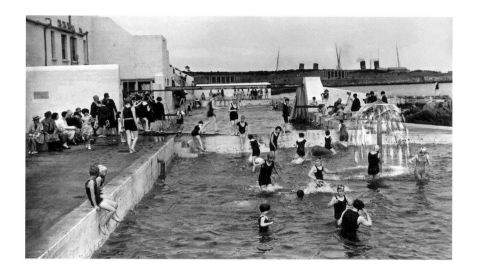

DUBLIN
Dún Laoghaire
1925

The public Baths at Dún Laoghaire in County Dublin, as photographed by the Dillon Family. The Royal Victoria Baths were built in 1843 beside Scotsman's Bay and eventually closed in the mid 1990s. In the background, docked on the Carlisle Pier (previously known as Kingston Pier and the Mailboat Pier), is the Dún Laoghaire Mailboat.

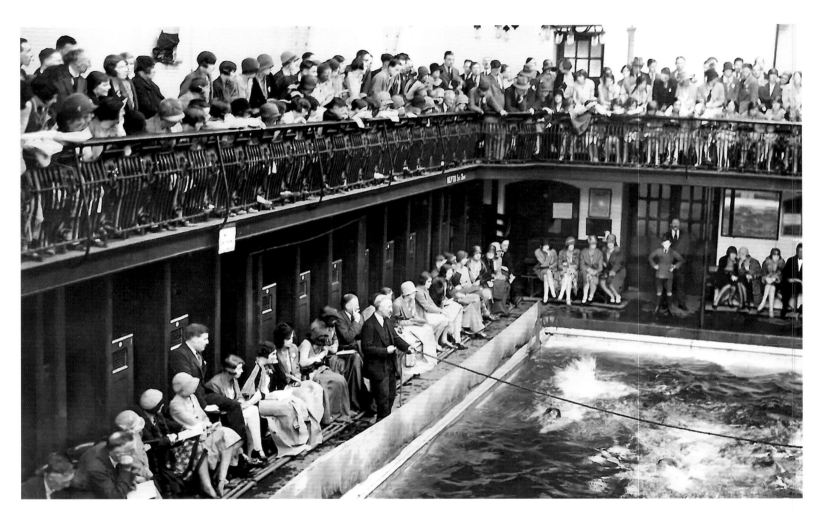

DUBLIN
The Iveagh Baths
1929

The Trinity College Swimming Gala taking place at the Iveagh Baths on Bride Road, Dublin City. The 65-foot by 30-foot swimming pool was tiled with white enamelled bricks to match the surrounding walls.

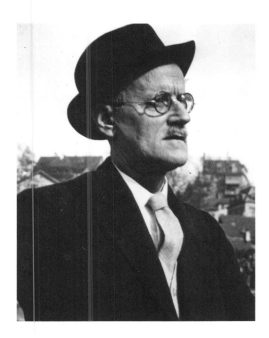

James Joyce
DUBLIN
1938

James Joyce was an Irish novelist, poet, teacher and literary critic. He is regarded as one of the most influential authors of the twentieth century. Joyce is best known for *Ulysses*, the short-story collection *Dubliners* and the novels *A Portrait of the Artist as a Young Man* and *Finnegans Wake*.

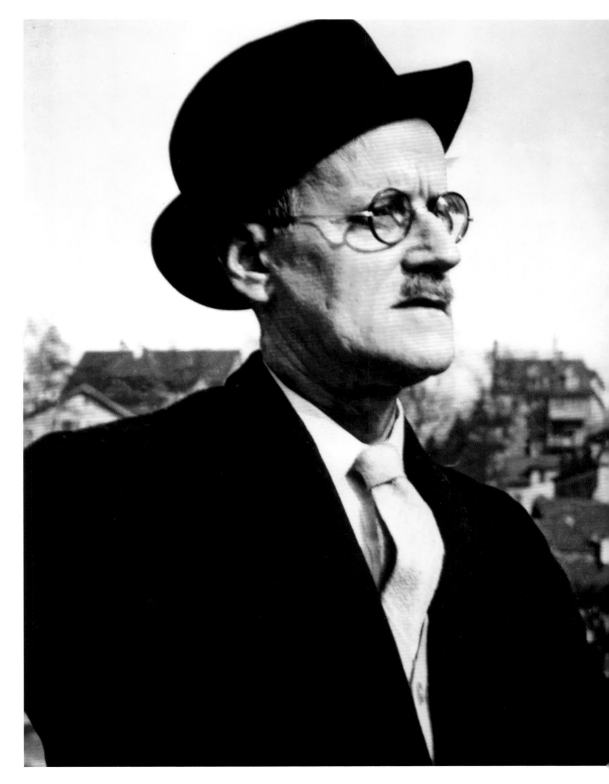

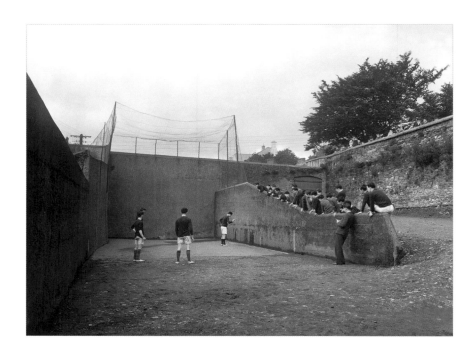

WEXFORD
New Ross
30 May 1931

A handball match in the old Good Counsel College handball court off Chapel Lane in New Ross, County Wexford.

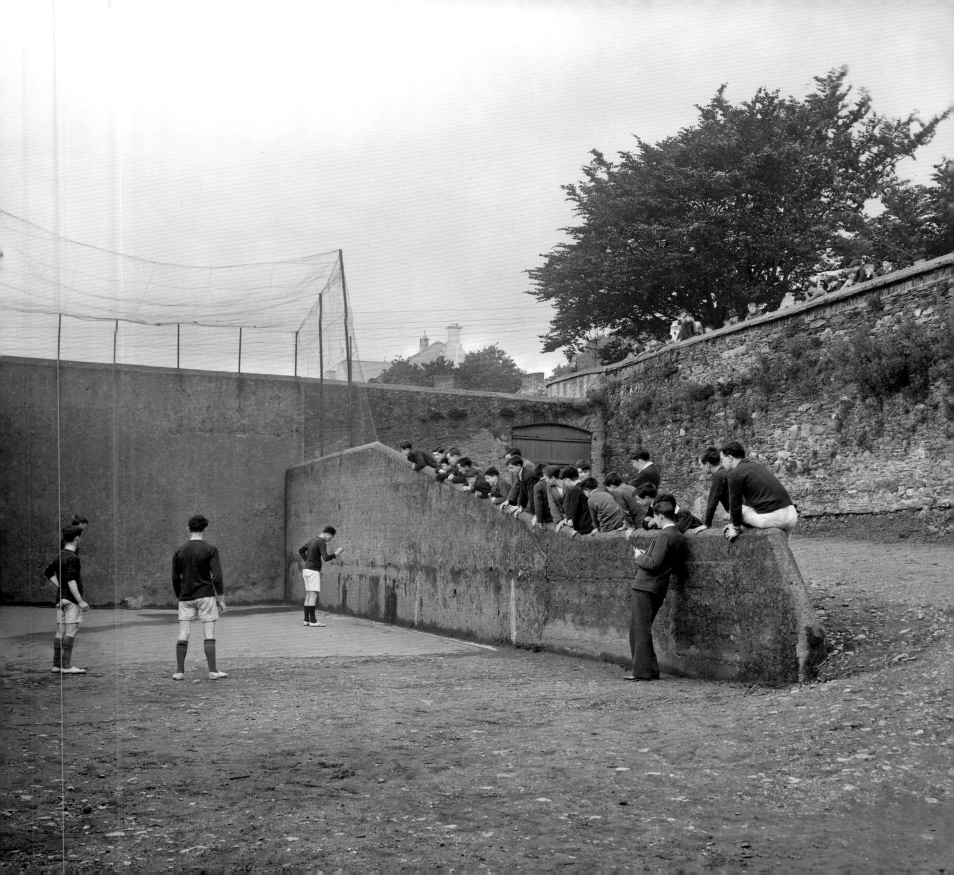

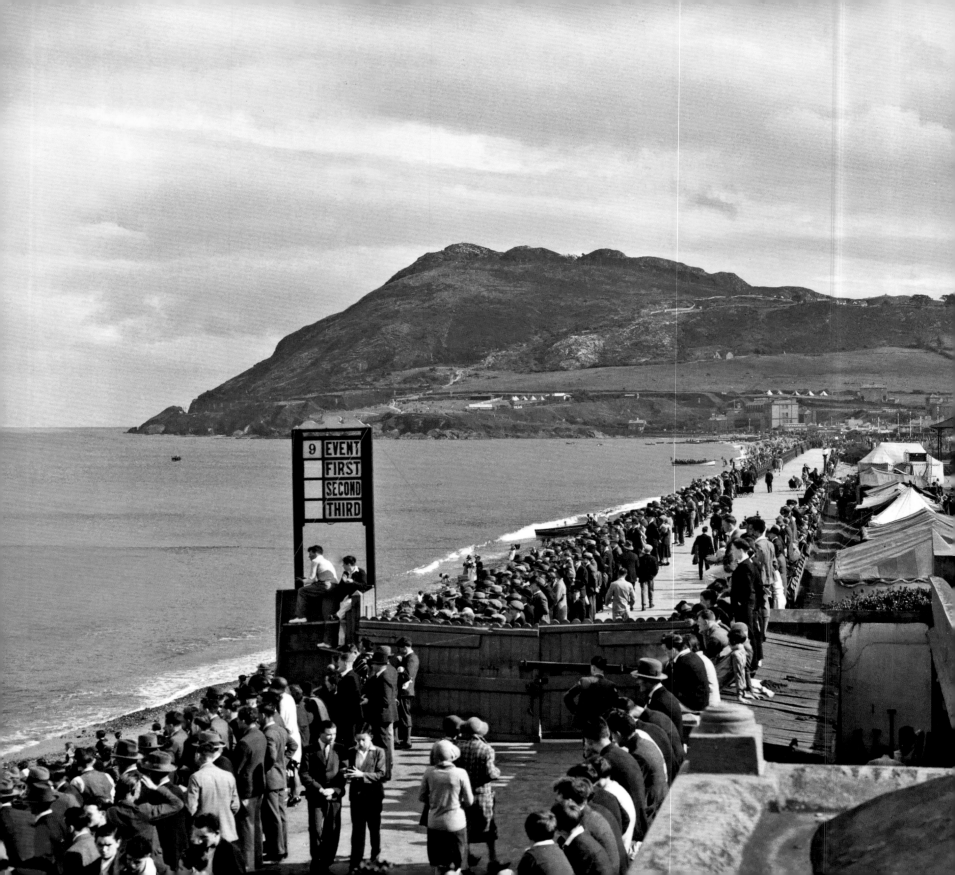

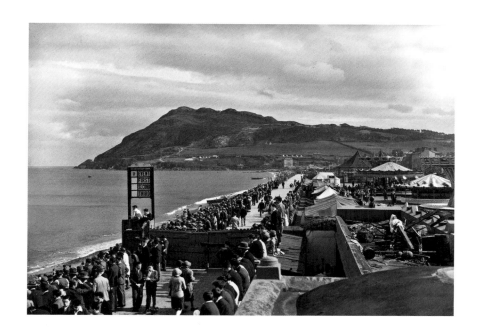

WICKLOW
Bray Promenade
1936

Huge crowds attend Regatta Day at Bray in County Wicklow. Bray Head can be seen in the background, but minus the Bray Head concrete cross which was erected in 1950.

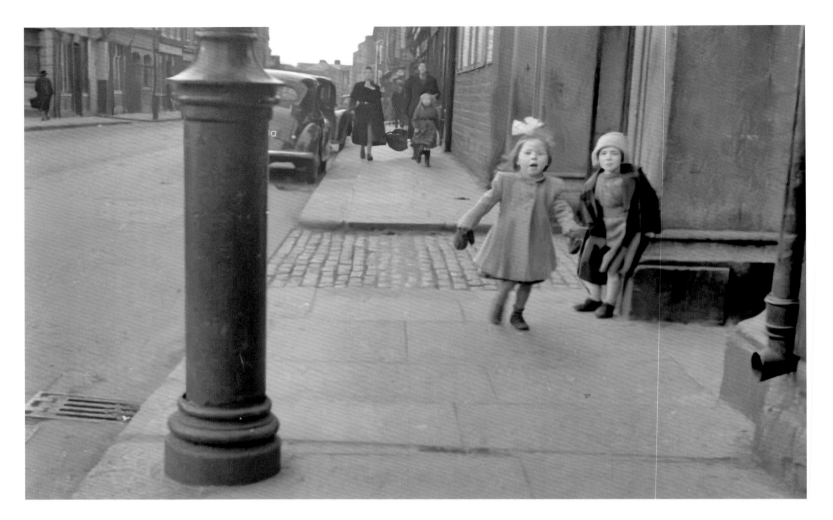

DUBLIN
Francis Street
1957

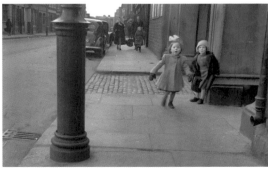

Two little girls play outside the gates of St Nicholas of Myra Church on Francis Street in the Dublin Liberties. The church site has been used as a place of worship as far back as the twelfth century.

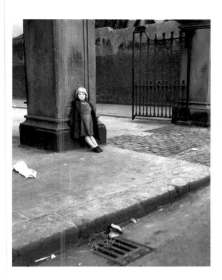

DUBLIN
Francis Street
1957

A little girl waits at the gates of St Nicholas of Myra Church. In the background, the parish priest carries his briefcase. The present church was designed in 1829 by the architect of Rusborough House, John Leeson. The church was built as the Metropolitan Church for Irish Catholic archbishops by Archbishop Patrick Russell, replacing the church in Limerick Lane.

MUNSTER

or an Mhumhain *in Irish*

*is one of the four traditional provinces of Ireland situated
in the south of Ireland.*

*Cork | Kerry | Tipperary | Clare
Limerick | Waterford*

THE PROJECT OF
BRINGING IRELAND'S
HISTORY *to* LIFE

My fascination with historic photo colourisation and restoration stems from my keen interest in architectural heritage, which I developed from growing up in the medieval heart of Limerick City just across the road from the thirteenth century King John's Castle on King's Island, which is surrounded by an abundance of architectural heritage, such as the Bishop's Palace (built in 1780), and St Mary's Cathedral (founded in 1168).

From those early days in 1980s Limerick, I could see a lot of Limerick's architectural heritage being left to fall into a state of disrepair owing to absentee landlords and poor urban planning. Then in 1985, the Limerick Civic Trust appointed the late Denis Leonard as full-time director and he set about implementing a series of conservation projects assisted by hundreds of locals via the FÁS training scheme. They aimed to conserve numerous heritage sites, including the Bishop's Palace, Potato Market, Corbally Canal, John's Square and parts of the old City Walls. Witnessing first-hand the great work of Limerick Civic Trust, and seeing all the benefits thus brought to the locality, instilled in me a passion for the appreciation and preservation of our built architectural heritage for future generations to enjoy.

To encourage people and policymakers to appreciate and hopefully preserve our architectural heritage, I started my Bringing Ireland's History to Life project in which I started sharing my research along with my photo colourisation and restoration work. The project has been featured extensively in both national and local media and has become a viral hit on Twitter, with a worldwide social media following which attracts people from all walks of life, including politicians, academics, historians, actors and film directors.

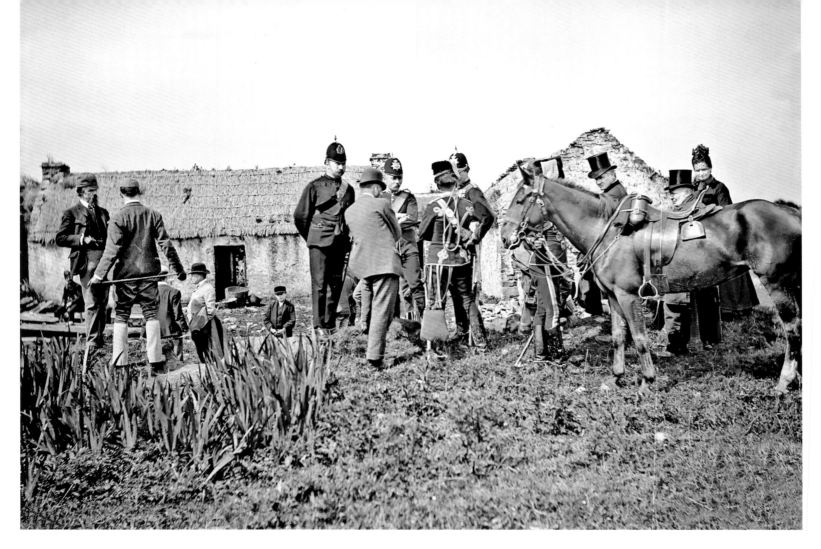

CLARE
Vandeleur Estate, Kilrush
c.1880s

Tenants are evicted by the Royal Irish Constabulary and the Royal Berkshire Regiment on the Vandeleur Estate in County Clare. The estate was owned by the absentee landlord, Captain Hector Stewart Vandeleur who lived mainly in London and only spent short periods each year in Kilrush, staying in Kilrush House until the house burned down in 1897.

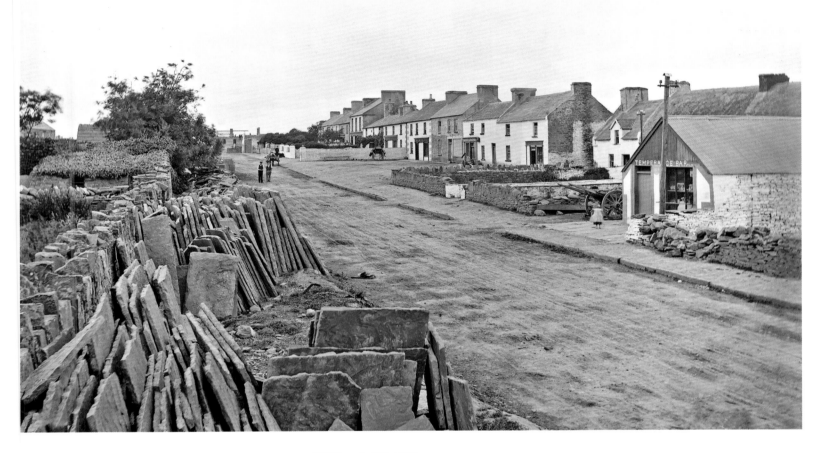

CLARE
Main Street, Liscannor
c.1880

Main Street in Liscannor (Lios Ceannúir, 'ringfort of Ceannúr') in County Clare. Liscannor was famous for its stone, used for flooring and paving, which was shipped around the world from Liscannor Pier.

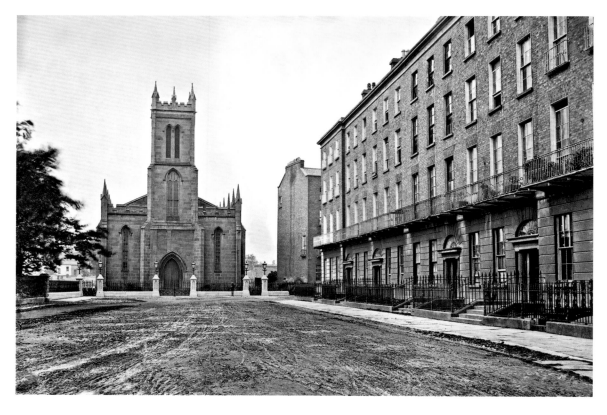

LIMERICK
Mathew Bridge
c.1880

A crowded Mathew Bridge, built between 1844 and 1846, in Limerick City. In the background is the 1168 St Mary's Cathedral and a signwriter working on Goggin's public house on Merchant's Quay. On the far left-hand side is the old Limerick Women's Prison; and the red brick building on Merchant's Quay is where Sylvester O'Halloran lived, an Irish surgeon and a pioneer of the modern cataract operation, who was later elected a member of the Royal Irish Academy.

LIMERICK
Pery Square
c.1900

Pery Square in the Newtown Pery area of Limerick City, featuring Georgian terraced houses and the Gothic-style St Michael's Church, designed by architect James Pain in 1840.

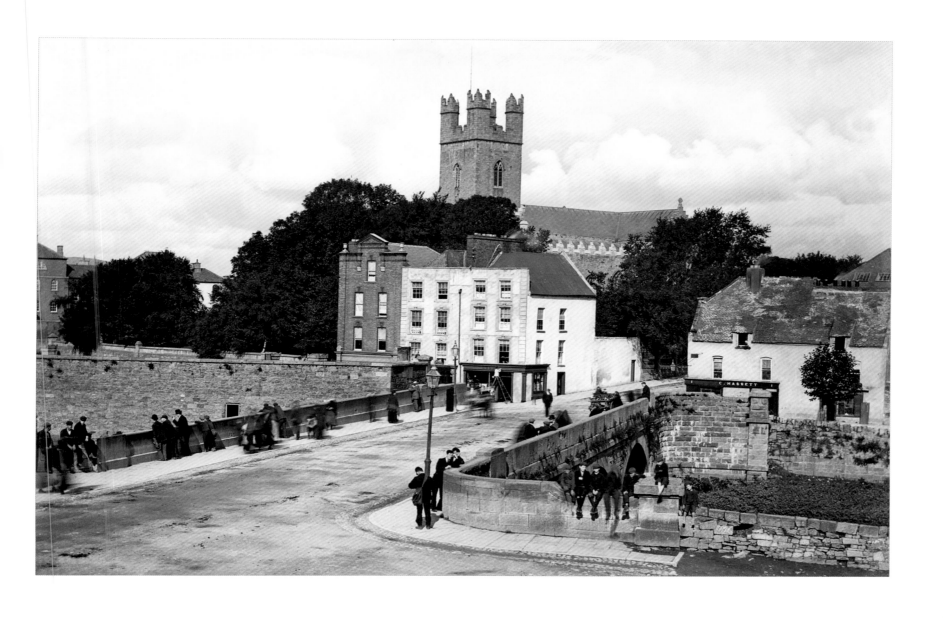

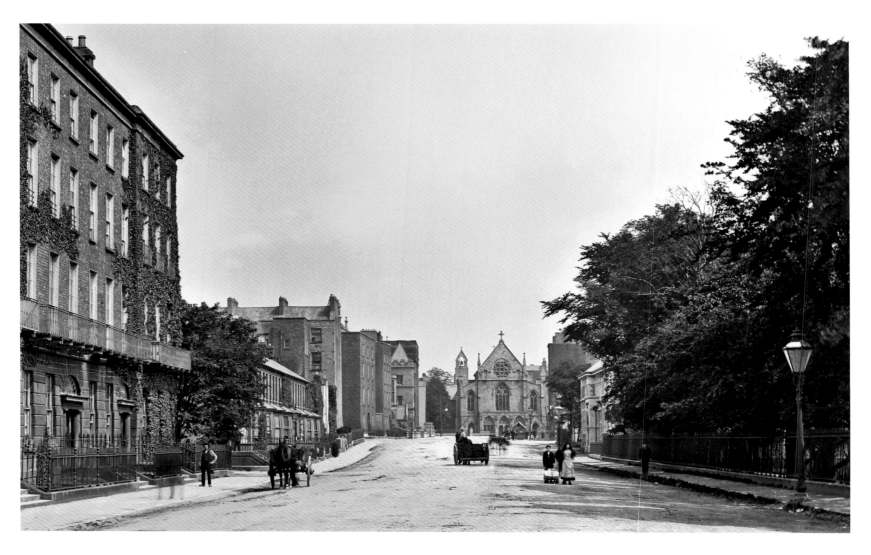

LIMERICK
Pery Sqaure
c.1908

Pery Square in Limerick's Georgian Quarter. On the right is Carnegie Library and Museum, next to the People's Park, which was formally opened in 1877.

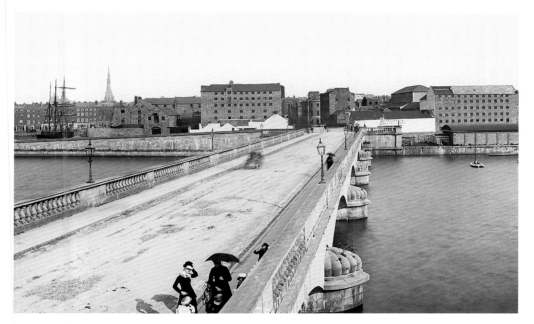

LIMERICK

*Wellesley Bridge
(now Sarsfield Bridge)*

1865

Seen here are Wellesley Bridge, built in 1835, and Arthur's Quay in the background before the Shannon Rowing Club was built. The industrious riverside is crammed with warehouses and factories, which is a testament to Limerick City's prodigious trade connections.

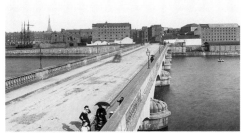

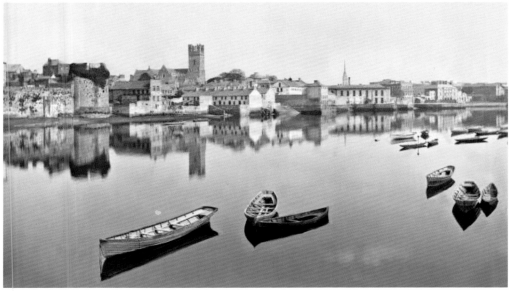

LIMERICK

River Shannon

c.1890s

Riverboats by Clancy Strand (North Strand) on the River Shannon, Limerick City. In the background is the thirteenth century King John's Castle and St Mary's Cathedral, which dates from 1168.

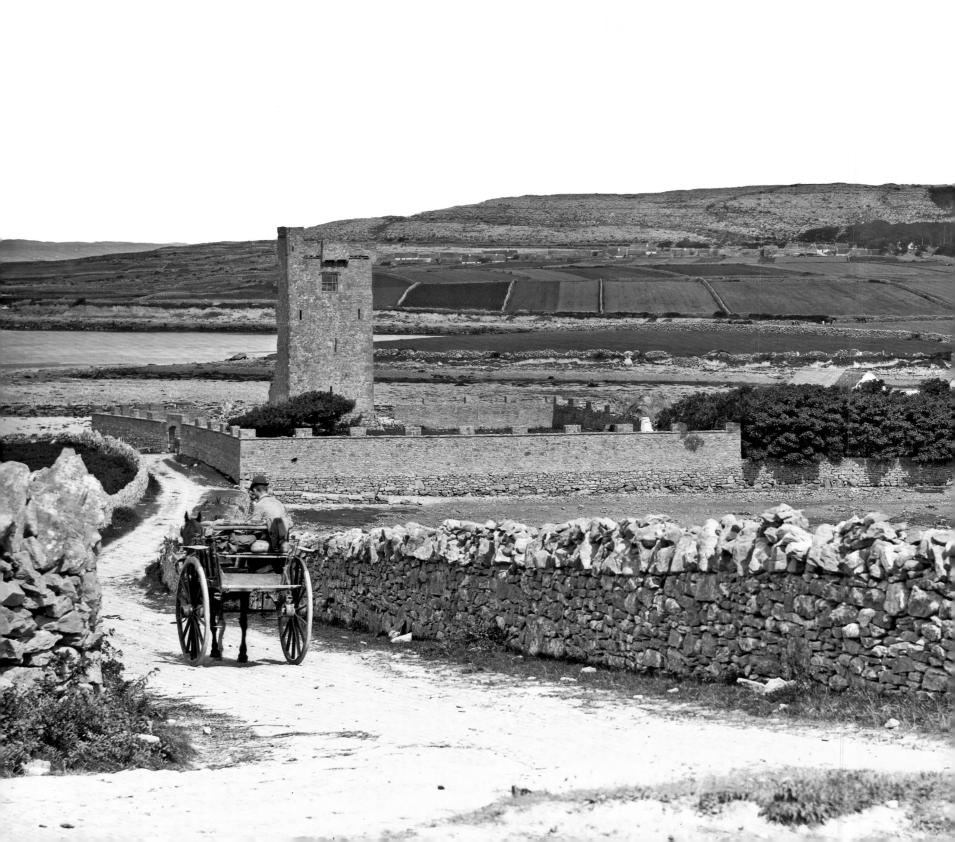

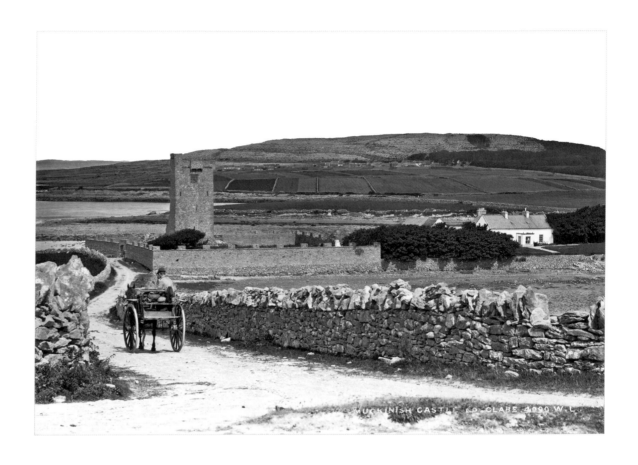

CLARE
Shanmuckinish Castle, Ballyvaughan
c.1885

The Burren (Boireann, 'great rock'), and the 1450 Shanmuckinish Castle Tower (Muck inis, 'pig island'), located in Drumcreehy parish, County Clare.

LIMERICK
George's Street (now O'Connell Street)
c.1882

George's Street in Limerick City featuring the Royal Cruises Hotel with its horse-drawn courtesy carriages and the majestic Cannock's department store on the right-hand side. In the foreground are white lines painted on the cobblestones, which is an early pedestrian crossing.

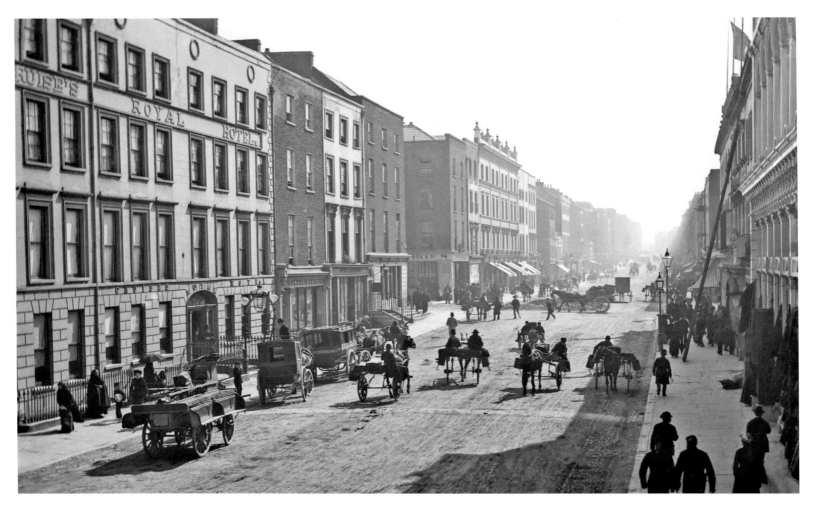

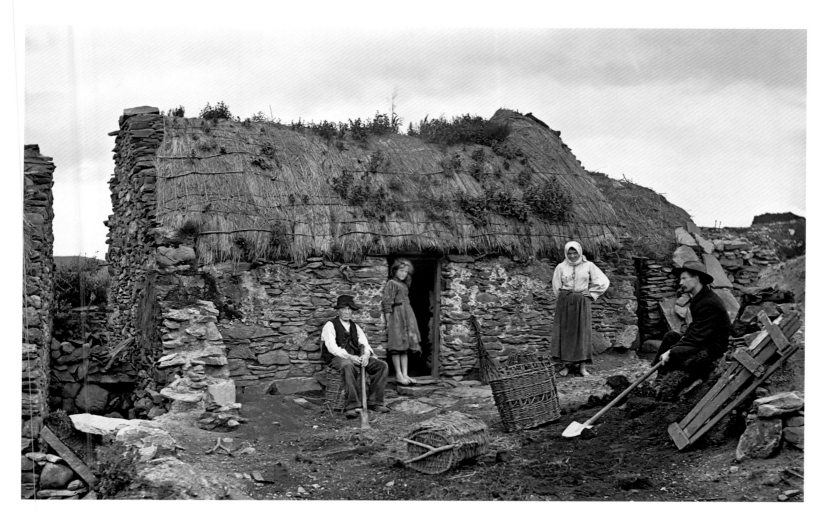

KERRY
Glenbeigh
c.1887

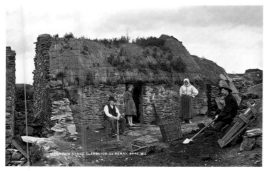

This mountain stage cottage, near Drom, Glenbeigh in County Kerry, was the last stop for a horse-drawn coach before the Hill of Drung. Here the road ended and passengers would either have to walk or go on horseback from there because of the rugged mountainous terrain.

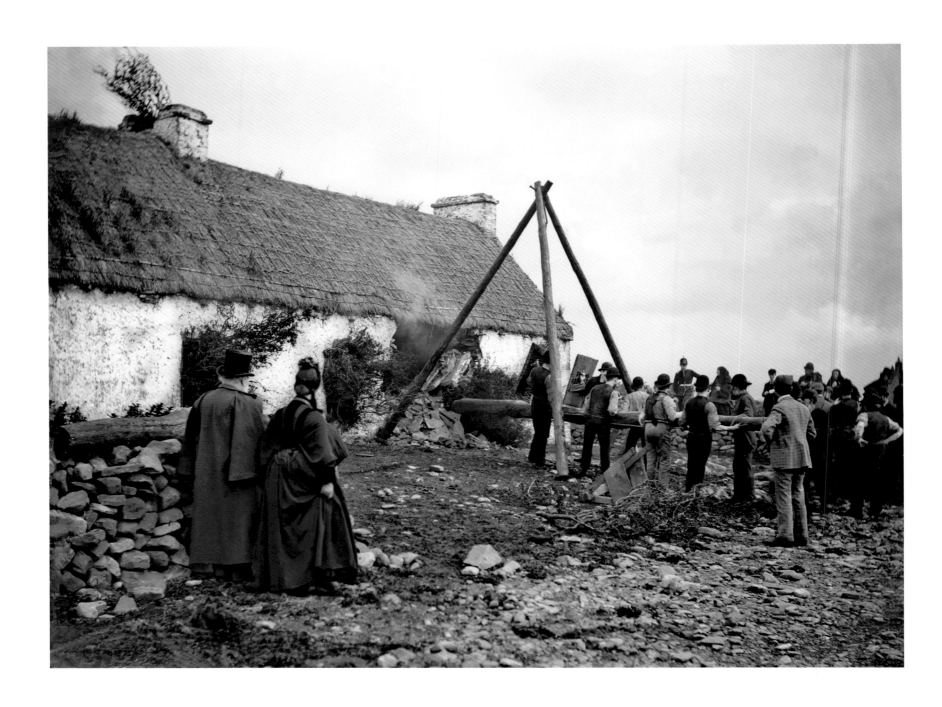

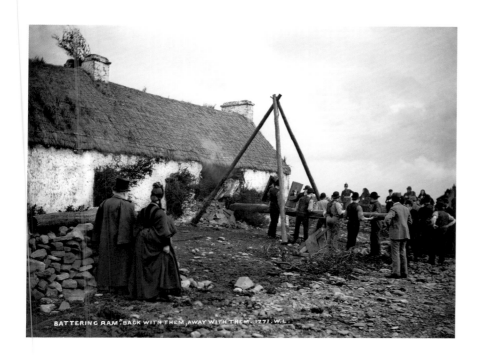

An eviction

CLARE

Vandeleur Estate

July 1888

Here a battering ram is used to evict the tenant Thomas Bermingham from his home on the Vandeleur Estate. In Irish evictions it was commonplace for landlords to forcibly evict their tenants in this way. The well-dressed couple on the left witnessing the evictions may be Major E. J. O'Shaughnessy and Margaretta Dunn O'Shaughnessy.

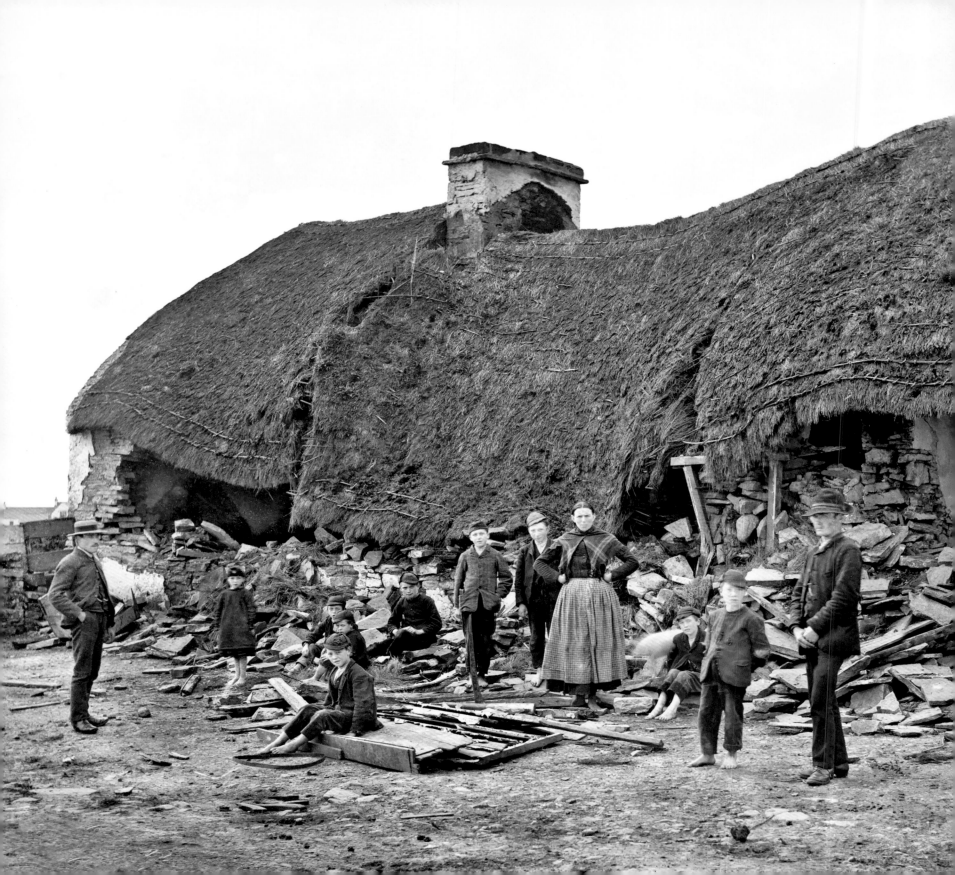

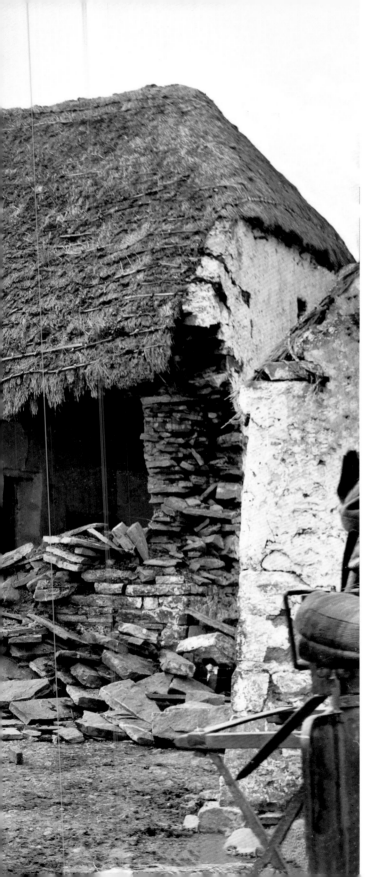

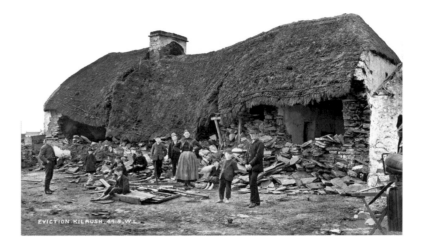

EVICTION.KILRUSH. 4918.W.L.

CLARE
Vandeleur Estate
July 1888

This photograph shows tenant Mathias McGrath's house after a battering ram was used to evict him and his family from the Vandeleur Estate. Captain Hector Stewart Vandeleur hiked up rents with no regard to his tenants' ability to pay them; he then would evict them as soon as they could no longer afford to live on the estate. The figure on the far left is Bernhard III, Duke of Saxe-Meiningen, who visited the estate with his wife and son to offer their sympathies to the evicted families. It was reported that the duke complimented the McGrath's son on his bravery while defending the family's home.

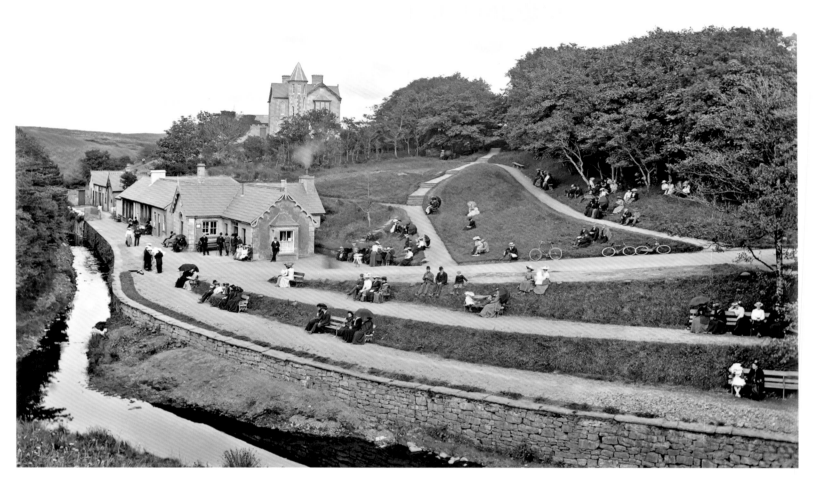

CLARE
Spa Baths, Lisdoonvarna
c.1890

The Victorian Spa Baths in Lisdoonvarna in County Clare was famous for its therapeutic mineral waters. The waters flow from springs in the Clare Shale in Lisdoonvarna and are rich in sulphur and iron. By 1895 over 20,000 people were visiting annually to benefit from the spa's curative properties, but unfortunately the spa itself has been closed since 2014.

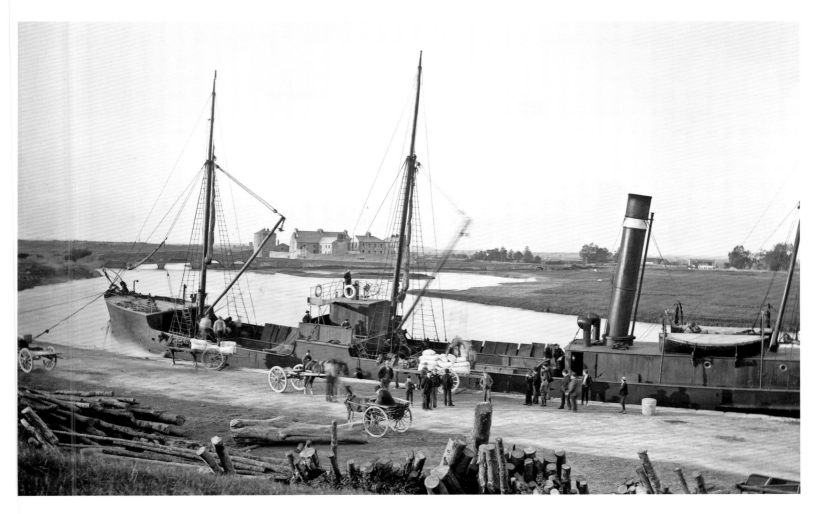

CLARE
Clarecastle, Ennis
c.1900

Clarecastle Harbour in Ennis, County Clare. In the background is Clarecastle and its Infantry Barracks, which stands on an island in the narrowest navigable part of the River Fergus. County Clare gets its name from the castle, adopting it in 1590.

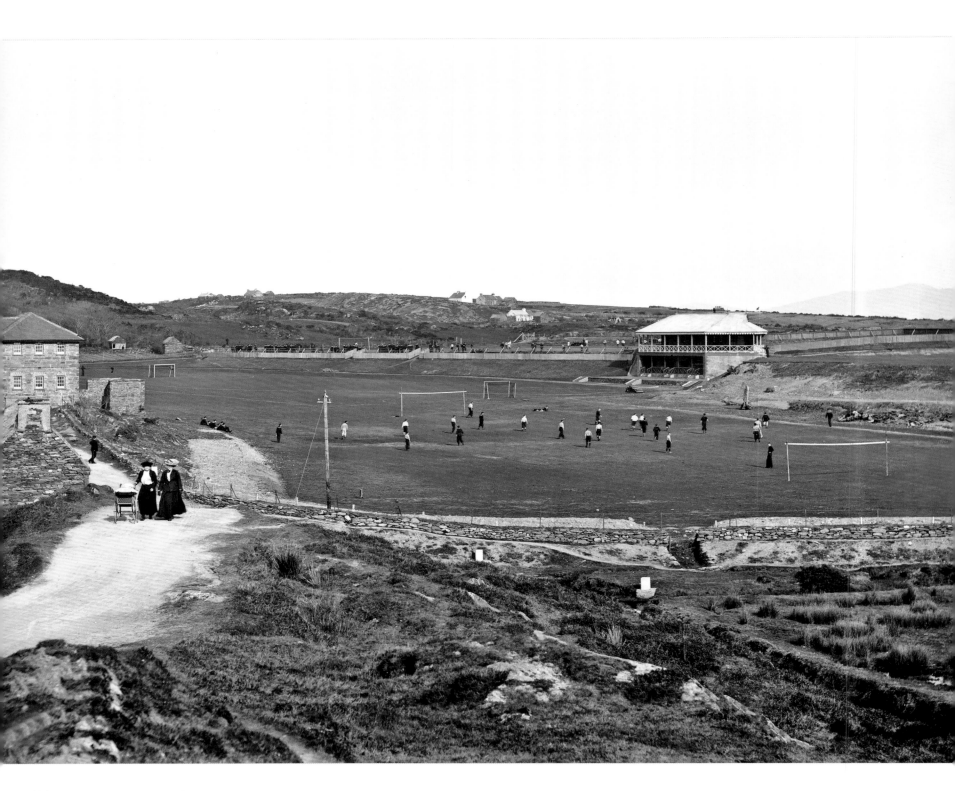

ADMIRALTY RECREATION GROUNDS, CASTLETOWN BEREHAVEN, CO.CORK. 8352 W.L.

CORK
Admiralty Recreation Grounds, Castletownbere
c.1904

The impressive Lawrence Cove Admiralty Recreation Grounds and
the Lawrence Cove Sports Pavilion on Bere Island, Castletownbere
in County Cork. In 1898 the British military raised a compulsory
purchase order on large areas of the island to construct additional
fortifications to protect the British fleet at anchor in Berehaven
Harbour. In the background is the Druid's Altar wedge tomb, which
collapsed in the 1960s. The Ardaragh tomb dates back to the early
Bronze Age (approx. 2500–500BC).

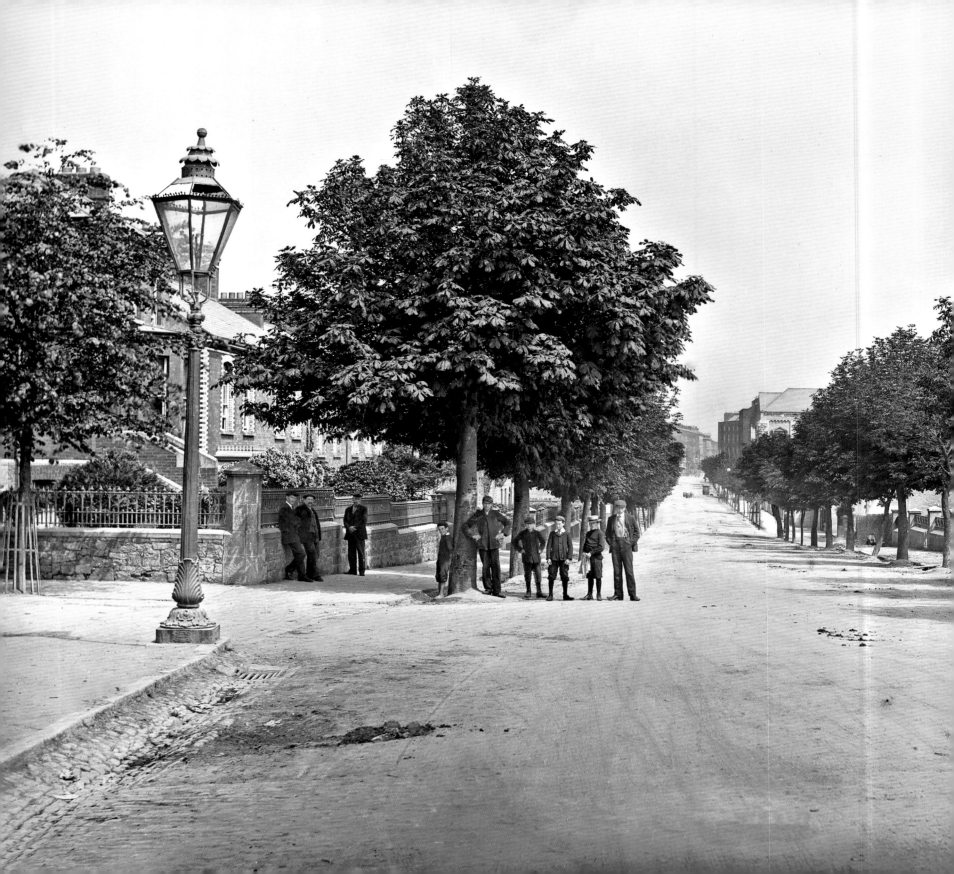

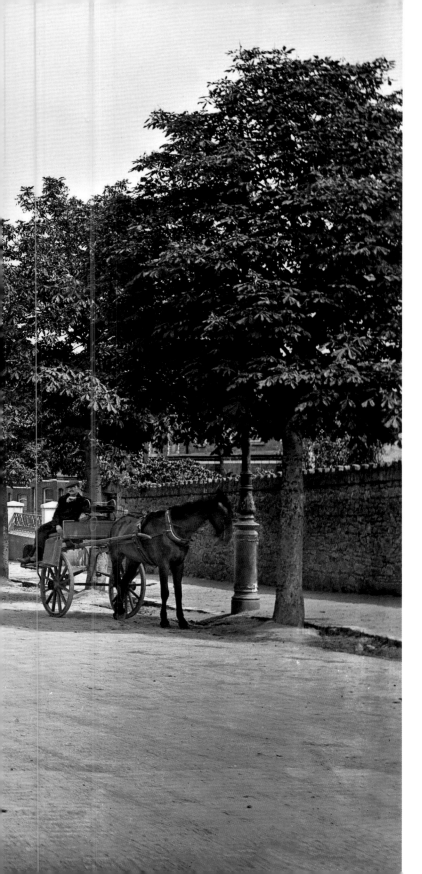

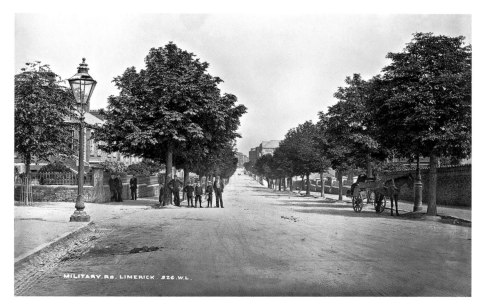

MILITARY. Rᴅ. LIMERICK. 526.W.L.

LIMERICK
Military Road (now O'Connell Avenue)
c.1890s

The tree-lined Military Road in Limerick City is now known as O'Connell Avenue; this image was taken at the junction with Quin Street. In the background is the Crescent, an area named for the shape of the Georgian terraced buildings on both sides. At the centre of the Crescent stands a monument to Daniel O'Connell, the nineteenth century Irish political leader. Unveiled in 1857, it was the first outdoor public statue of O'Connell in Ireland.

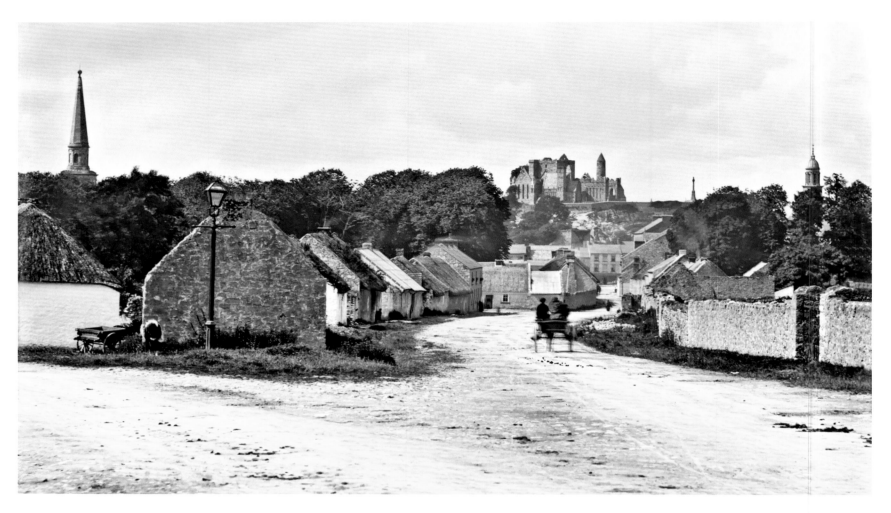

TIPPERARY
Rock of Cashel
c.1890s

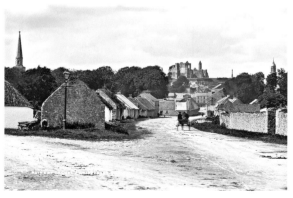

The Rock of Cashel Bore in County Tipperary. According to legend, St Patrick himself came here to convert King Aenghus to Christianity; and Brian Boru was crowned High King at Cashel in 978.

TIPPERARY
Rock of Cashel
c.1890s

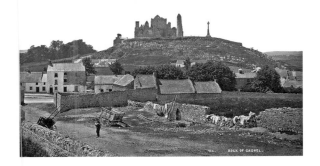

The Rock of Cashel set on a dramatic outcrop of limestone in the Golden Vale in Cashel, County Tipperary. Brian Boru made Cashel his capital in 978. The Scully High Cross is a memorial to the Scully family erected in 1870 but, unfortunately, the ringed top of the cross was sheared off in 1976 when lightning struck the metal rod that ran the length of the cross.

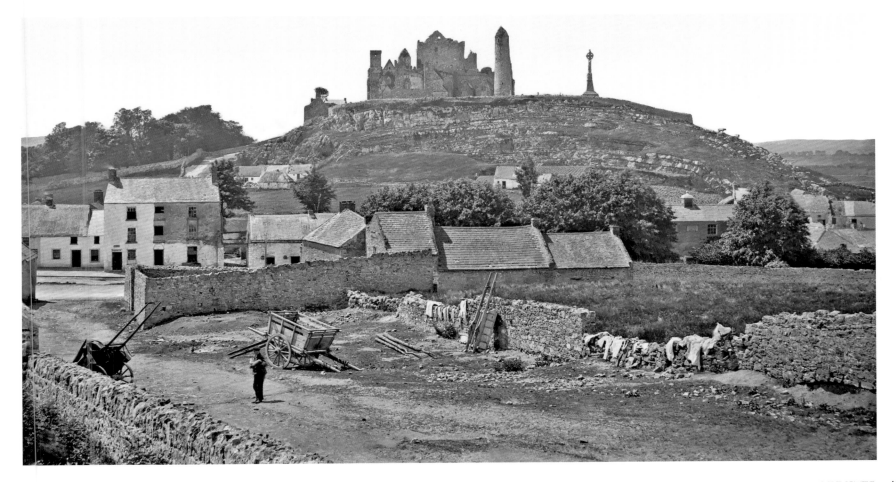

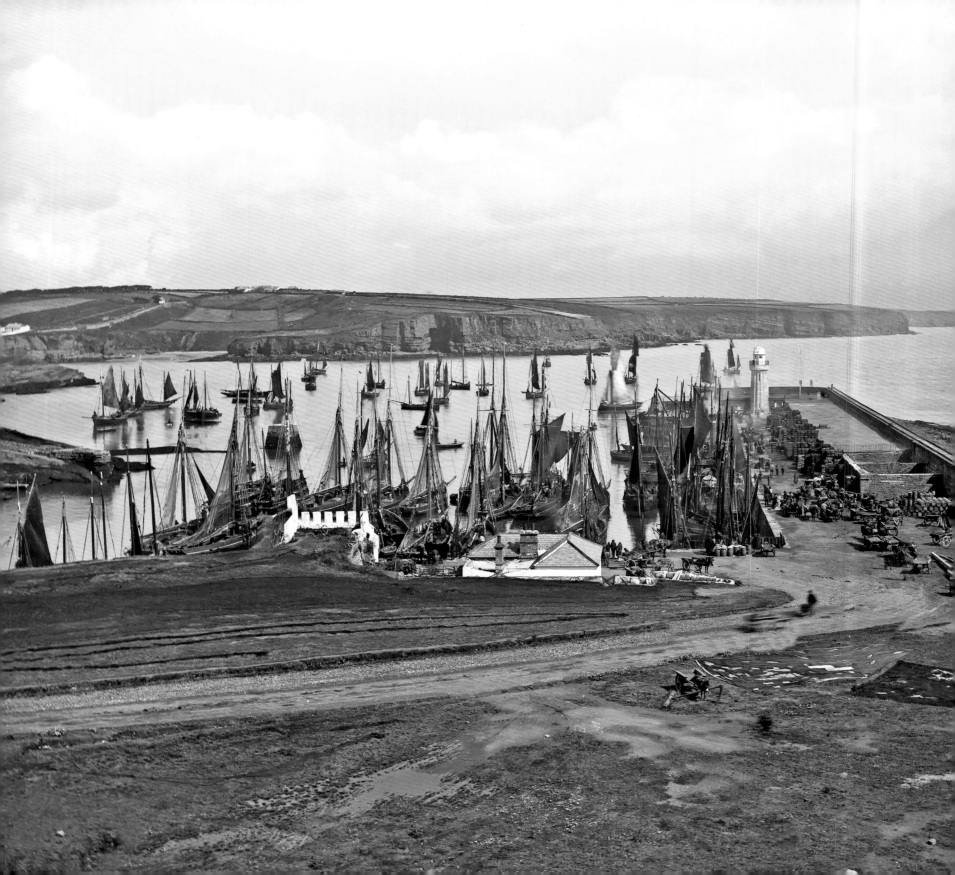

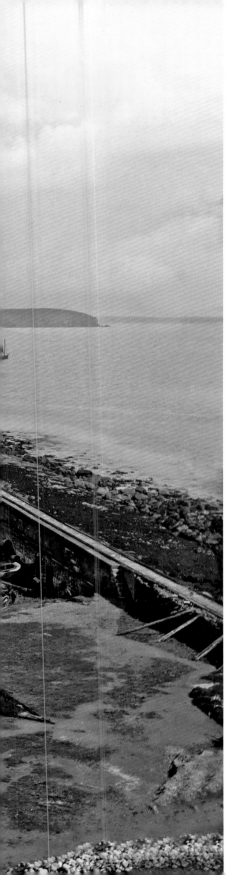

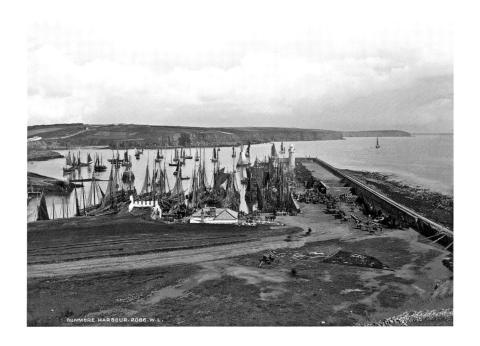

WATERFORD

Dunmore Harbour

1890s

Dunmore East (An Dún Mór Thoir) harbour in County
Waterford featuring a hive of activity along the quay
wall. Its elegant lighthouse was designed by the
Scottish engineer Alexander Nimmo in 1814.

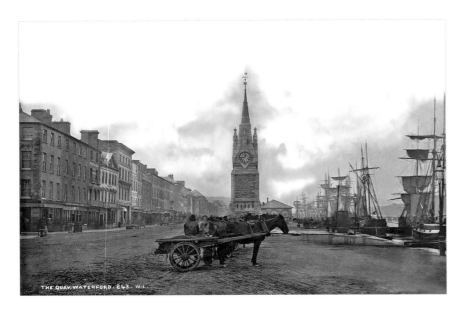

WATERFORD

Meagher's Quay

c.1890s

Meagher's Quay, Coal Quay, on the River Suir in
Waterford City. The Gothic revival clock tower was
designed by architect Charles Tarrant in 1854 and the
fountain erected in 1863.

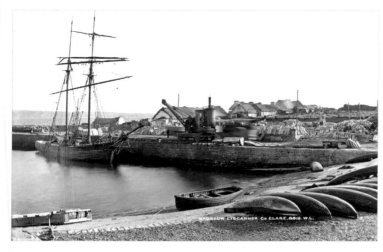

CLARE
Liscannor Pier
c.1885

Liscannor flagstones were locally used to floor the hearth area of the traditional Irish cottage and were also shipped around the world from Liscannor Pier.

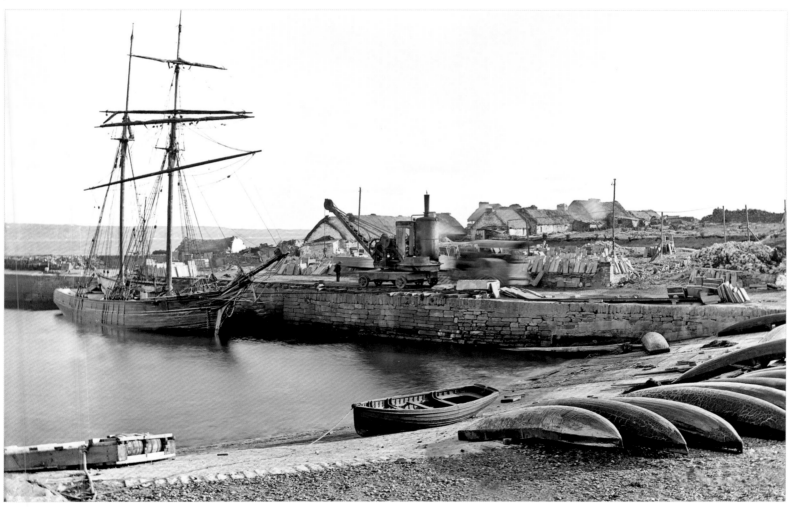

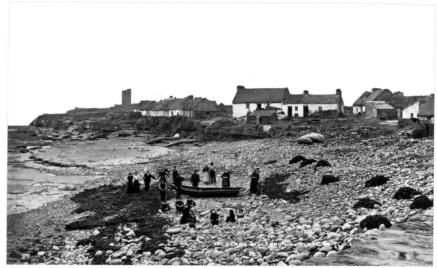

CLARE
Liscannor Beach
c.1885

Liscannor takes its name from Liscannor Castle; 'Lis' meaning a 'fort' and 'Cannor' a corruption of the name 'Connor' in Irish.

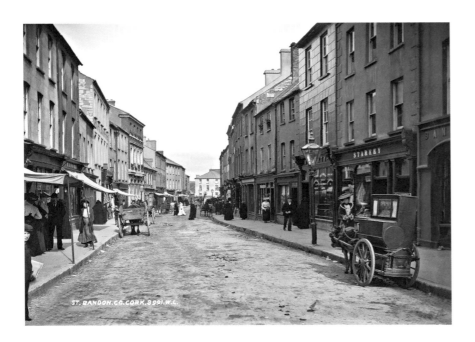

CORK
Main Street, Bandon
c.1900

A bustling Main Street, Bandon in County Cork. Notice some of the women in those marvellous hooded cloaks; and on the bottom right is a barrel piano which is powered by turning a hand crank.

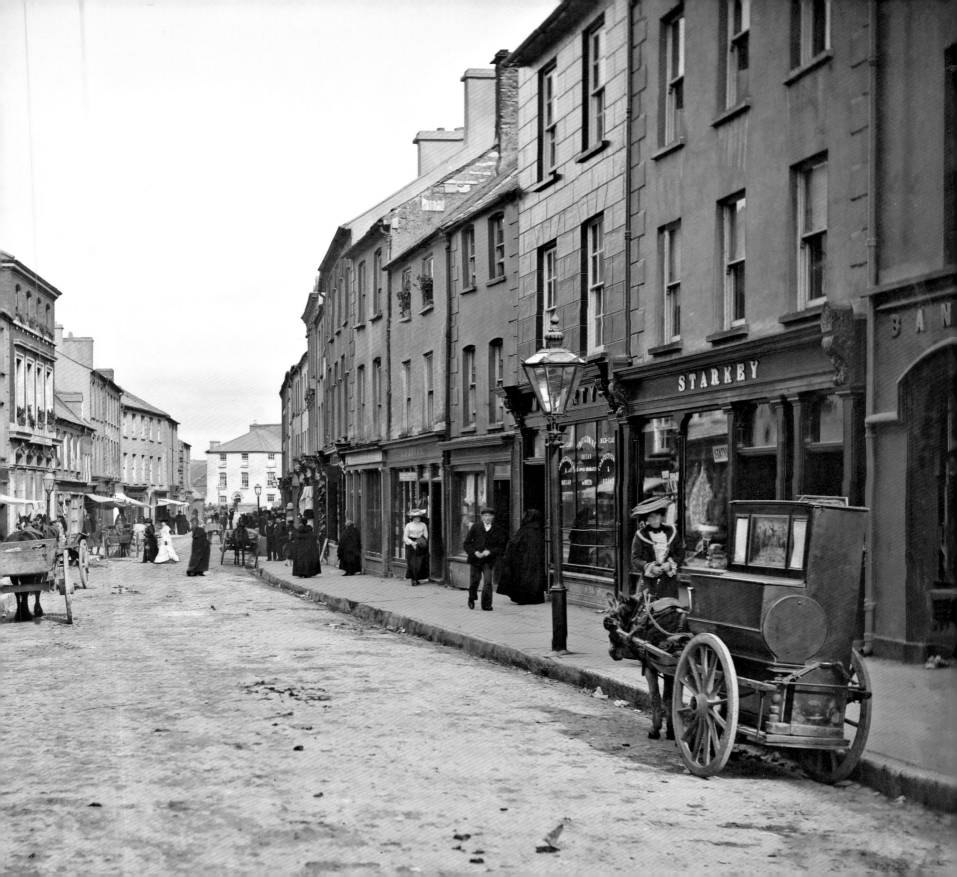

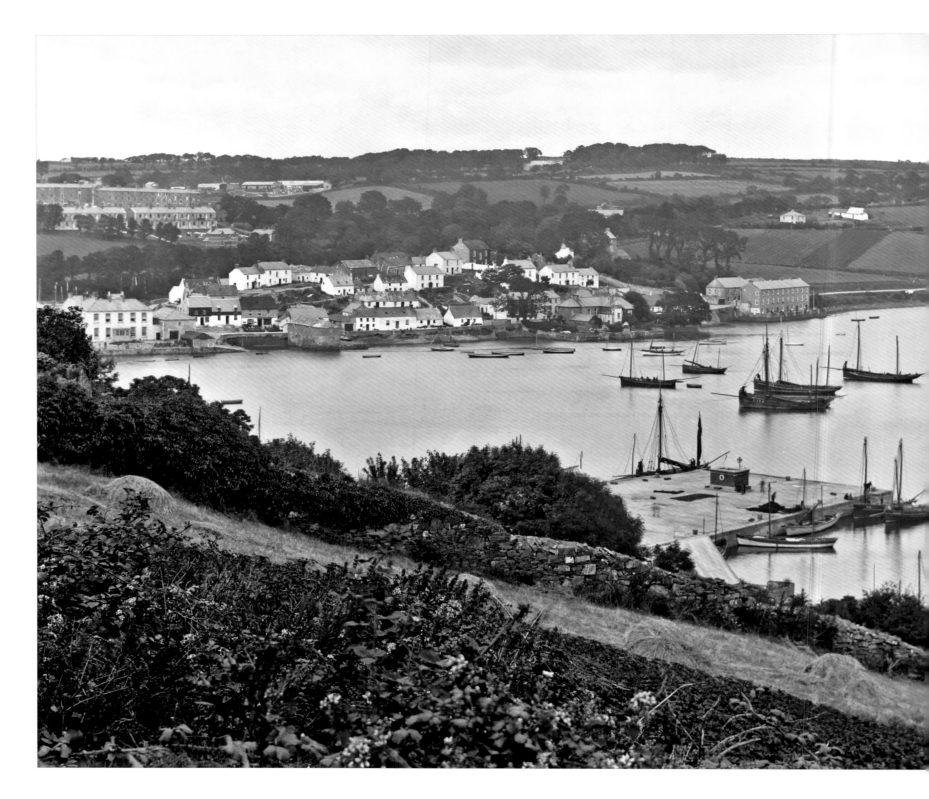

CORK

Kinsale Harbour

c.1900

The fishing town of Kinsale (Cionn tSáile, 'head of the brine'), located at the mouth of the River Bandon, County Cork.

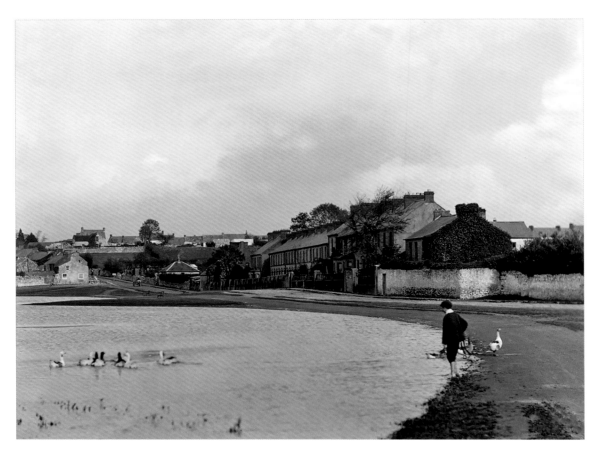

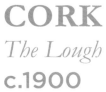

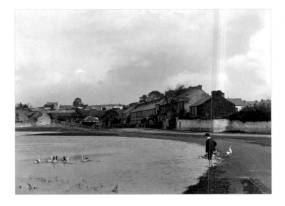

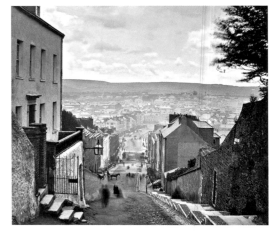

CORK

The Lough

c.1900

A Fergus O'Connor photograph of the Lough in County Cork. In 1881, this shallow spring-fed freshwater lake was declared a Public Wildlife Refuge and is thus one of Ireland's oldest protected areas.

CORK

St Patrick's Hill

c.1890s

St Patrick's Hill, the county's steepest hill, looking out towards Father Mathew Bridge and Patrick Street in Cork City.

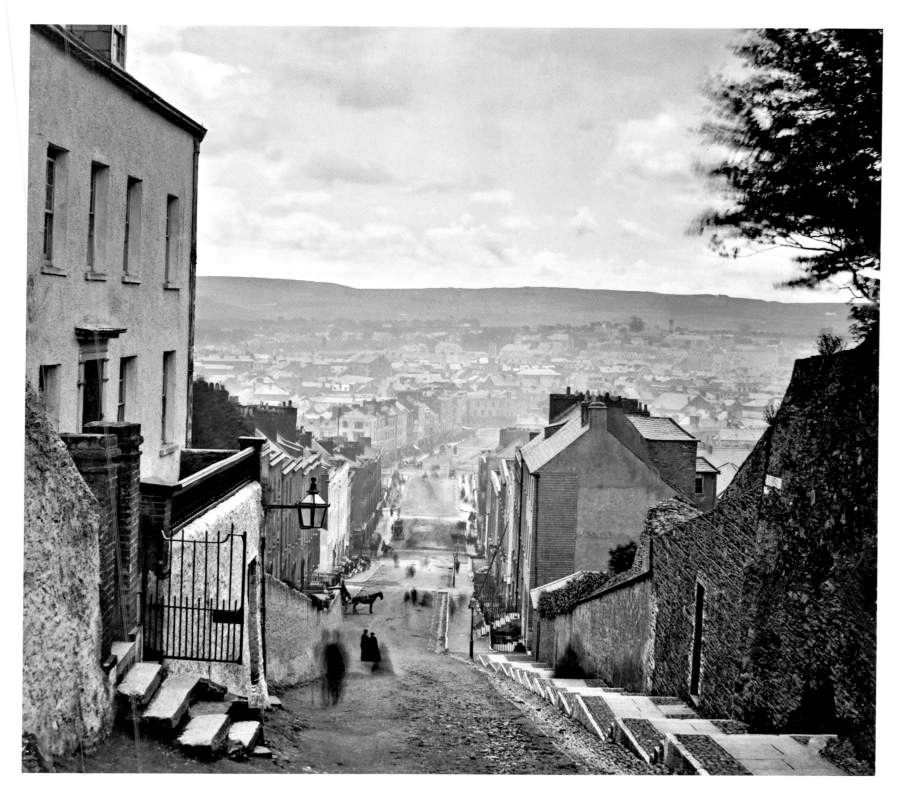

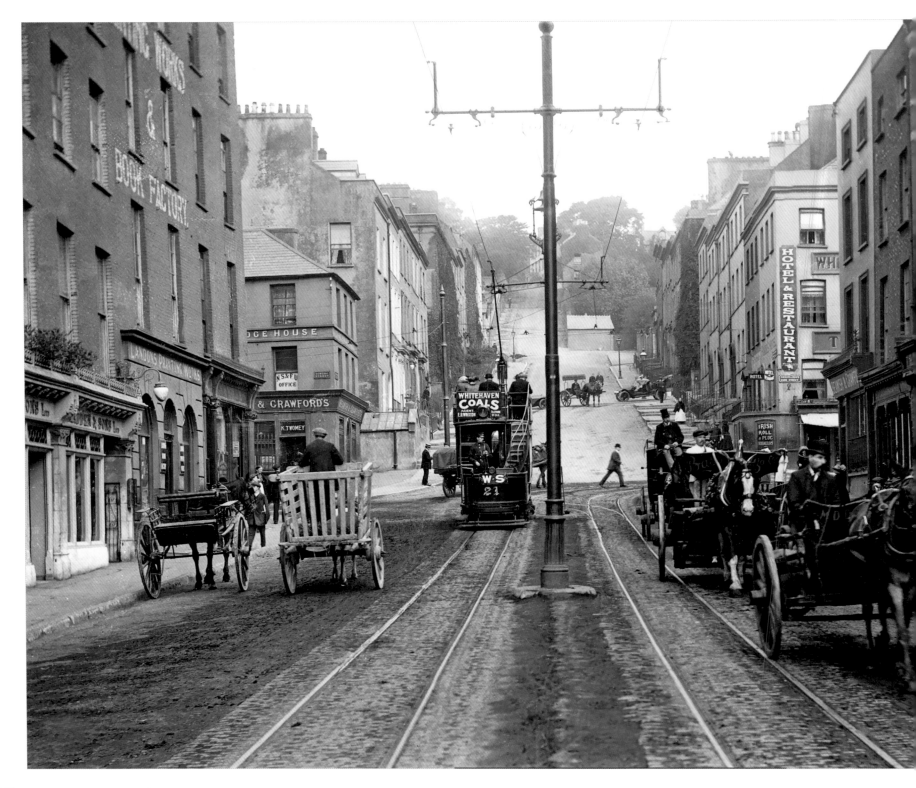

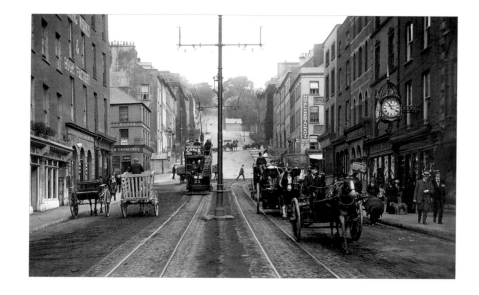

CORK
Bridge Street and St Patrick's Hill
c.1900

Bridge Street in Cork City featuring St Patrick's Hill in the background. On the right-hand side, at number 5 Bridge Street, is the Barriscale's Jewellers and Watchmakers shop, with its beautiful street clock.

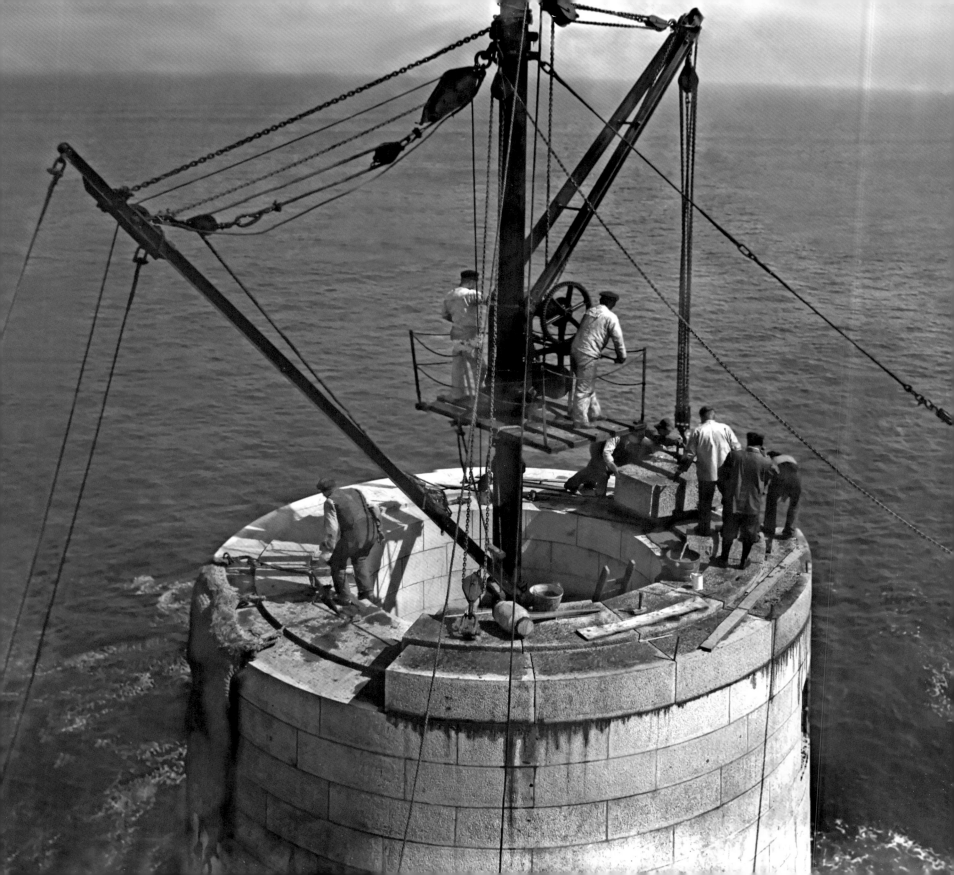

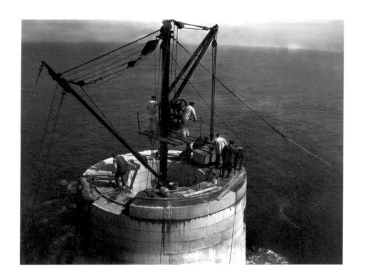

CORK

Fastnet Rock

c.1890s

A Robert Stawell photograph featuring the fearless construction workers working on the Fastnet Lighthouse. Situated on the remote Fastnet Rocks, the lighthouse is eight miles off the coast of County Cork in the wild Atlantic Ocean. The current lighthouse is the second to be built on the rock and is the tallest in Ireland with a height of 54 metres. The first of 2,047 Cornish granite dovetailed blocks weighing up to three tons was laid in June 1899. These were cut at Penryn in Cornwall and transported to Rock Island in Crookhaven, from where a specially built steamship, SS *Ierne*, brought them out to the rock. The man in the white coat is master stonemason James Kavanagh, and it is said that he placed every stone of the lighthouse with his bare hands. Unfortunately, he died before the Fastnet Lighthouse entered service on 27 June 1904.

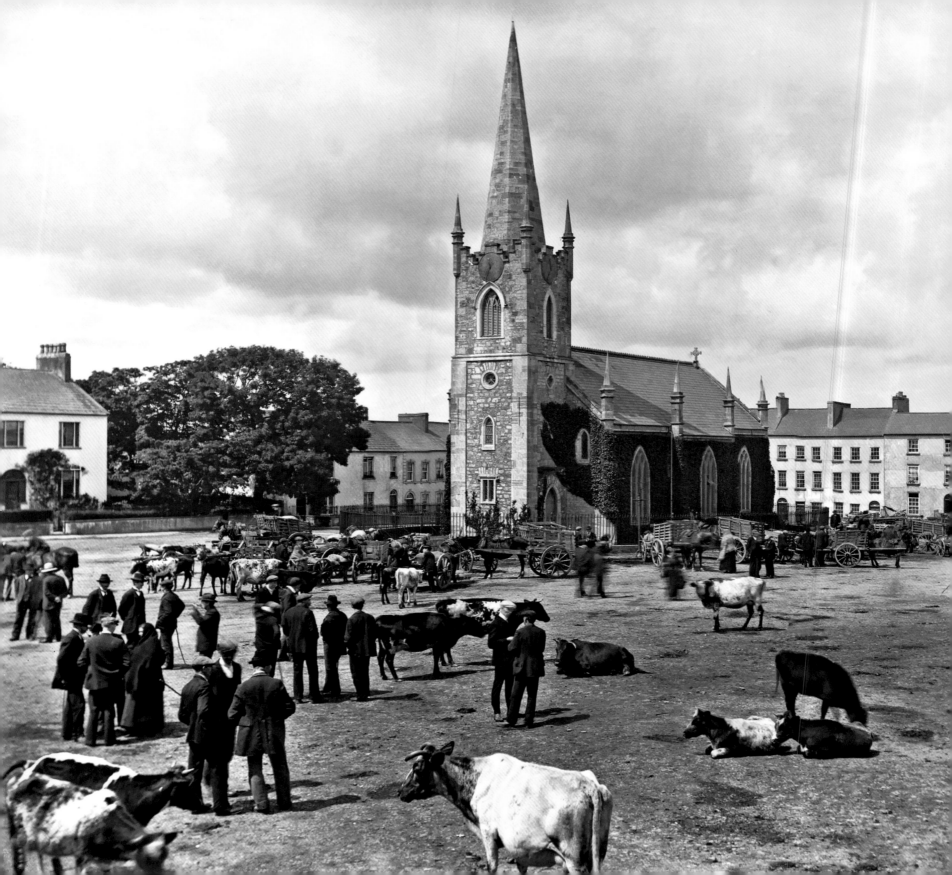

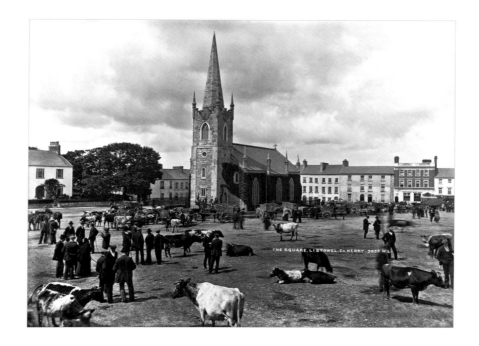

KERRY
The Square, Listowel
c.1910

Market day in the Square in the heritage market town of Listowel in County Kerry. The Gothic-style St John's Church was designed by James Pain in 1819 and is now the St John's Theatre & Arts Centre. The upper-storey red brick building on the right-hand side is the Provincial Bank (now the Allied Irish Bank).

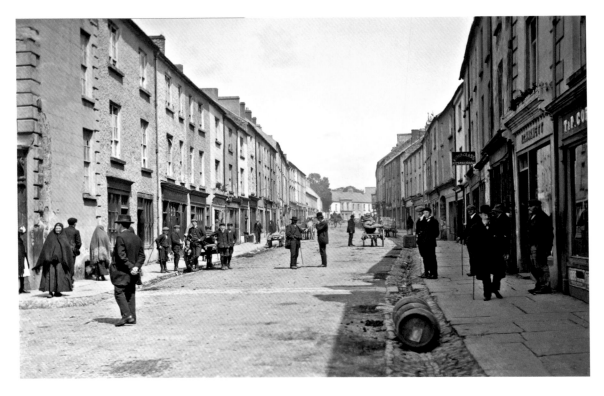

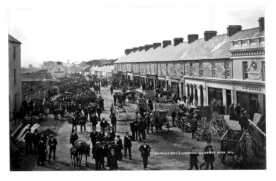

KERRY
Market Street, Listowel
c.1900

Market day on Market Street in Listowel, County Kerry. The array of agricultural machinery on display is outside Jeremiah McKenna's hardware store, today now familiarly known as McKenna's Corner. The McKenna family, with the current management representing the fourth generation, started trading at 3 Market Street in 1871, adding number 5 in 1912 and number 1 in 1962.

KERRY
Listowel
c.1900

Church Street in Listowel, County Kerry, featuring local women wrapped in their colourful shawls, along with women wrapped in black shawls, who were known locally as 'Shawlies'.

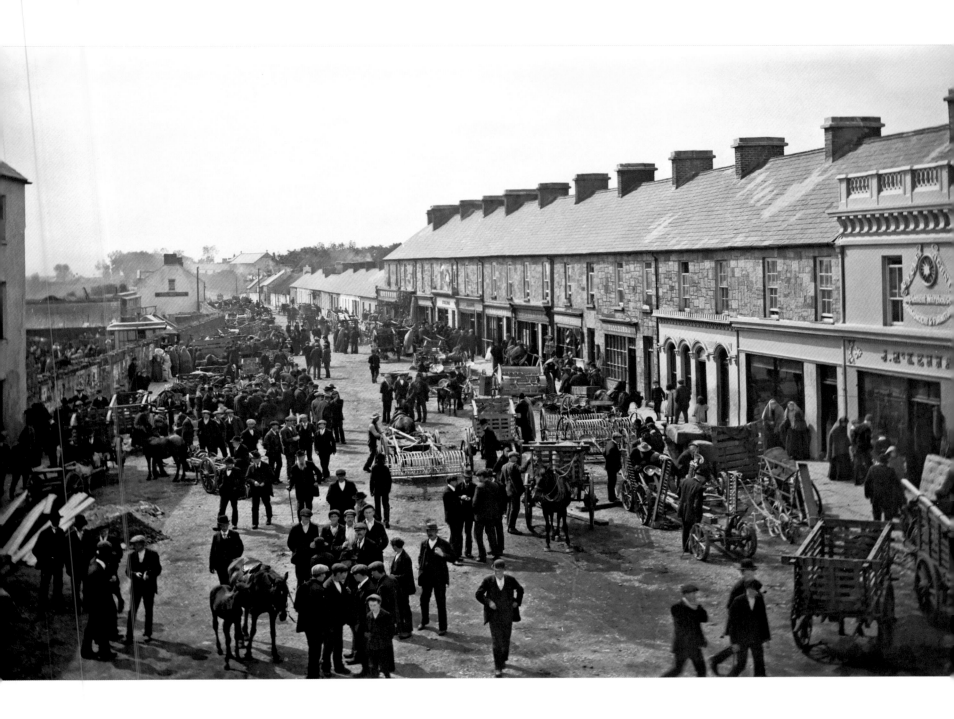

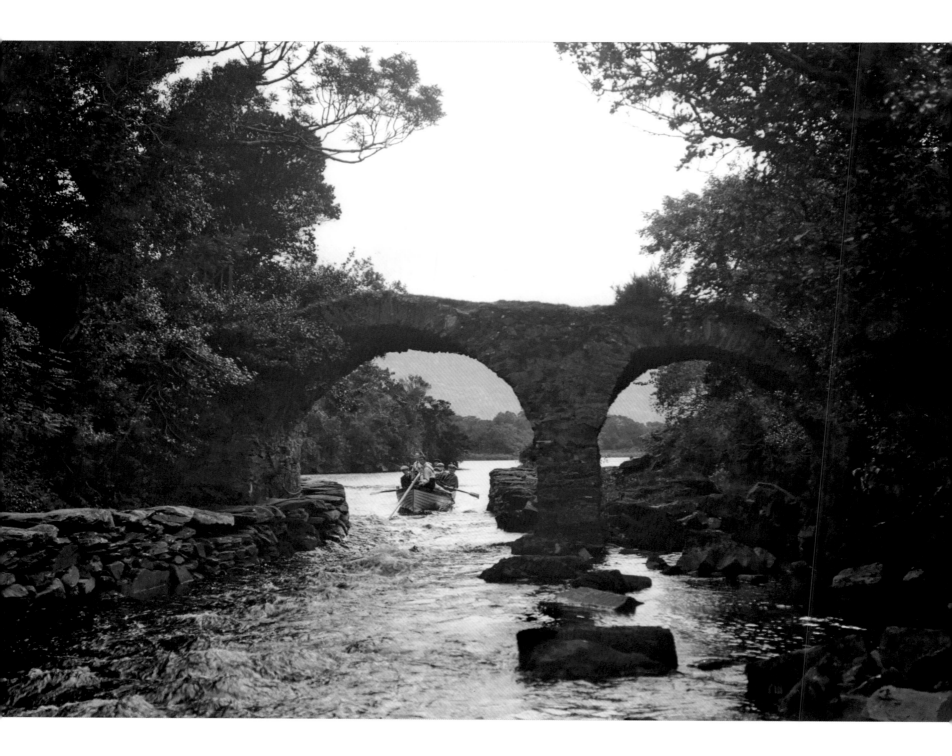

KERRY
Killarney
c.1900

Tourists shoot the rapids in the Meetings of the Waters, Killarney, County Kerry.

KERRY
Derrylooscaunagh
c.1900

Stacked turf piles await collection down by the Gearhameen River in Derrylooscaunagh (Doire Luiseagán), MacGillycuddy Reeks, Killarney in Country Kerry. In the background on the right-hand side, located on the southern end of the MacGillycuddy Reeks Mountain Range, is the Black Valley National School.

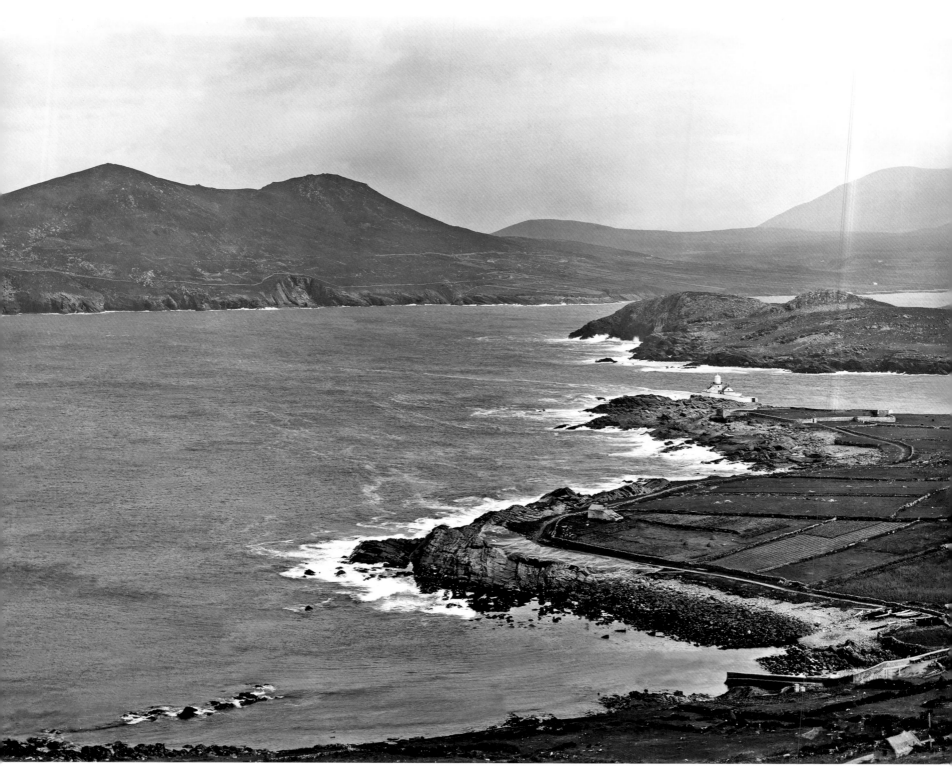

KERRY
Valentia Lighthouse
c.1900

The Valentia Lighthouse at Cromwell Point, County Kerry. The lighthouse sits on the site of the seventeenth century fort known as 'Fleetwood Fort' built to guard Valentia Harbour against invaders.

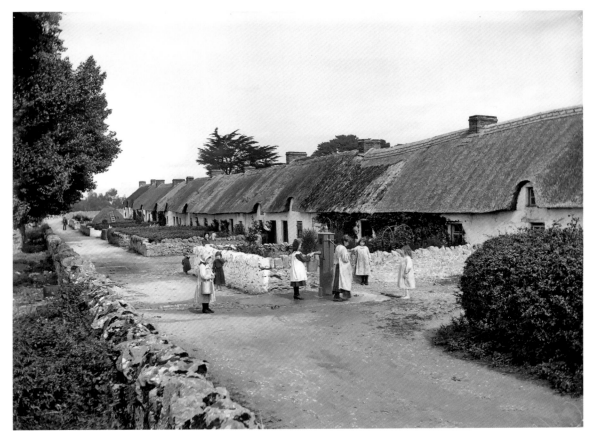

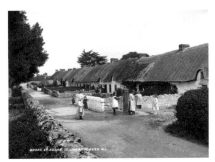

LIMERICK
Broad Street, Adare
c.1900

A row of traditional thatched-roof cottages on Broad Street in the village of Adare in County Limerick. Adare (Áth Dara, 'ford of the oak'), is a historic market town, which in the Middle Ages had three monasteries.

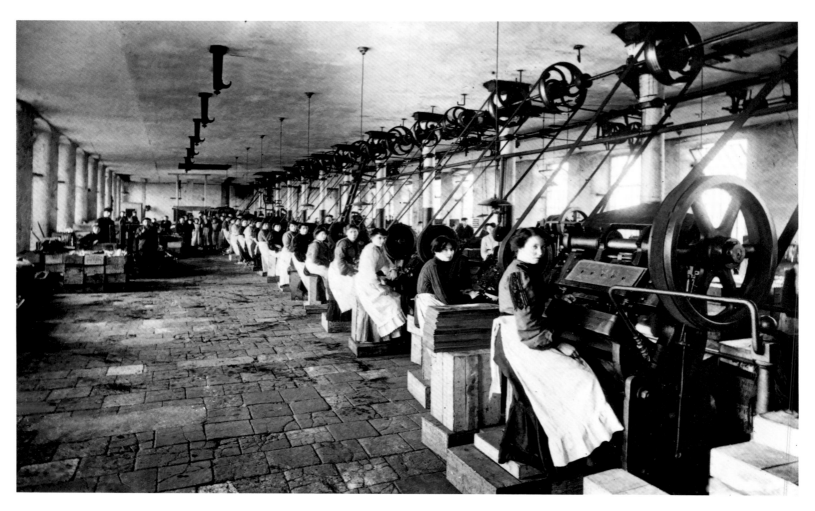

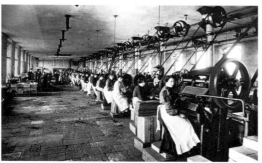

LIMERICK
Cleeves Toffee Factory
c.1900

The Condensed Milk Company of Ireland factory in Limerick City owned by the Cleeves Brothers, confectionery entrepreneurs. Women are making milk cans while men are packing. The factory at its peak produced 60,000 cans of condensed milk each day.

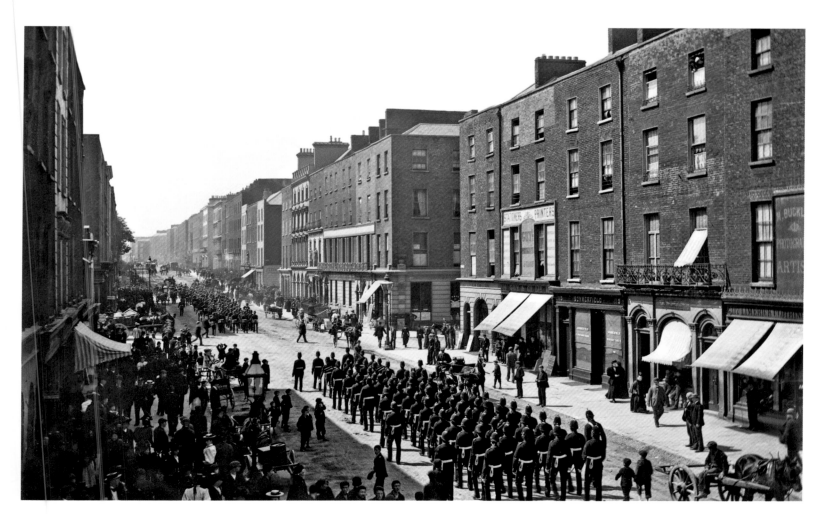

LIMERICK
George's Street (now O'Connell Street)
c.1890s

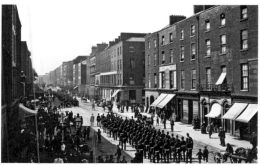

George's Street in Limerick City, featuring a Royal Irish Constabulary parade. The Constabulary was established in 1814 and by 1901 it had 1,600 barracks and 11,000 constables in Ireland.

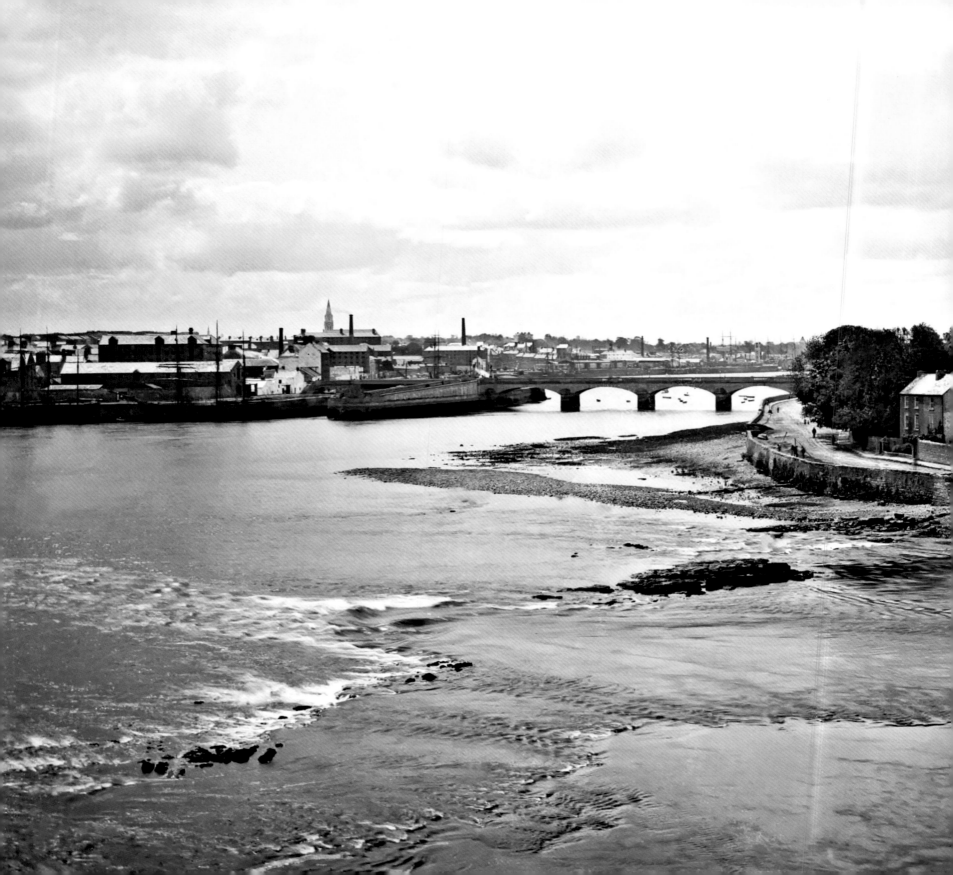

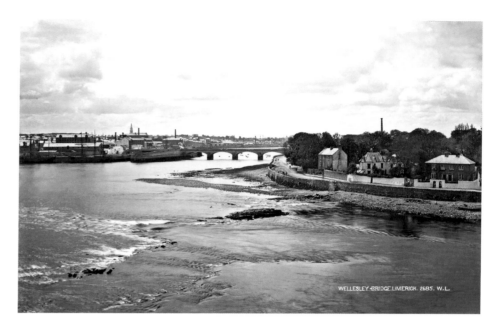

LIMERICK
River Shannon
c.1865

The Curragower Falls and Wellesley Bridge (formerly Sarsfield Bridge) designed by the Scottish engineer Alexander Nimmo in 1835. The red brick house (third from the right) is the Curragower House on Clancy Strand, which was demolished on 12 June 2021.

LIMERICK
Arthur's Quay
c.1880

These majestic merchant ships are moored at Arthur's Quay in Limerick City. In the background is the thirteenth century King John's Castle next to Thomond Bridge, which was designed by Pain Architects and completed in 1840. In the late eighteenth century, Arthur's Quay was the resort of numerous turf boats; with the completion of the Grand Canal, by 1804 the Shannon Navigation linked up with Dublin City on Ireland's east coast.

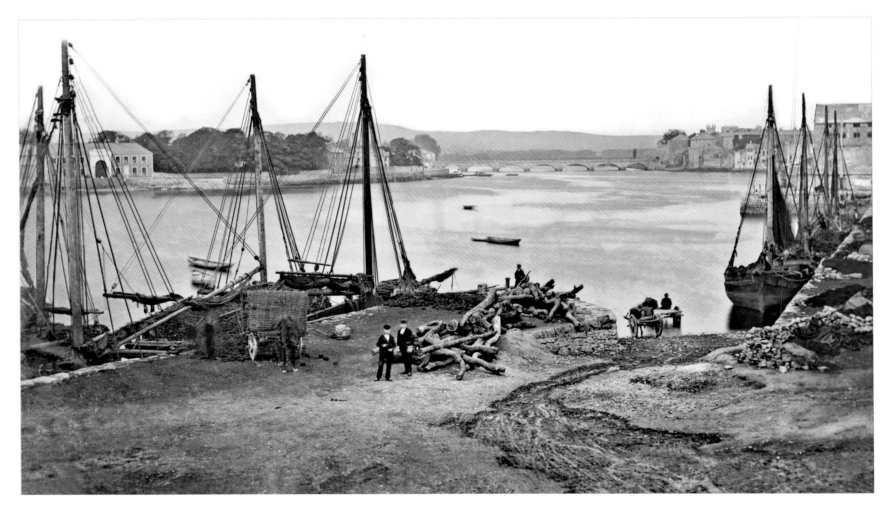

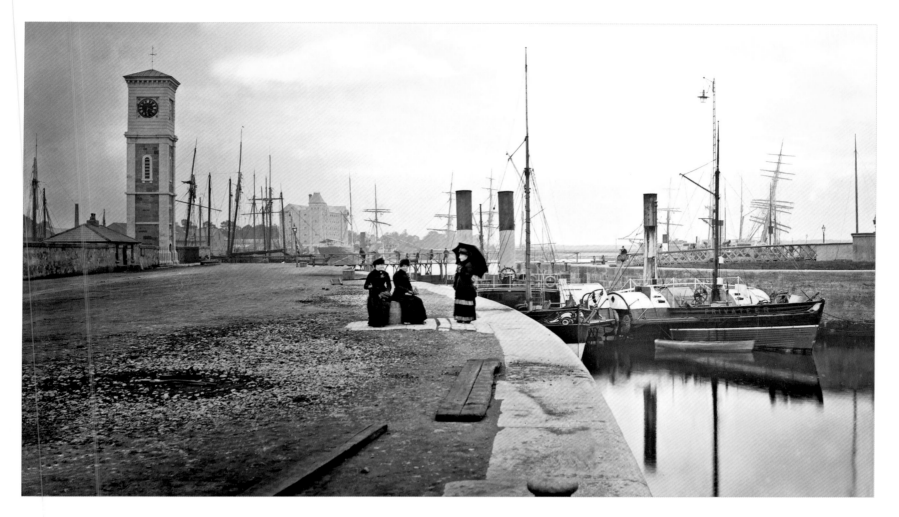

LIMERICK
The Docks
c.1900

The floating dock in Limerick City, which features the old entrance to the docks, and the majestic Dock Clock built in 1880. The Bannatyne Mill is in the background.

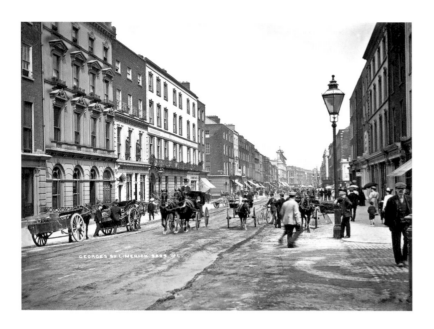

LIMERICK
George's Street (now O'Connell Street)
c.1900

A bustling George's Street in Limerick City,
featuring the Royal George Hotel and, in the
background, the majestic Cannock's department
store, now Penney's department store.

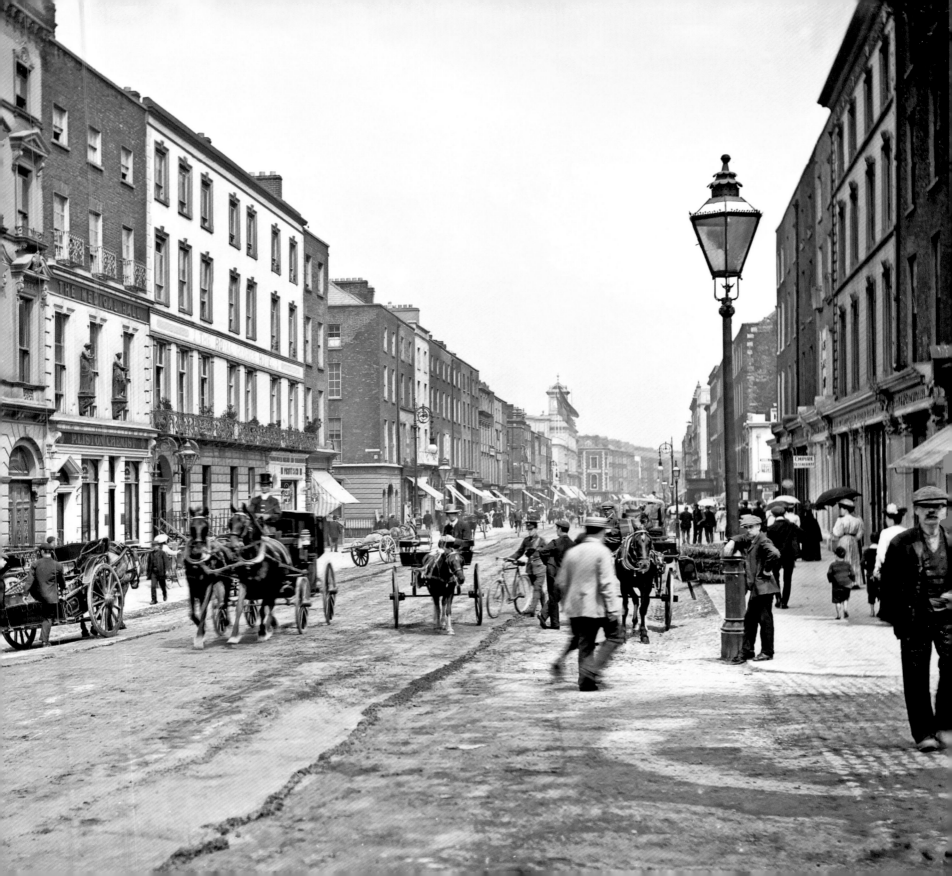

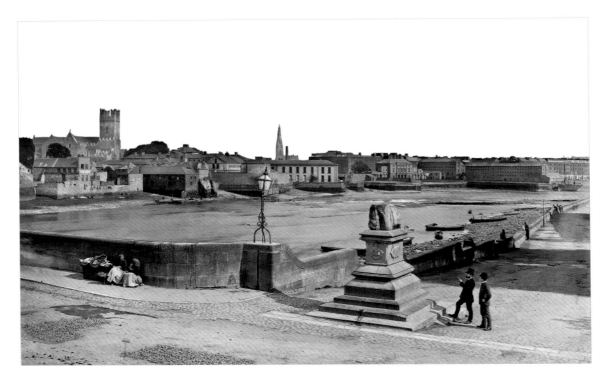

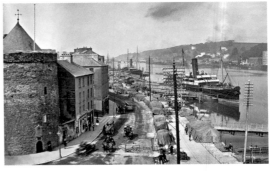

WATERFORD
Waterford Quay
c.1905

A busy Waterford Quay on the River Suir featuring Ireland's oldest civic building, Reginald's Tower, which has been in continuous use for over 800 years. Next to Reginald's Tower is the photographer A. H. Poole's studio. In the background is the Redmond Bridge which opened in 1903 and was eventually replaced by the Rice Bridge in 1984.

LIMERICK
The Treaty Stone
c.1890s

Limerick City on the River Shannon featuring the Treaty Stone and Thomond Bridge. In the background are the two cathedrals of St Mary's and St John's.

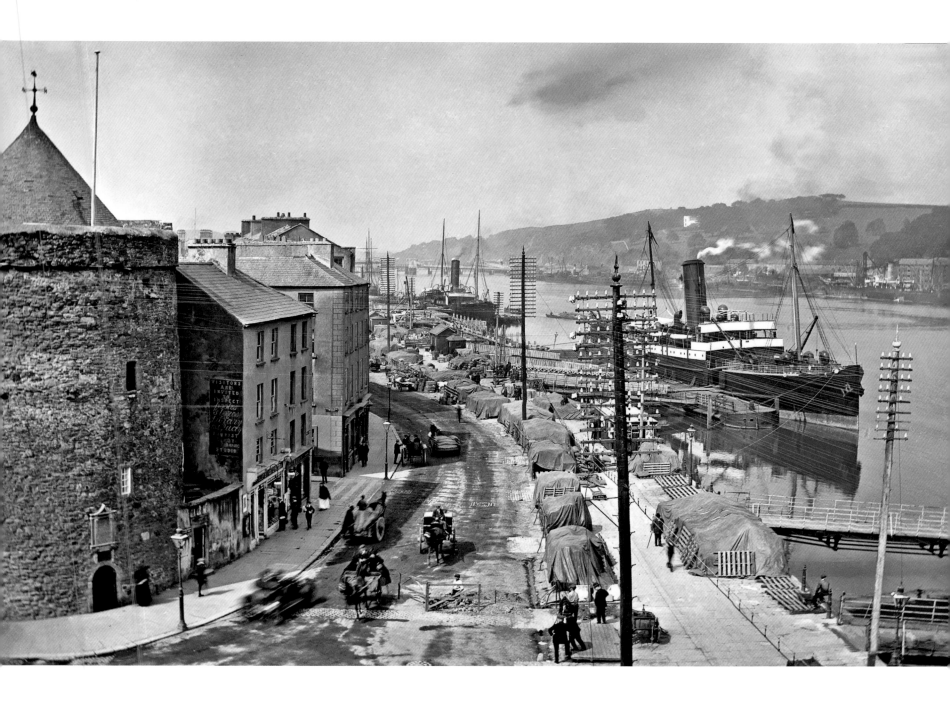

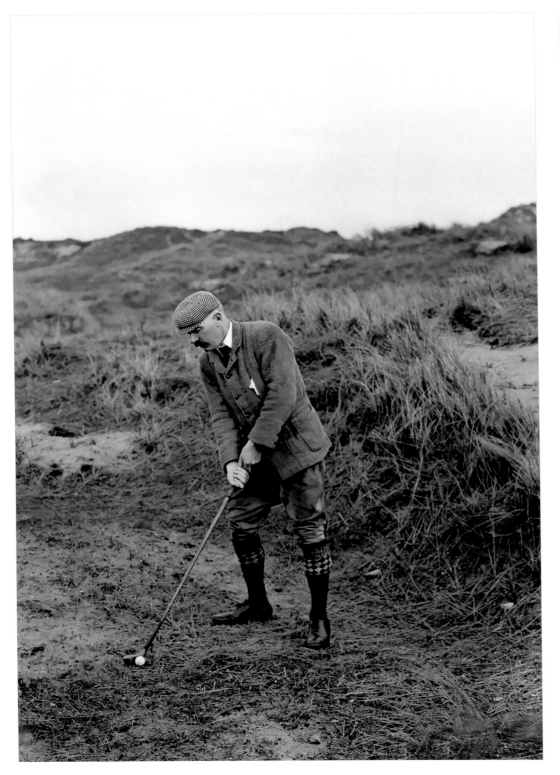

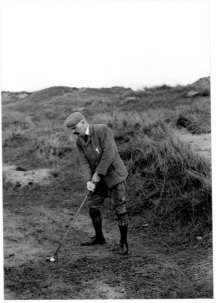

WATERFORD
Tramore
15 April 1901

Dr Patrick Joseph Gallwey, aged forty-one, playing golf on the old Tramore Golf Club course. The club was founded in 1894 in the seaside town of Tramore in County Waterford. Sadly, a few months later Patrick died on 11 July owing to heart failure, and six months later his son died of scarlet fever at only twelve years old.

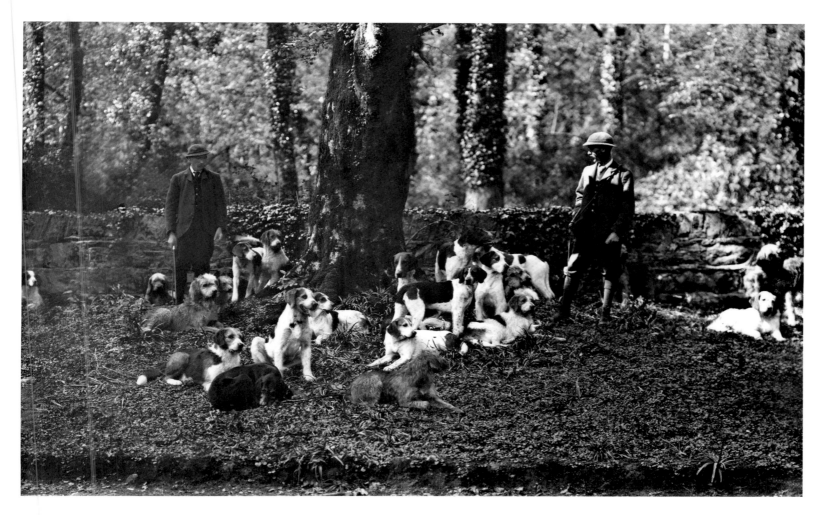

WATERFORD
Curraghmore Estate
14 May 1901

The otter hunt on the Curraghmore Estate near Portlaw, County Waterford. Curraghmore, meaning 'the great bog', once covered 100,000 acres and was given to Sir Roger le Puher (la Poer) by King Henry II in 1177, after the Anglo-Norman invasion of Ireland.

CORK
Patrick Street
c.1902

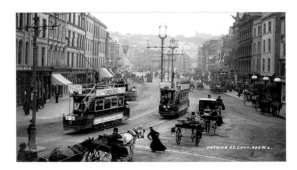

Patrick Street in Cork City with an array of British flags. On the left-hand side of the street are traders such as Lester's (Family Druggist), Kiloh & Company (Chemists), and on the hillside is the Victorian Government House, built in the 1880s and destroyed by fire in 1922.

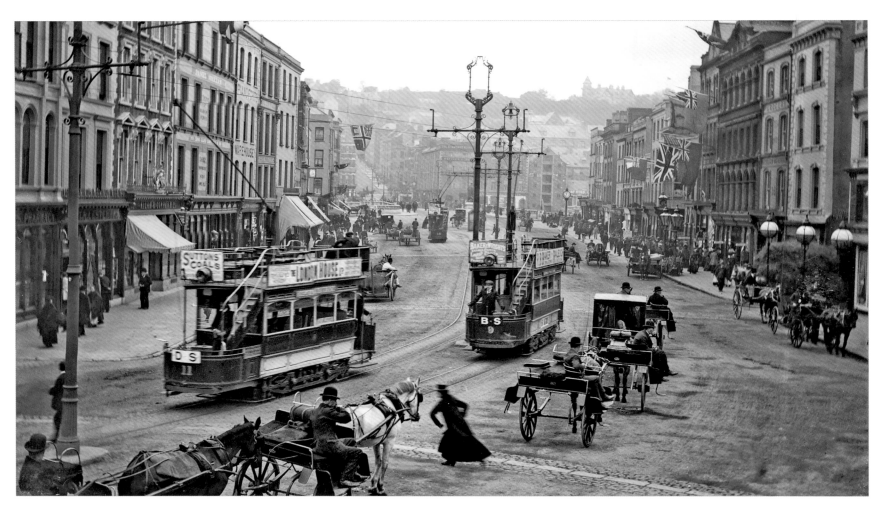

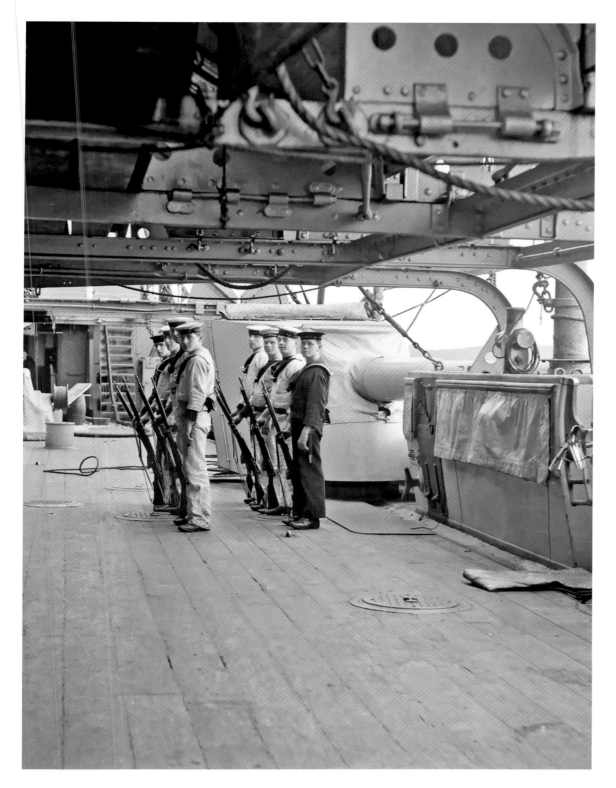

CORK
Castletownbere
c.1905

A British Royal Navy crew on a Naval Artillery Warship in Castletownbere, County Cork. Bere Island and Berehaven remained a British Navy and Army base up until 29 September 1938 when, pursuant to the Anglo-Irish Trade Agreement on 25 April 1938, the territory was ceded to Ireland.

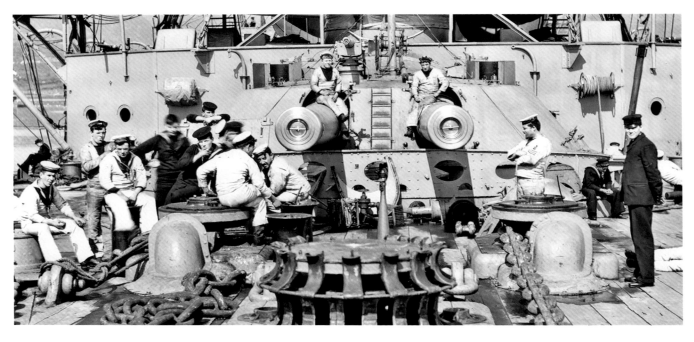

CORK

Castletownbere

c.1905

A British Royal Navy crew sun themselves on a Naval Artillery Warship in Castletownbere, County Cork.

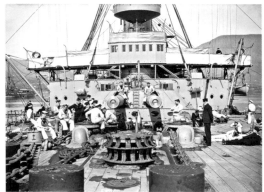

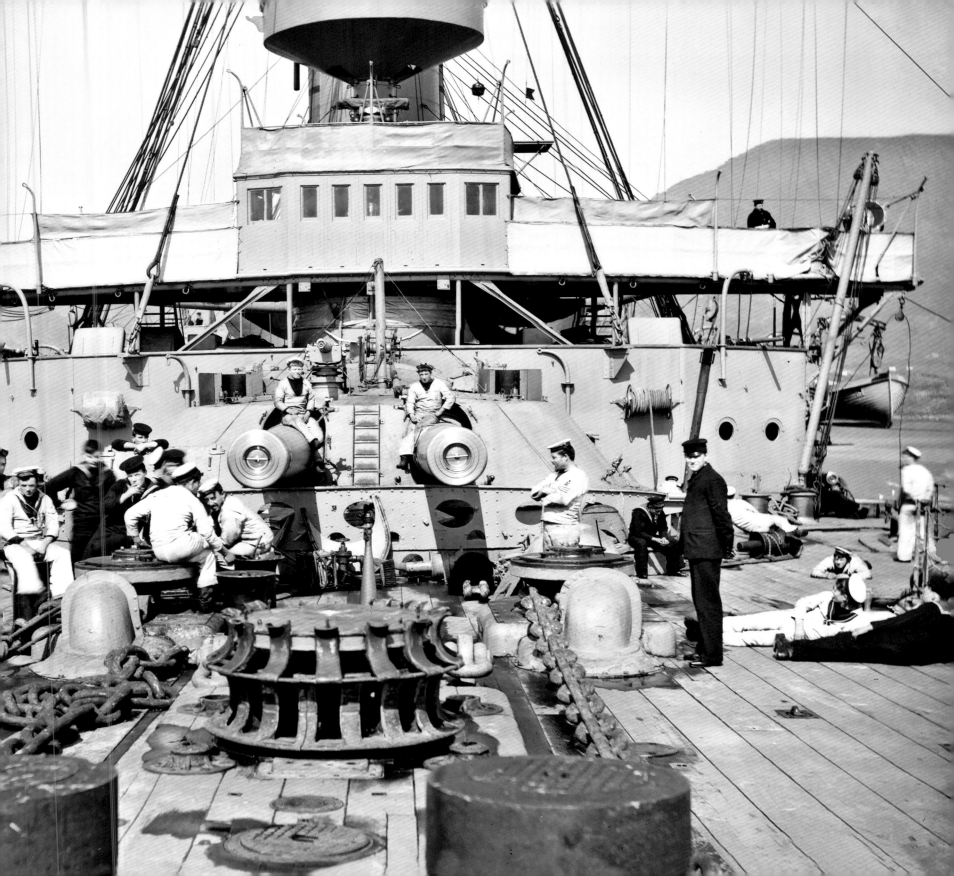

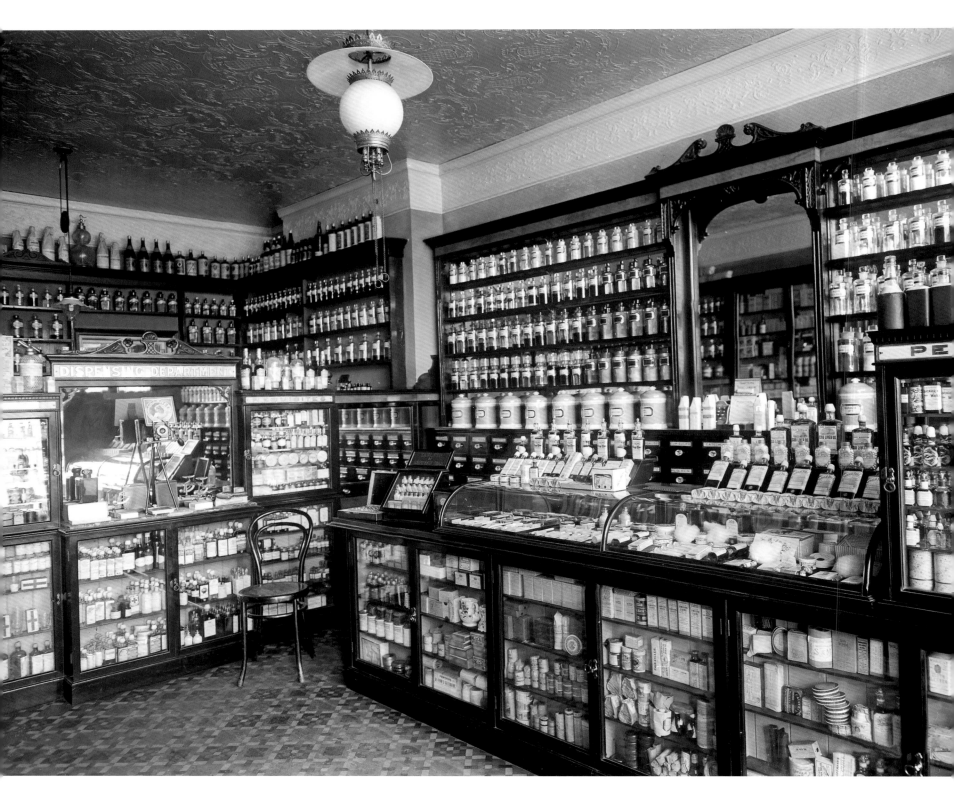

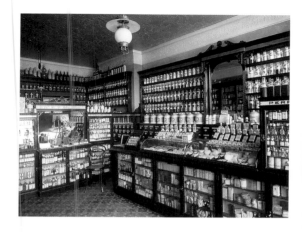

WATERFORD
The Quay
1907

W. J. Jones Chemist (now Clock
Tower Cleaners) at 82 The Quay in
Waterford City, featuring an array
of early medicaments including
the latest 'Tablets of Compressed
Drugs'.

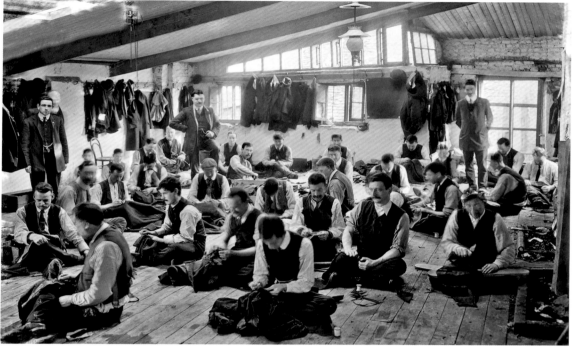

WATERFORD
Hearne & Co., George's Street
26 July 1907

Tailors at work at Hearne & Co., George's Street in Waterford City. Notice
the man forefront on the right ironing his workpiece with a cast-iron iron.

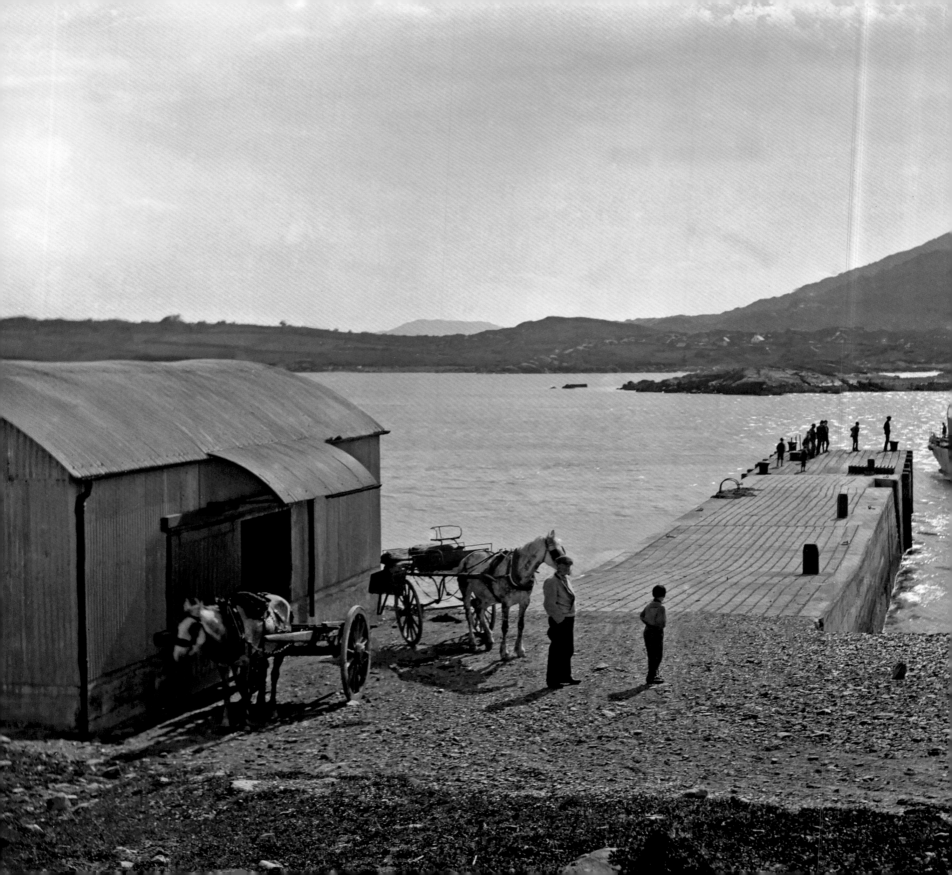

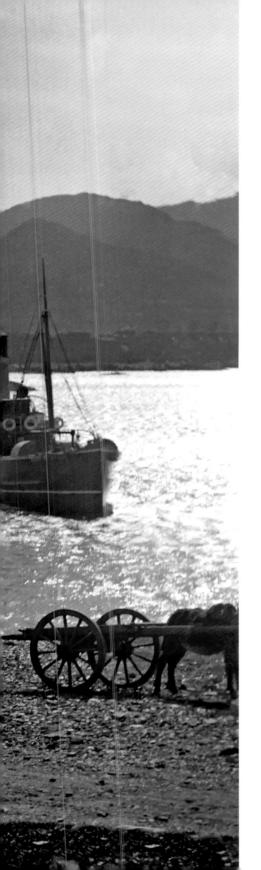

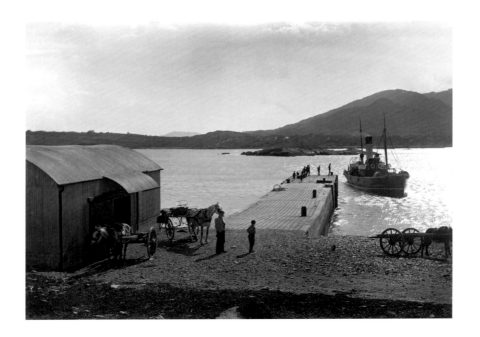

CORK
Pier at Adrigole
c.1910

The pier at Adrigole Harbour on the Beara Peninsula, County Cork. Adrigole, in Irish *Eadargóil*, means 'between two inlets'. The steamboat approaching is the *Princess Beara* owned by the Bantry Bay Steamship Company. The *Princess Beara* provided a goods only service between Castletownbere and Bantry with stops at Glengarriff, Adrigole and Bere Island. At Bantry, it connected up with trains from Cork City. Eventually, the *Princess Beara* was withdrawn from service in 1948.

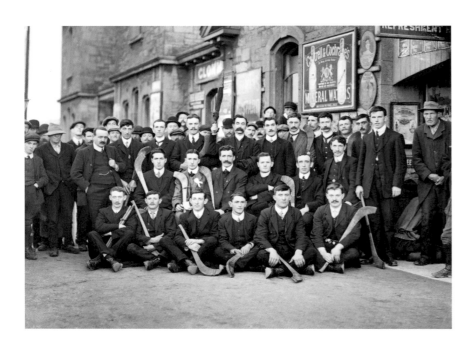

Tipperary Hurling Team

TIPPERAY

Clonmell train station

26 August 1910

The County Tipperary hurling team outside Clonmel train station. In the centre of the middle row sits Tom Semple, after whom Semple Stadium in Thurles was named.

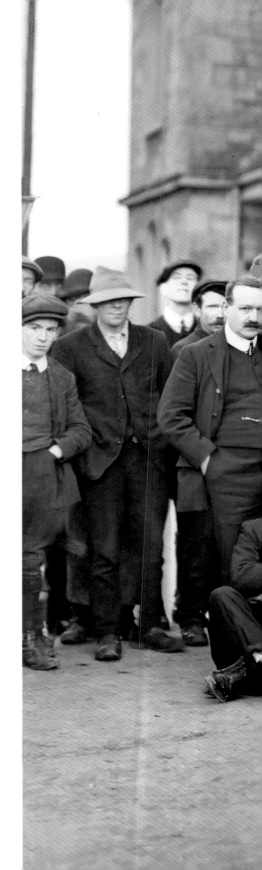

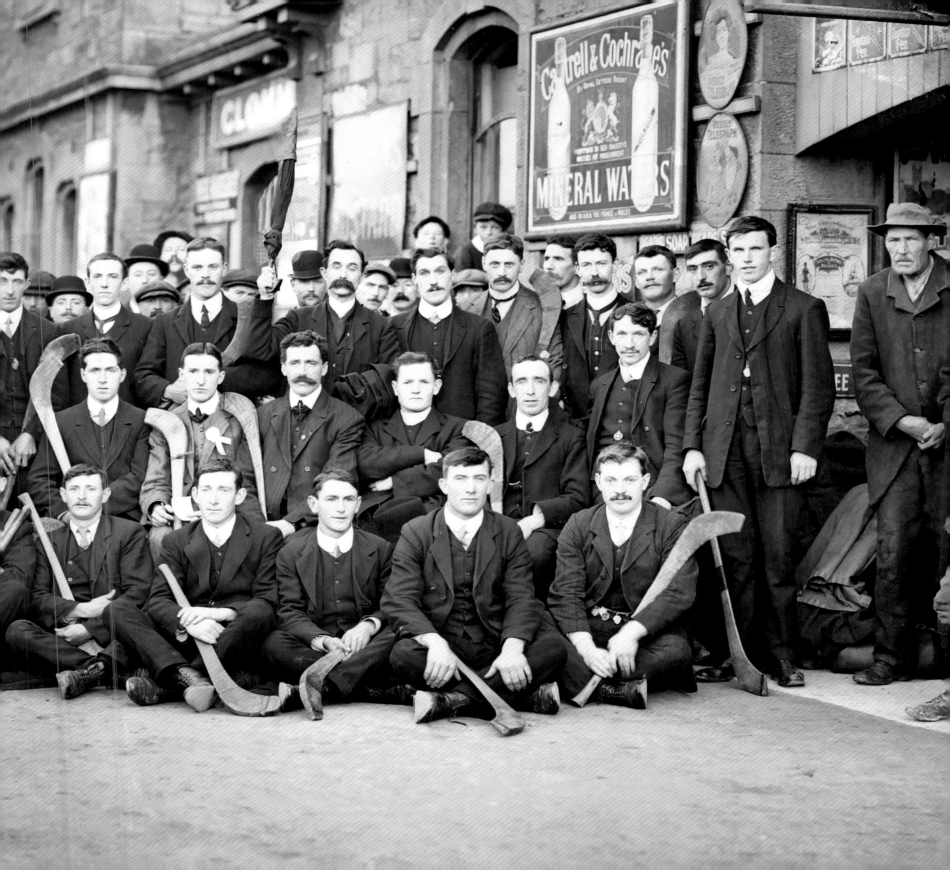

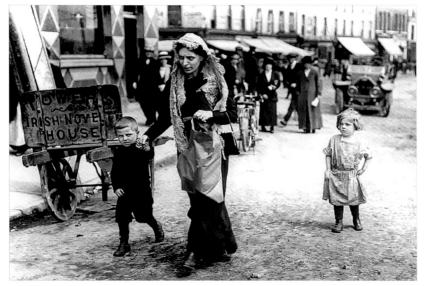

Sinking of the RMS Lusitania
CORK
8 May 1915

Annie Riley, with her four-year-old twins Ethel and Sutcliffe. They were on their way to England when their ship, the RMS *Lusitania*, was torpedoed by the German submarine, U20, on 7 May 1915.

CORK
Cobh
1915

Survivors of the RMS *Lusitania*. The *Lusitania* was torpedoed twelve miles off the Irish coast from the Old Head of Kinsale.

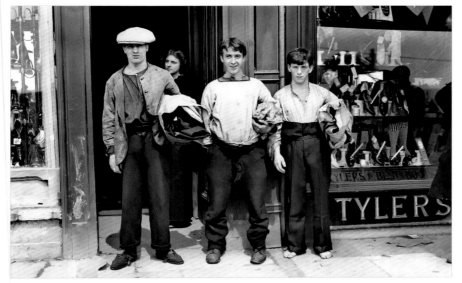

CORK
Cobh
1915

Survivors of the RMS *Lusitania* sinking, in Cobh. Of the 1,960 passengers on board, 1,198 people died.

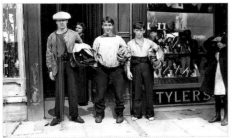

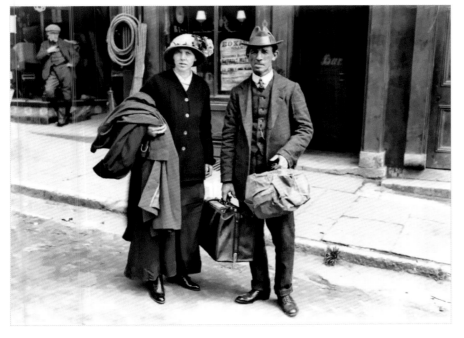

CORK
Cobh
1915

Many of the survivors and victims of the sinking were brought to Cobh, where there is now a memorial and heritage centre. Cobh was known as Queenstown from 1849 until 1920.

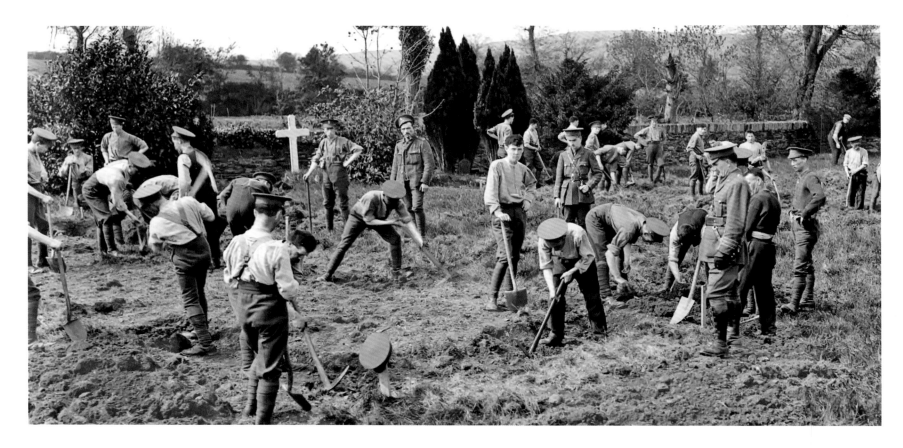

CORK
Old Town Cemetery, Cobh
1915

Soldiers dig graves in the Old Town Cemetery in Cobh for the victims of the sinking of the RMS *Lusitania*.

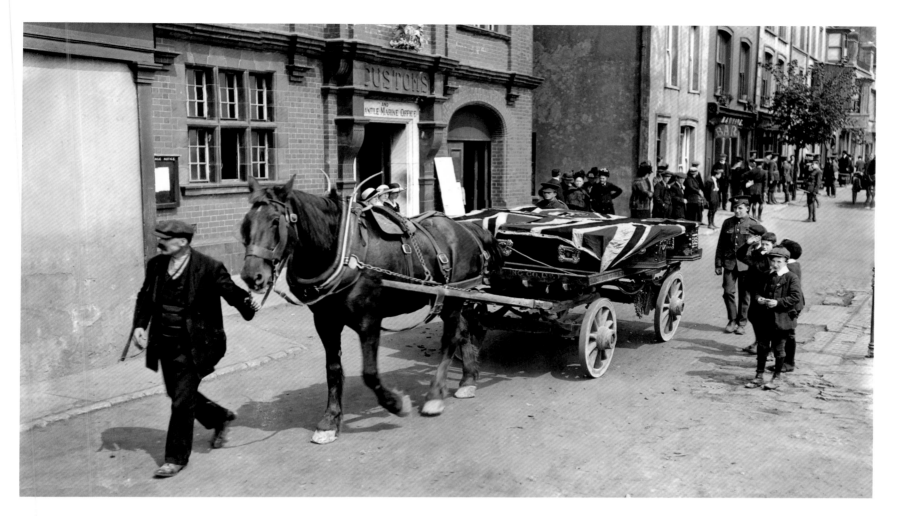

CORK
Lynch's Quay, Cobh
1915

The British flag is draped over coffins on Lynch's Quay,
Cobh, County Cork, where many victims of the sinking
were buried. The red brick building in the background is
the 1896 Custom House.

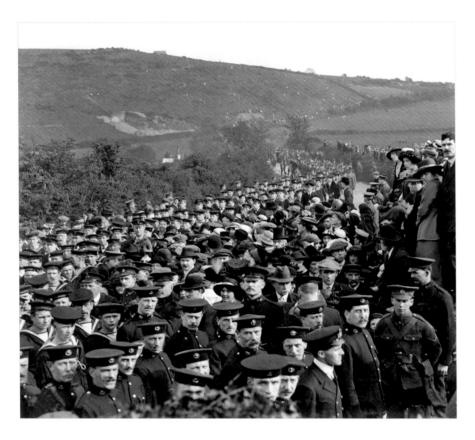

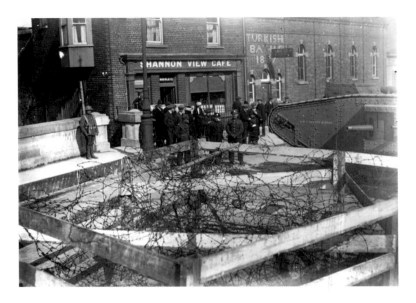

CORK
Cobh
1915

A funeral was held at the Old Town Cemetery in Cobh for the victims of the sinking of the RMS *Lusitania*.

LIMERICK
*Wellesley Bridge
(now Sarsfield Bridge)*
April 1919

A British military checkpoint featuring the HMT Scotch and Soda tank on Wellesley Bridge in Limerick City when the city was a self-declared soviet for twelve days. Only people with a pass could gain access through these military checkpoints. In the background is the Shannon View Café and the 1887 Turkish Baths.

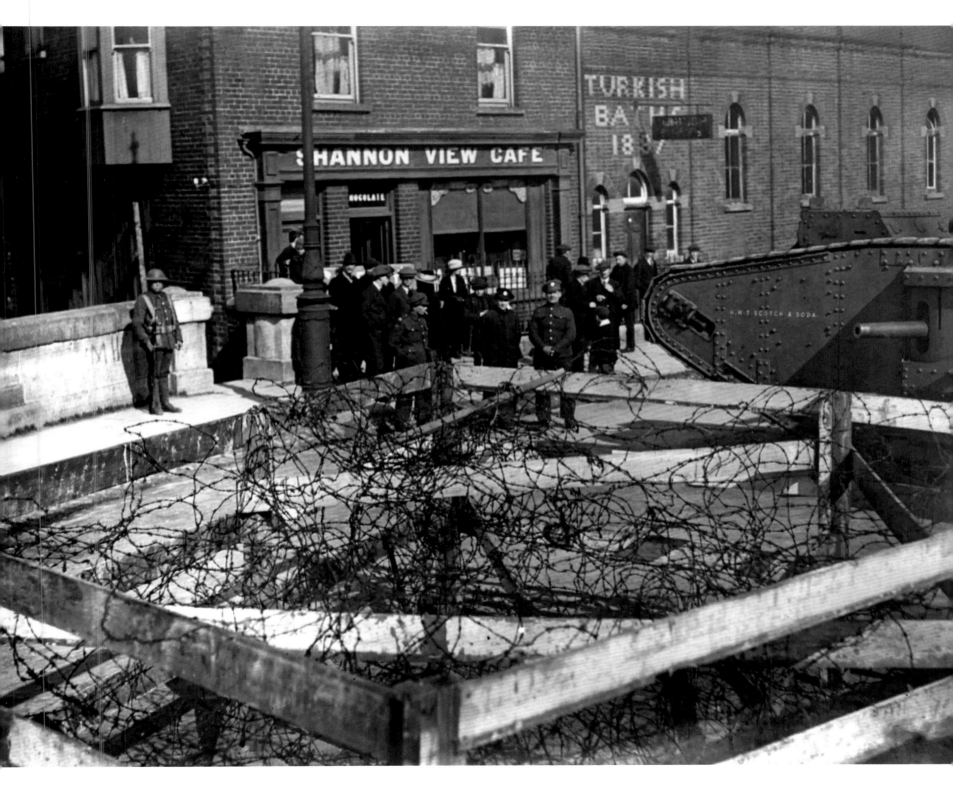

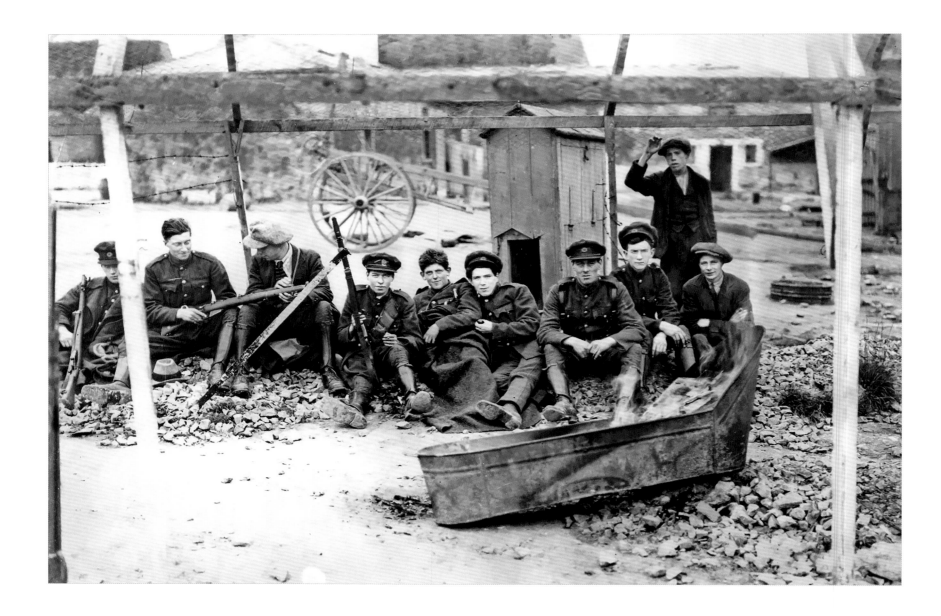

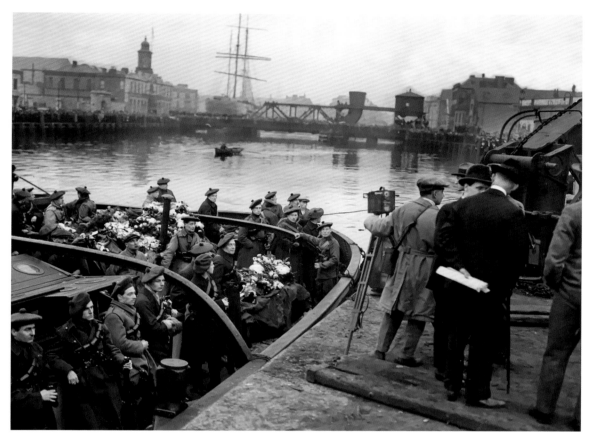

LIMERICK

Ordnance Barracks,
Mulgrave Street
24 July 1922

National Army soldiers warm themselves in front of a fire in an old bathtub at the Ordnance Barracks, Mulgrave Street in Limerick City.

CORK

Custom House Quay, Cork City
29 October 1920

This photograph shows the body of the Lord Mayor of Cork, Terence MacSwiney, as it arrives at Custom House Quay on the British Admiralty tug boat, the *Mary Tavy*, having been taken directly to Cork from England on board the HMS *Rathmore*. MacSwiney had died after seventy-four days on hunger strike in Brixton Prison, and here his body is under the guard of fifty auxiliary policemen who had accompanied the tug upriver from Cobh.

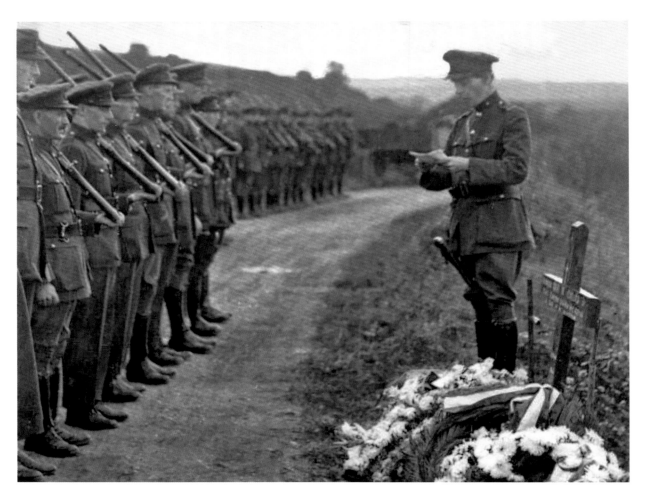

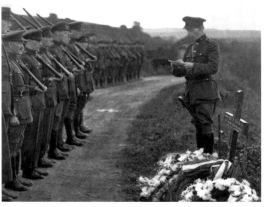

CORK
Béal na Bláth
1922

Irish Republican Army soldiers attend the mass service for Michael Collins. Collins was killed here at Béal na Bláth, County Cork, in an ambush by anti-Treaty Irish Republican Army forces on 22 August 1922. It's thought that the soldier delivering the oration could be General Richard James Mulcahy, who was the commander-in-chief of the Irish Republican Army.

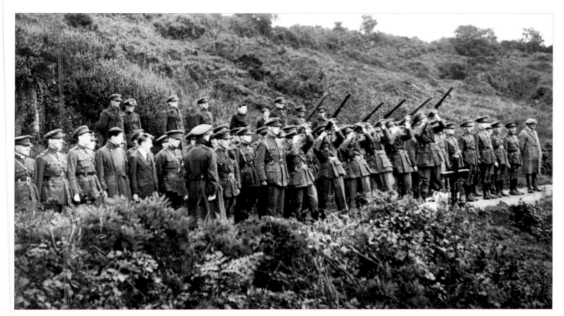

CORK
Béal na Bláth
1922

Irish Republican Army soldiers fire a volley on the Béal na Bláth roadside in County Cork.

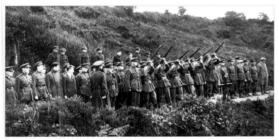 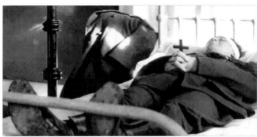

CORK
Shanakiel hospital
August 1922

Michael Collins at Shanakiel hospital, County Cork. A Dr Ahern was the first to examine Collins' body and pronounced him dead. Dr Ahern's army experience led him to conclude that the fatal wound had been caused by a dum-dum bullet.

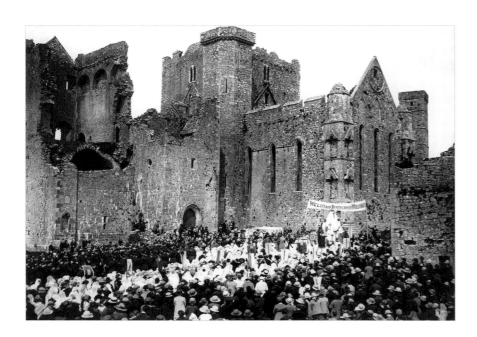

TIPPERARY
The Rock of Cashel
c.1923

The Rock of Cashel in Cashel, County Tipperary, featuring a Corpus Christi procession. The Benediction was given to the people outside the church door for the first time in 300 years.

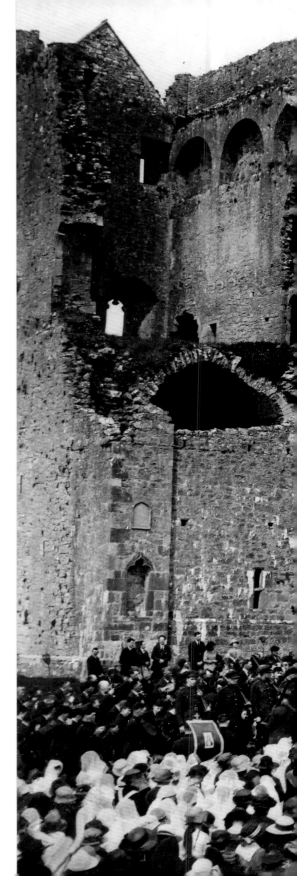

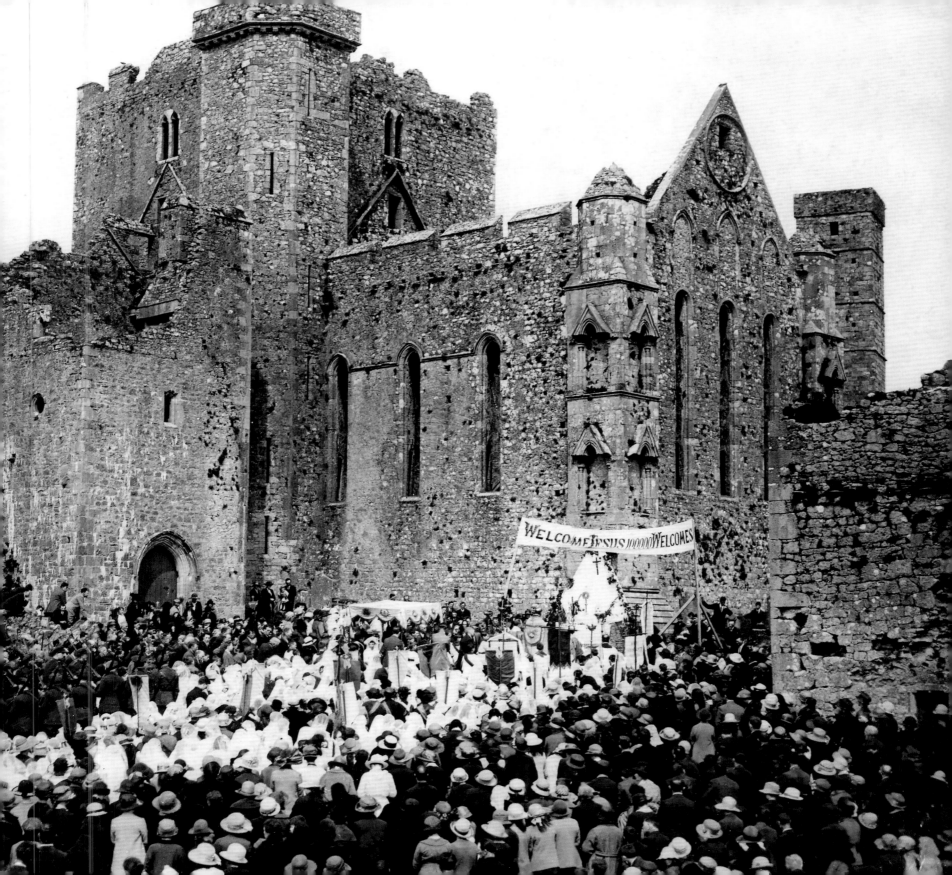

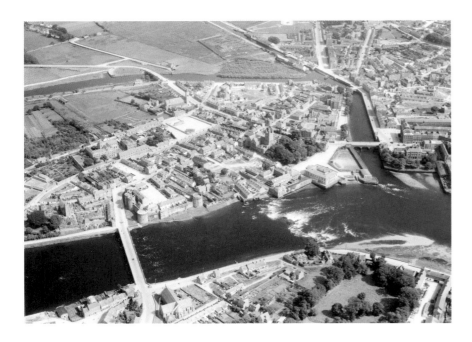

LIMERICK

King's Island

5 August 1947

An aerial photograph of King's Island on the
River Shannon in Limerick City featuring a host of
landmarks such as Thomond Bridge, King John's Castle
and St Mary's Cathedral. In the background is the old
Corbally Canal and O'Brien's Park on Clare Street.

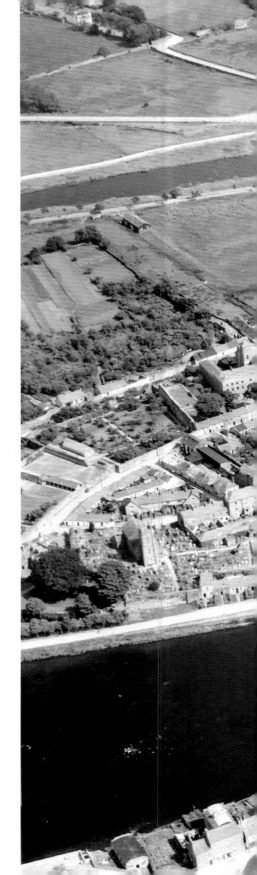

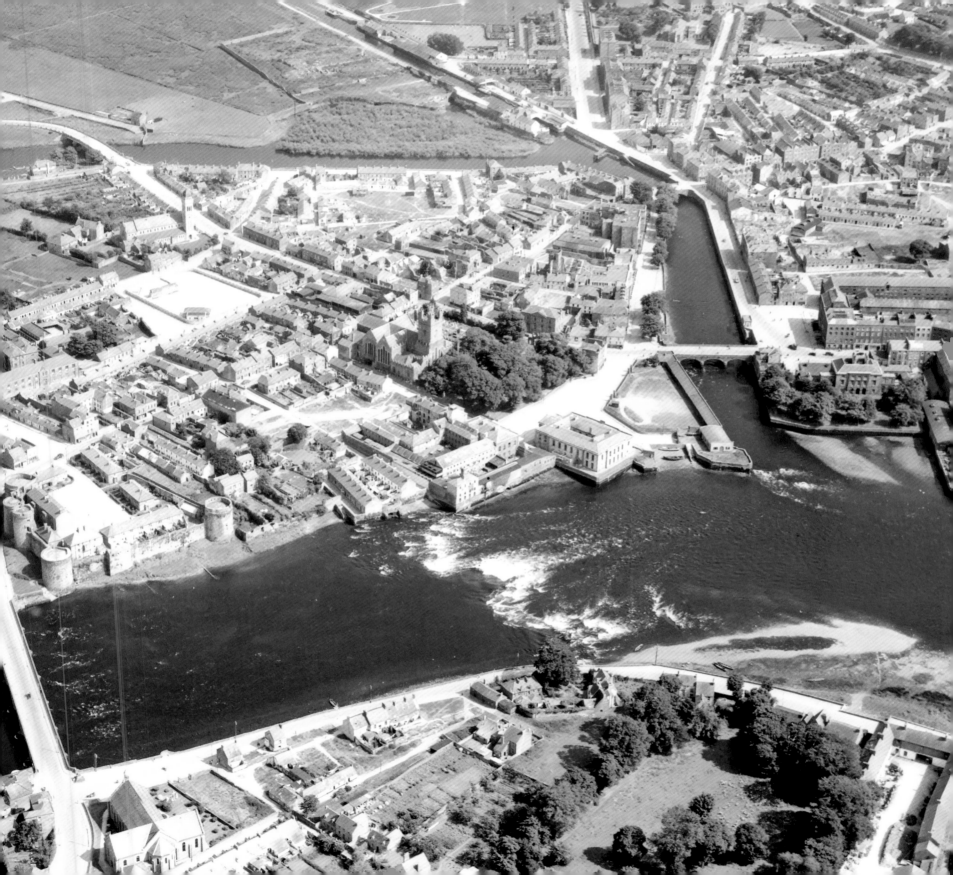

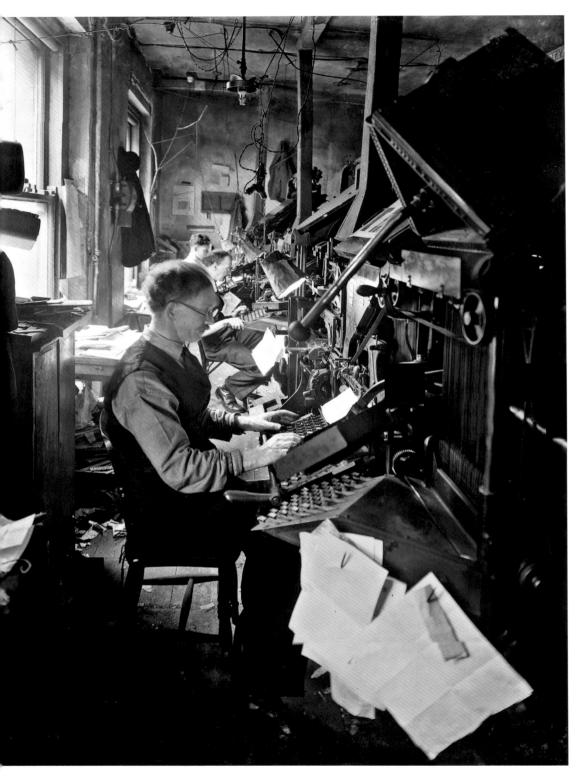

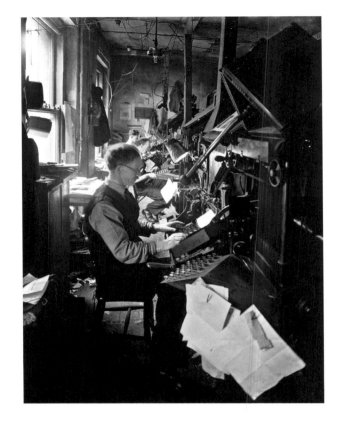

WATERFORD
Waterford News
1938

Typesetters work on their Intertype A-3 SM Linecaster machines at the *Waterford News* in Waterford City. The publication was formed on 22 September 1848.

CORK
Buttevant
1954

A beautifully decorated caravan en route to the Cahirmee Horse Fair at Buttevant, County Cork. The ancient horse fair was originally held at the Fair Field of Cahirmee, some two miles to the east of the town. In 1921 it was transferred into the town and is still held every year on 12 July.

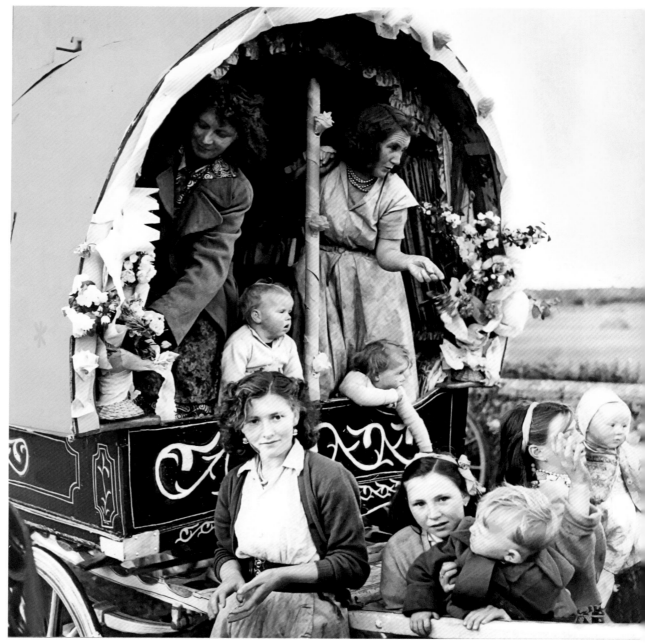

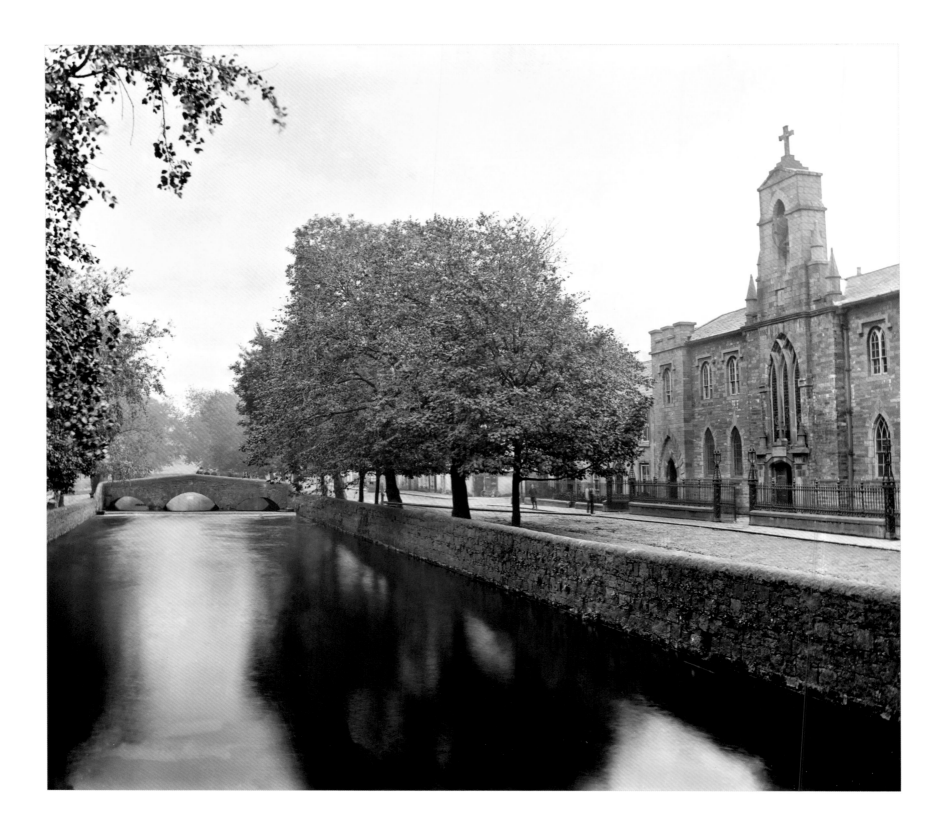

CONNACHT

or Connachta *in Irish*

*is one of the four traditional provinces of Ireland situated
in the west of Ireland.*

Galway | Mayo | Roscommon

Sligo | Leitrim

THE
PHOTO COLOURISATION
and RESTORATION
PROCESS

The key technology used in the photo colourisation process is called DeOldify, which is an open-source, deep-learning artificial intelligence model created by deep-learning programmers Jason Antic and, later, Dana Kelley. DeOldify itself is a self-attention GAN-based machine learning tool that learns from millions of coloured images in order to decide what colours should be applied to black and white images and videos.

DeOldify is great for colourising objects such as skin, grass, trees, skies and water, but for any object that DeOldify cannot predict a colour for, then the deep-learning software uses brown as an average colour. This is where post-production image editing software – such as Photoshop and GIMP – is used to layer the photograph and manually adjust and hand paint all the incorrect colours to capture and reproduce the right atmosphere of the photo.

Making a choice as to the correct colour is where painstakingly researched expertise and awareness comes into play, enabling the verification of colours via colour or written sources to get every tiny detail and texture exactly right. In addition, this level of research is utilised in this book's photo narratives, which provide context that elevates a photo to a new level beyond that of just another colourised photo. The research process involves extensive internet searches and numerous visits to various art galleries, archives, libraries and museums in order to source the background and the historically correct colours on objects such as clothes, army tanks, military uniforms and advertising street signage that might feature in the photo.

Internet tools such as Google Street View and the Ordnance Survey Ireland historical maps on their GeoHive spatial data platform were used extensively in this project to verify objects such as buildings and street names plus present-day streetscapes and the colours of buildings and scenery. Image editing software is also used at this stage of the process to faithfully restore these historical photos by removing blemishes such as tears, scratches, dirt and any other signs of photographic ageing.

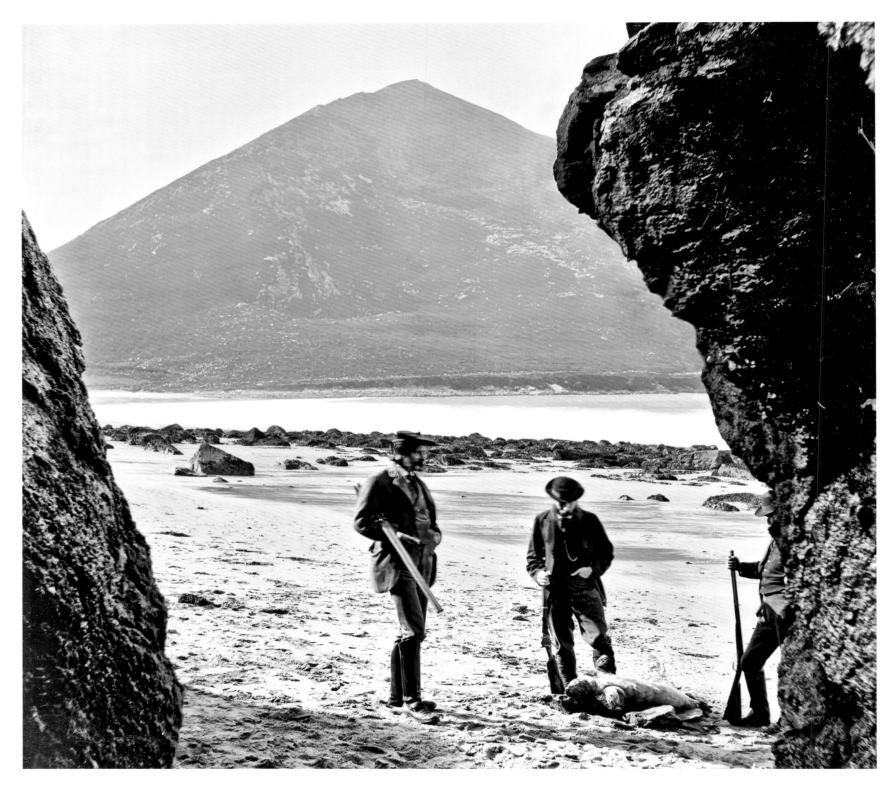

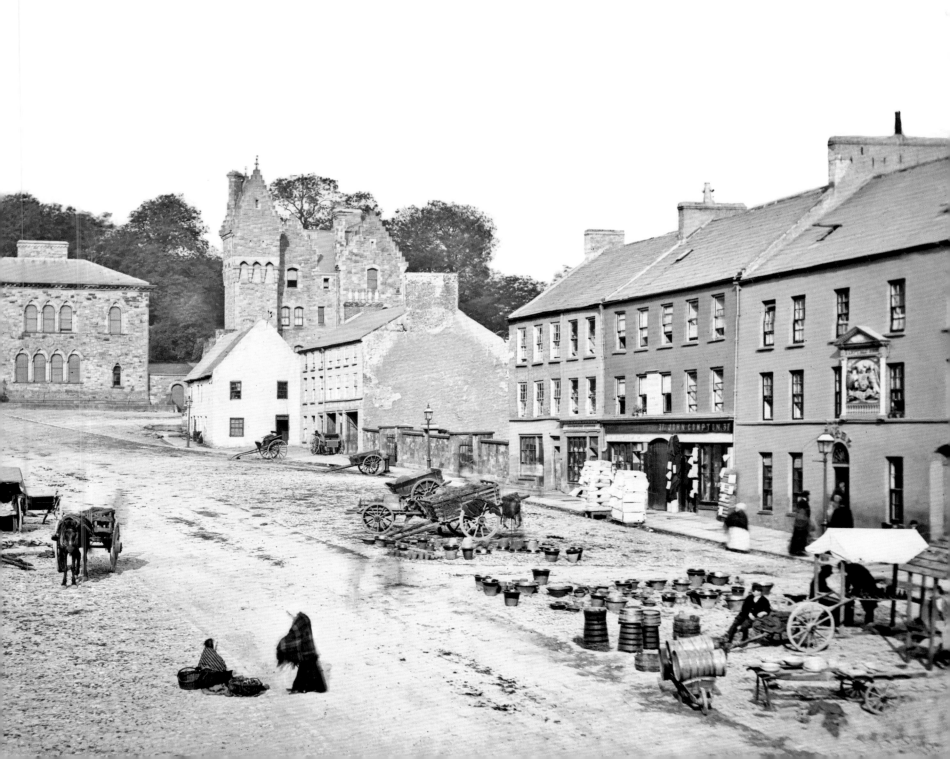

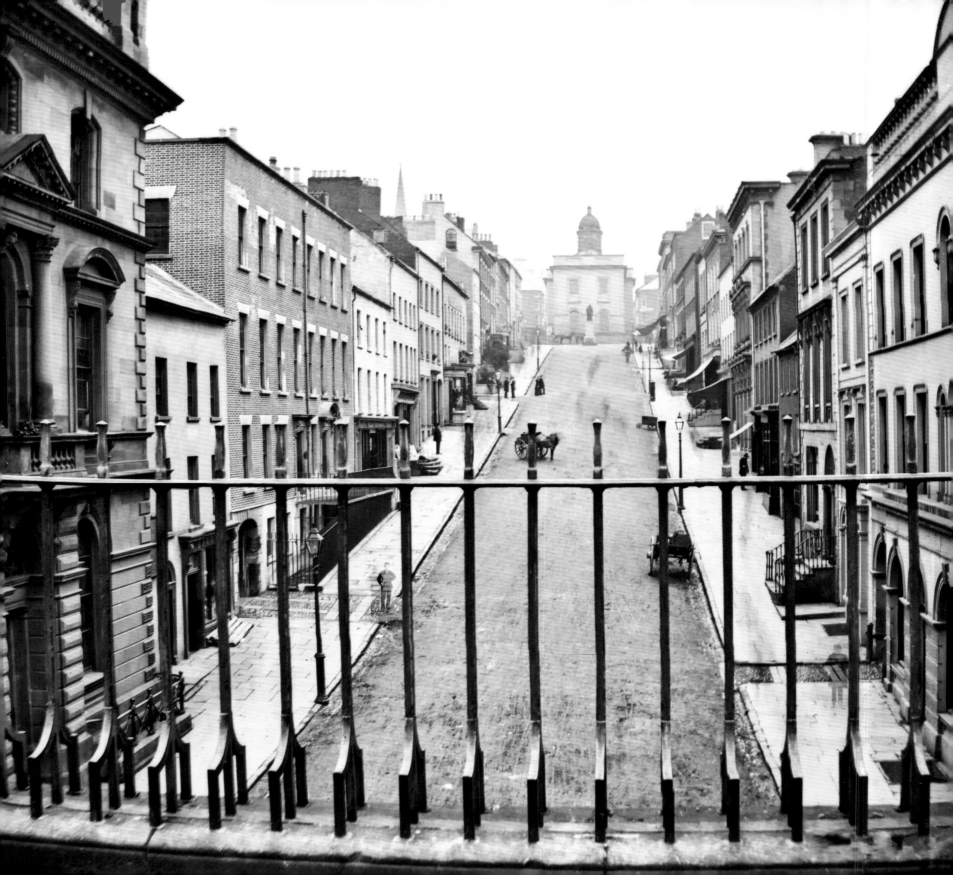

DERRY/LONDONDERRY
Shipquay Street
c.1900

Shipquay Street in Derry/Londonderry. In the background is the old town hall which sadly burned down in 1904. The railing in the foreground is the upper section of the Shipquay Gate which was one of the four original gates into the seventeenth century city. The structure shown here – which still stands today – was built in 1805.

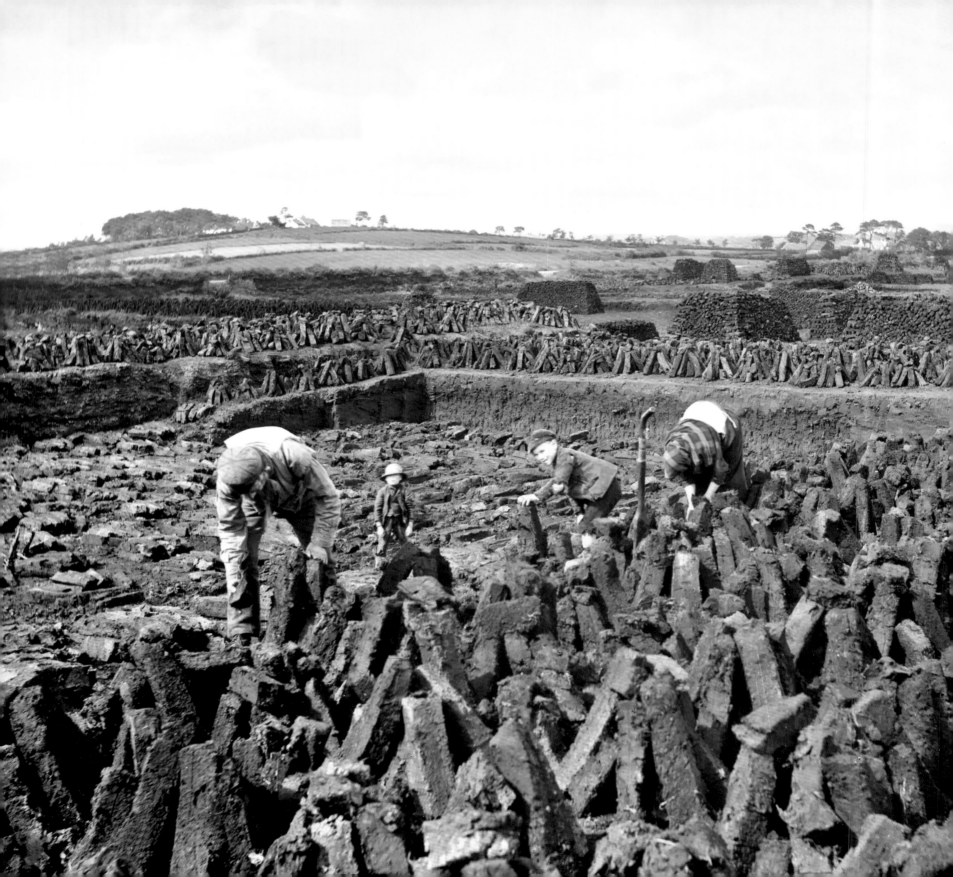

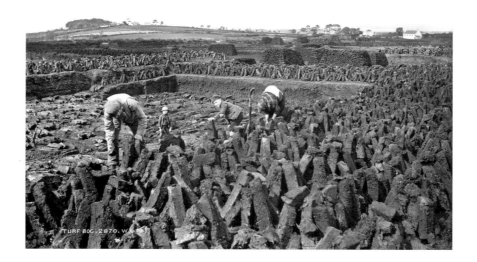

ANTRIM

Ballymena

c.1885

A family foot the turf in Ballymena, County Antrim. The small village in the background with the thatched roof cottages is called Rasharkin, which is located thirteen kilometres south of Ballymoney, near Dunloy and Kilrea.

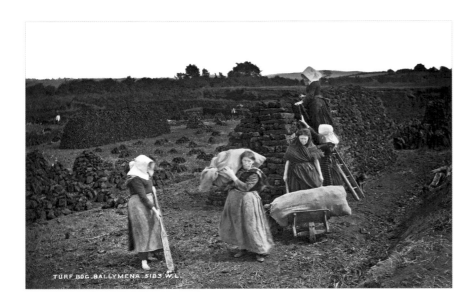

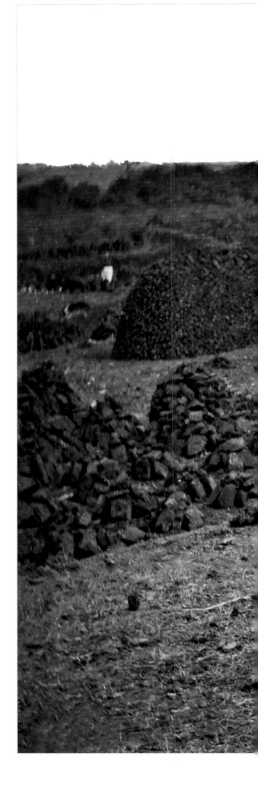

ANTRIM

Ballymena

c.1890s

Harvesting the Turf in Ballymena. Bogs were common throughout Ireland and in the summer months people would cut turf to provide fuel for the year ahead. The turf was cut using a specially shaped tool, known as a sleán or slane, and the cut sod was laid out to dry away from the turf bank, before being made into stacks or reeks.

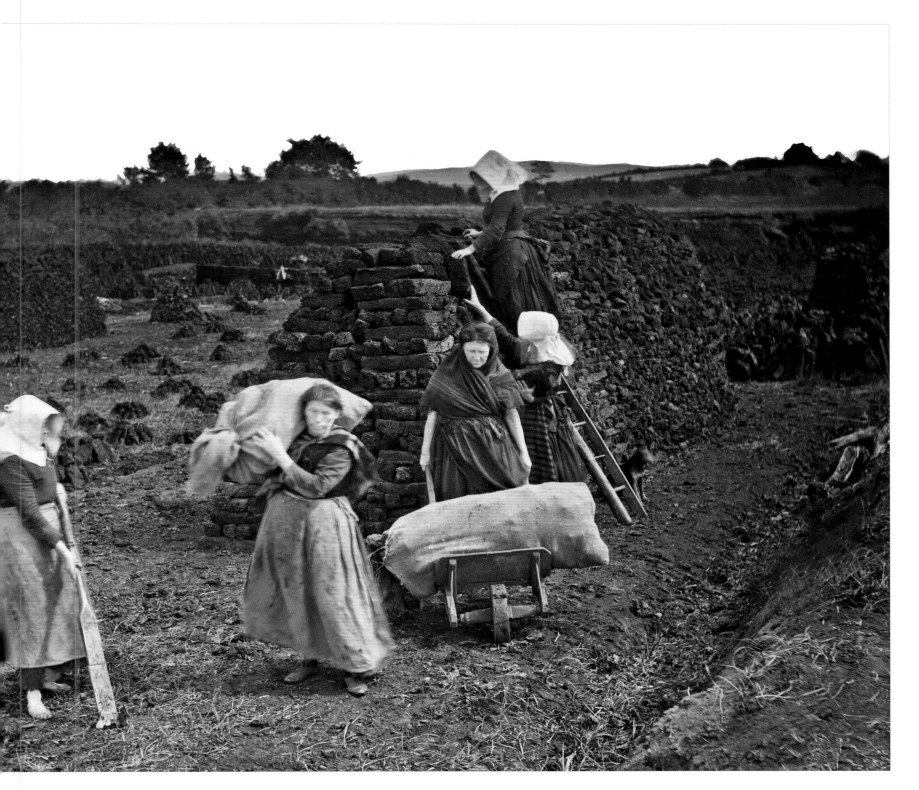

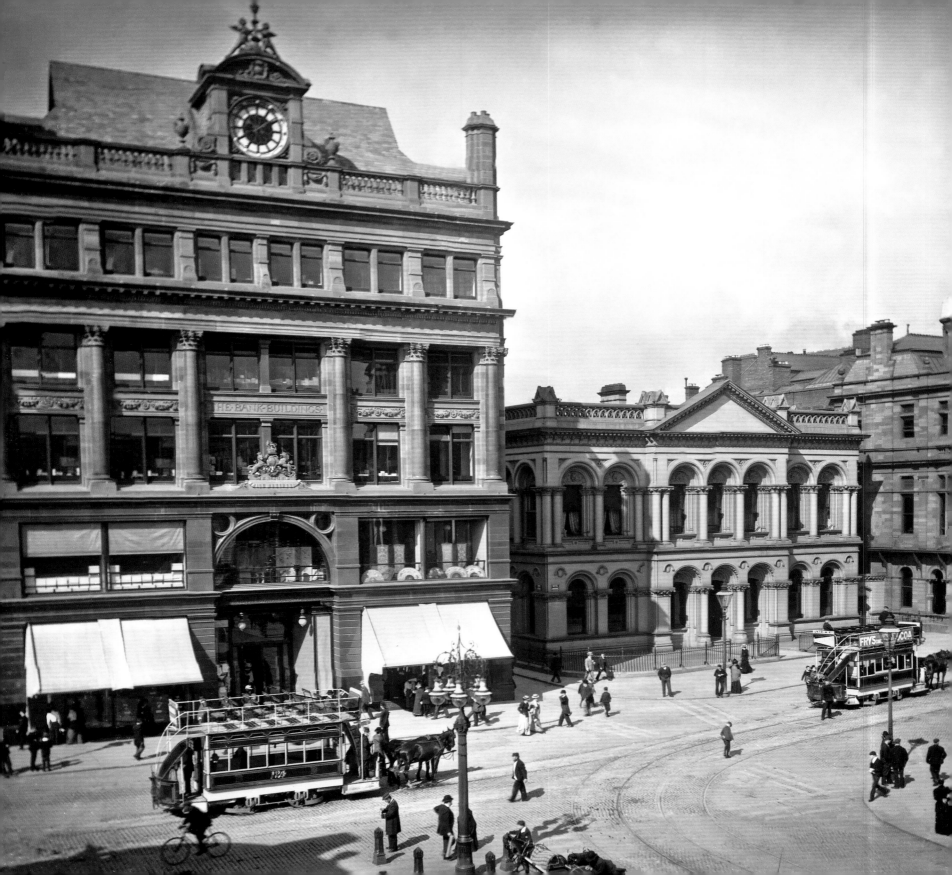

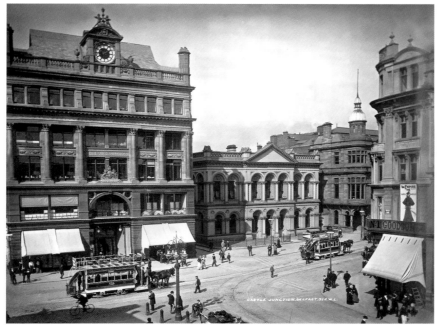

ANTRIM
Castle Junction, Belfast
c.1906

Castle Junction in Belfast City featuring the magnificent Bank Buildings and the elegant Belfast Tramways Company horse-drawn trams. The Bank Buildings was designed and built between 1899 and 1900 by architect W. H. Lynn. First used as a department store and warehouse, owned by the firm of Robertson, Ledlie, Ferguson & Co, the building stands on the site of a bank erected in 1785, from which it takes its name. On 28 August 2018, during a £30 million two-year renovation, the building was gutted by fire, severely damaging most of the internal structure. Thankfully the fashion retailer Primark, who had owned the building since 1979, opted to restore the building to its 1900 appearance. The building on the far right with the cupola and spire is the Ulster Reform Club which opened its doors for the first time on 1 January 1885.

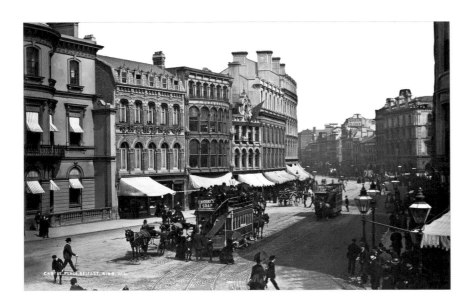

ANTRIM

Castle Place, Belfast

c.1890

Castle Place with its elegant gaslight lamps in Belfast City, County Antrim. In the background, the signage of the Robinson & Cleaver department store is clearly displayed on the side of the building. The shop was opened on 30 Castle Place in 1874, before moving to High Street a few years later.

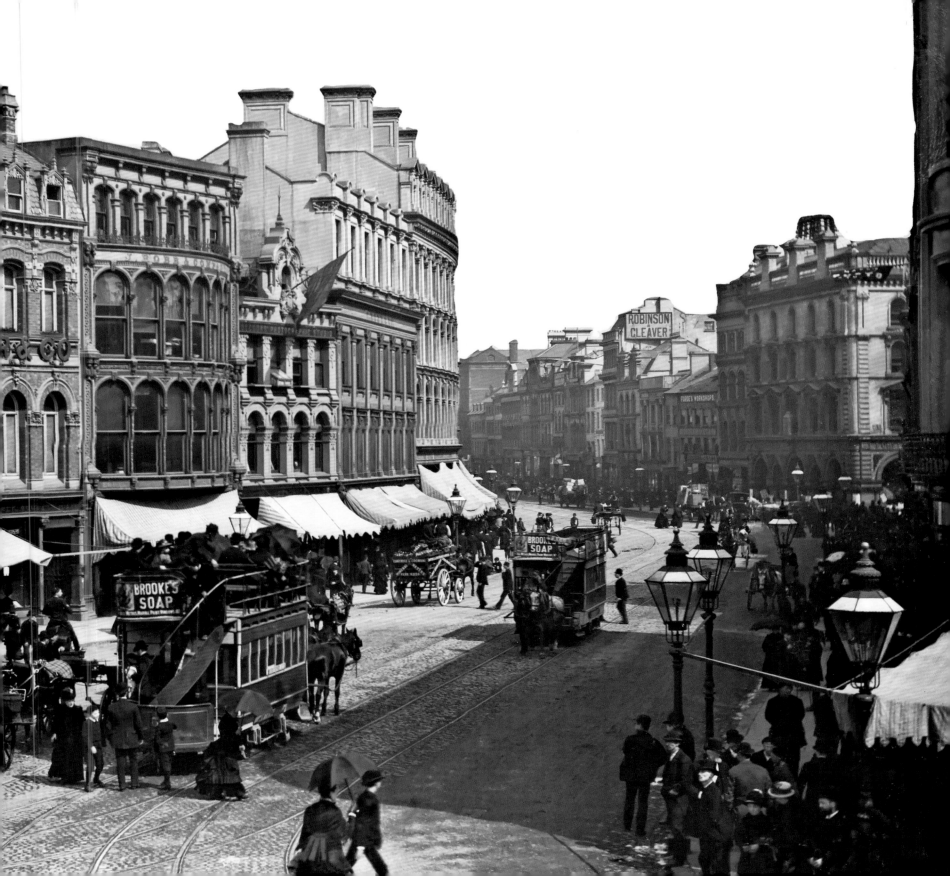

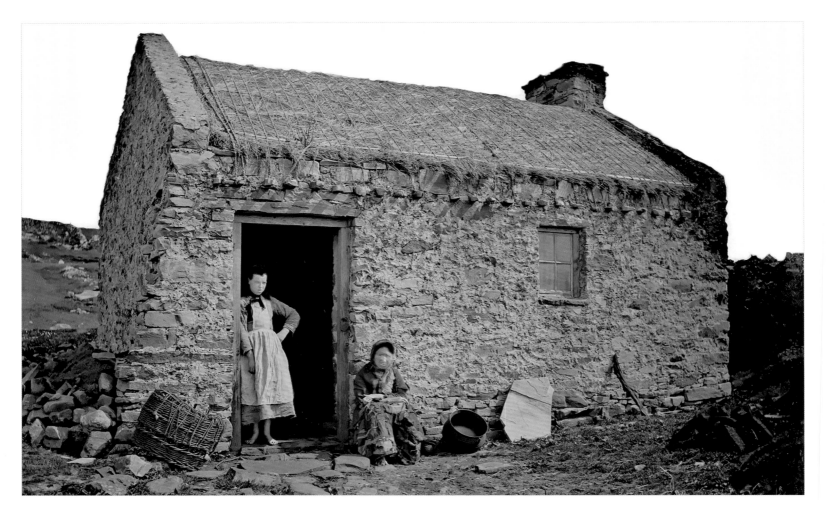

DONEGAL
Gaoth Dobhair
c.1890s

Gweedore is officially known by its Irish name, Gaoth Dobhair. 'Gaoth' is an inlet of the sea at the mouth of the River Crolly, known as An Ghaoth.

DONEGAL

Gaoth Dobhair

c.1890s

The cottage roof seen here is made using a rope thatching technique known locally as 'Bachan'. The thatch is not secured directly to the roof, but held in place by a series of ropes that lie over the thatched surface and are tied to the tops of the walls or held down by large stones. This type of roof thatching was popular along the western coast, owing to the strong winds.

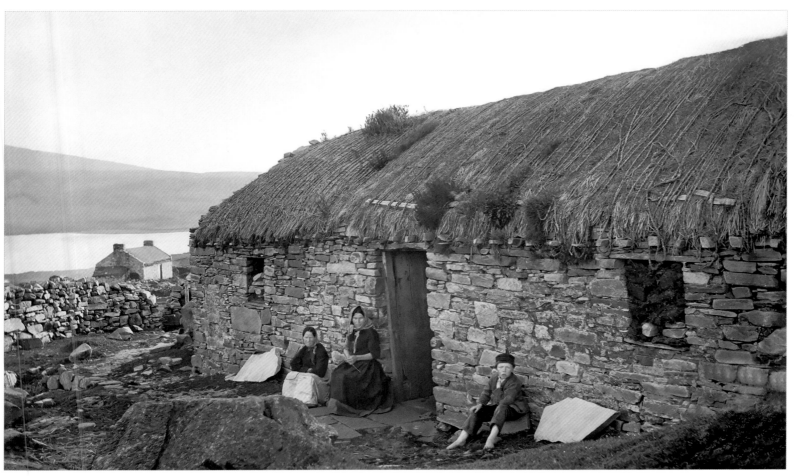

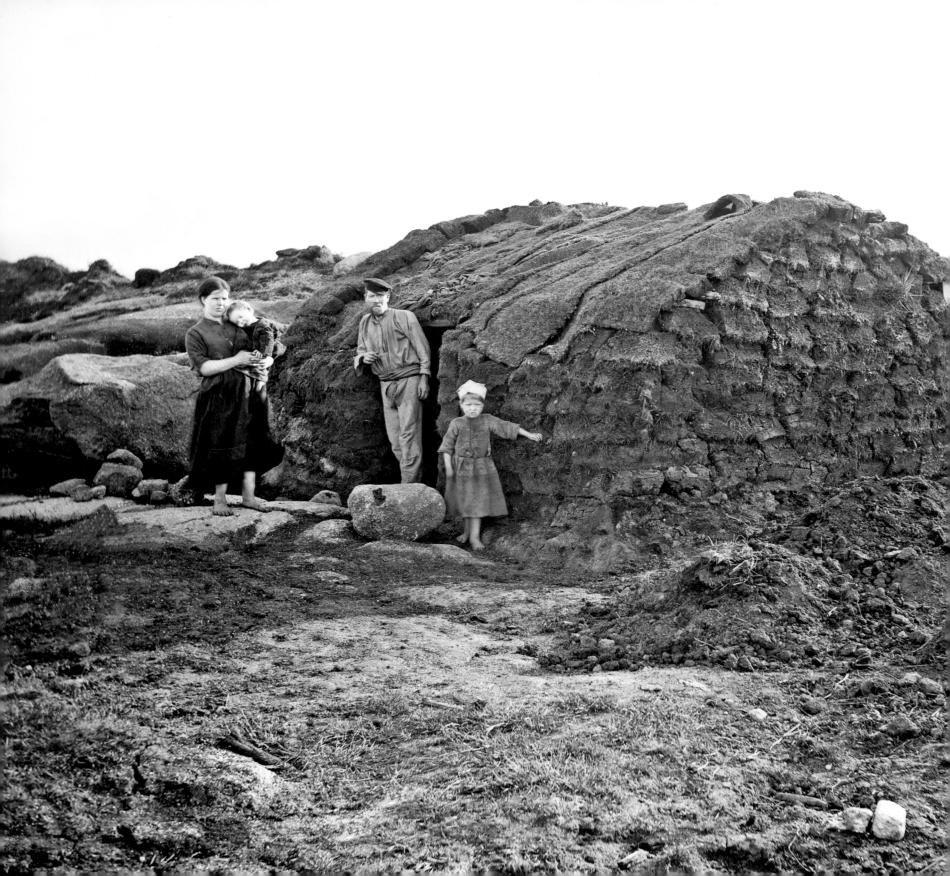

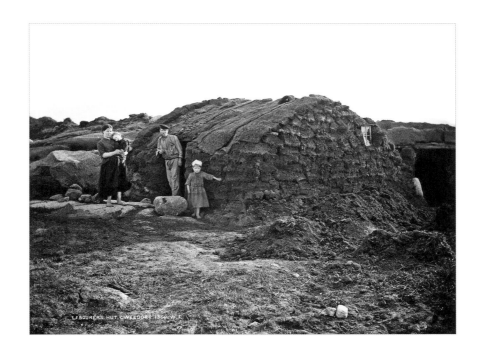

DONEGAL
Gaoth Dobhair
c.1887

A labourer's turf hut in Gaoth Dobhair, County Donegal. Around this time, local newspapers reported that a farm labourer named Daniel O'Donnell had made a temporary turf hut for his family in the area after they were evicted from the Hill Estate. It's possible this photograph is of Daniel and his family. However, these mass evictions in the late nineteenth century meant that many people were homeless, and temporary structures like the one depicted here were not uncommon. The window on the gable wall of the turf hut was salvaged from the cottage from which the O'Donnell family were evicted.

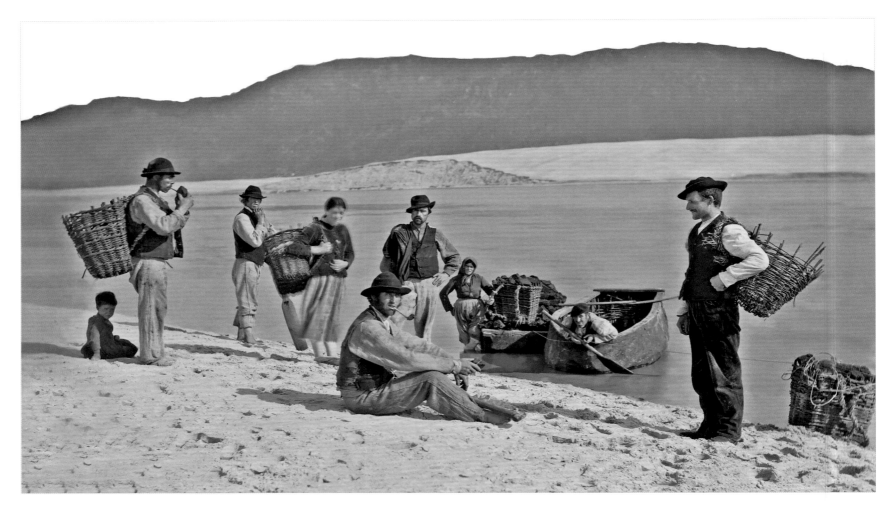

DONEGAL
Loughros Point, Ardara
c.1890s

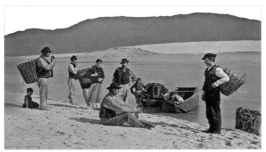

The local fishermen and boys of Loughros Point, Ardara. The individuals in the photo were also turf cutters, who harvested peat on the Slievetooey (Sliabh Tuaidh) mountain on the southern side of Loughros Beag Estuary. Turf cutting on Slievatooey mountain stopped around 1916, when the Irish Land Commission allocated plots at Tullycelave, just outside Ardara.

DONEGAL
Ardara
c.1890s

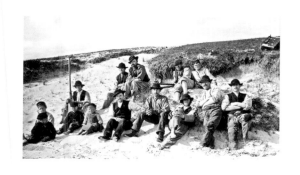

The local fishermen and boys of Ardara (Ard an Rátha, 'height of the fort'), County Donegal. Close by is the Owenea River, which is one of the best spring salmon rivers in the country and runs for some thirteen miles to Lough Ea in the west of the Croaghs, to Loughrosmore Bay at Ardara.

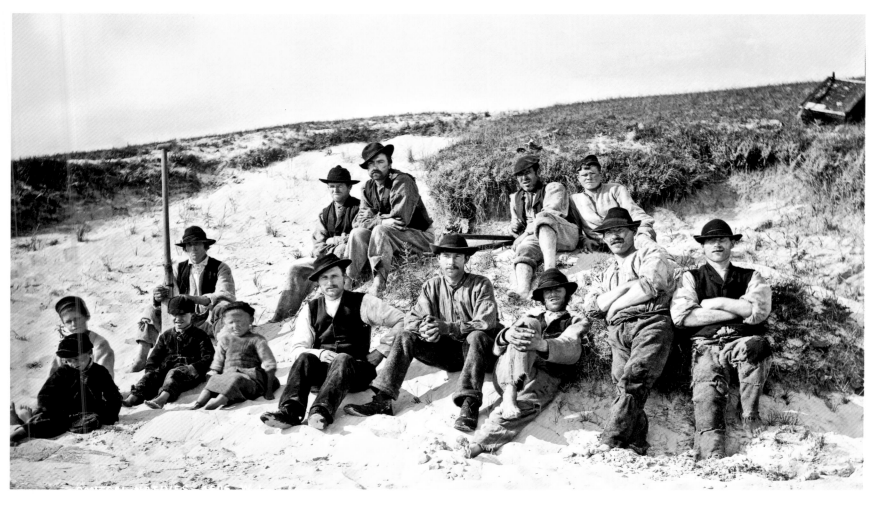

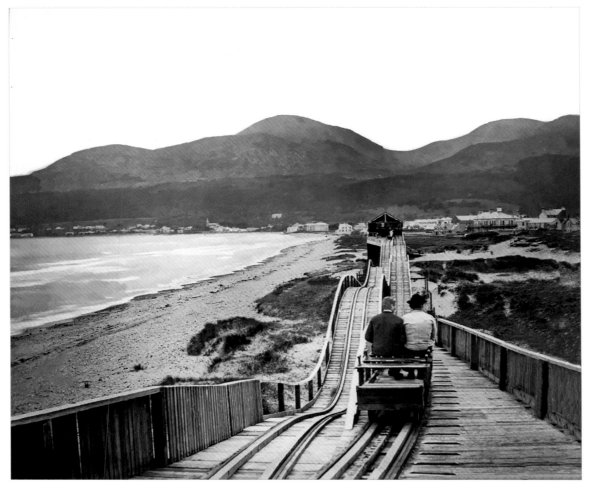

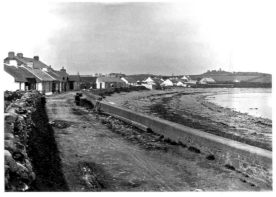

DOWN
Coney Island, Ardglass
c.1900

The 1851 Isabella Tower in the background was built by Aubrey William Beauclerk for his sickly daughter, Isabella. Northern Irish singer-songwriter Van Morrison wrote the song 'Coney Island' and included it on his 1989 album, *Avalon Sunset.*

DOWN
Newcastle Beach
c.1890

The beautiful Newcastle Beach in Newcastle, County Down, featuring a rack and pinion switchback rollercoaster with the Mountain of Mourne beyond. In this particular type of rollercoaster, the carriages travel to the highest point, switch lanes and let gravity do the rest.

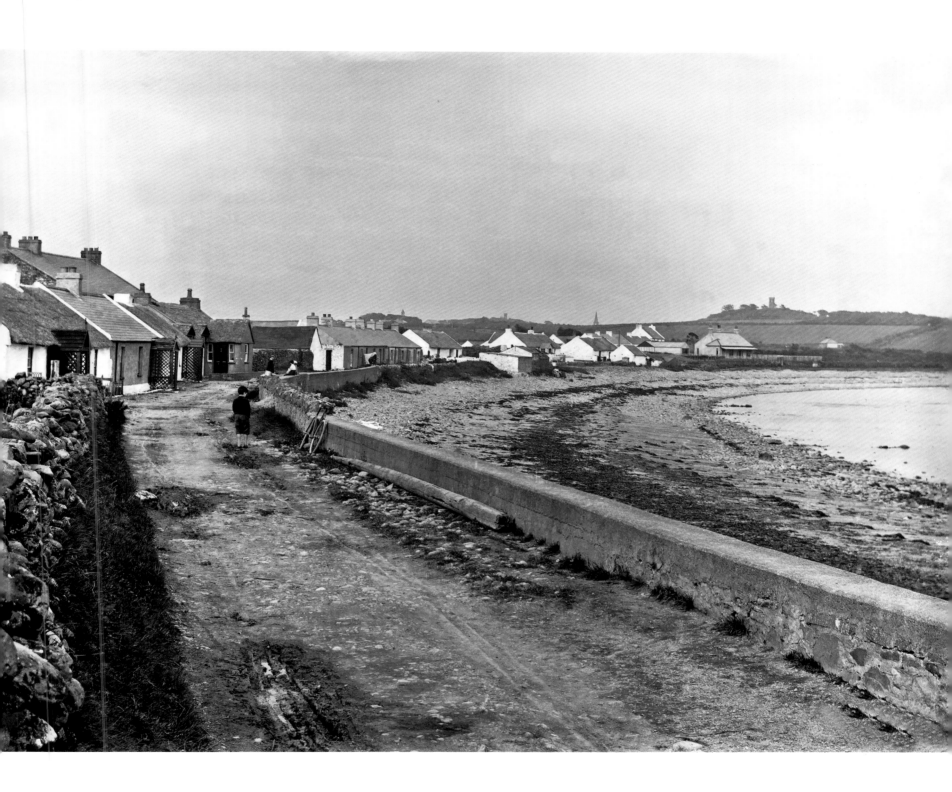

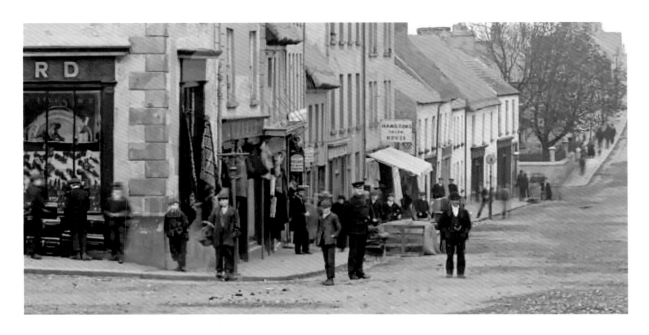

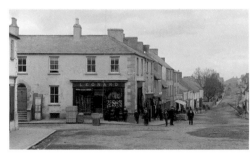

CAVAN

Main Street, Belturbet

c.1899

The Diamond on Main Street in Belturbet, a town situated between the counties of Cavan and Fermanagh. Belturbet (Béal Tairbirt, 'mouth of the isthmus') is historically one of the best places for crossing the River Erne. It was a thriving urban centre, whose prosperity relied heavily on its position on the Erne. One can also see a smiling Royal Irish Constabulary policeman and some of the last traditional Irish urban thatched roofs.

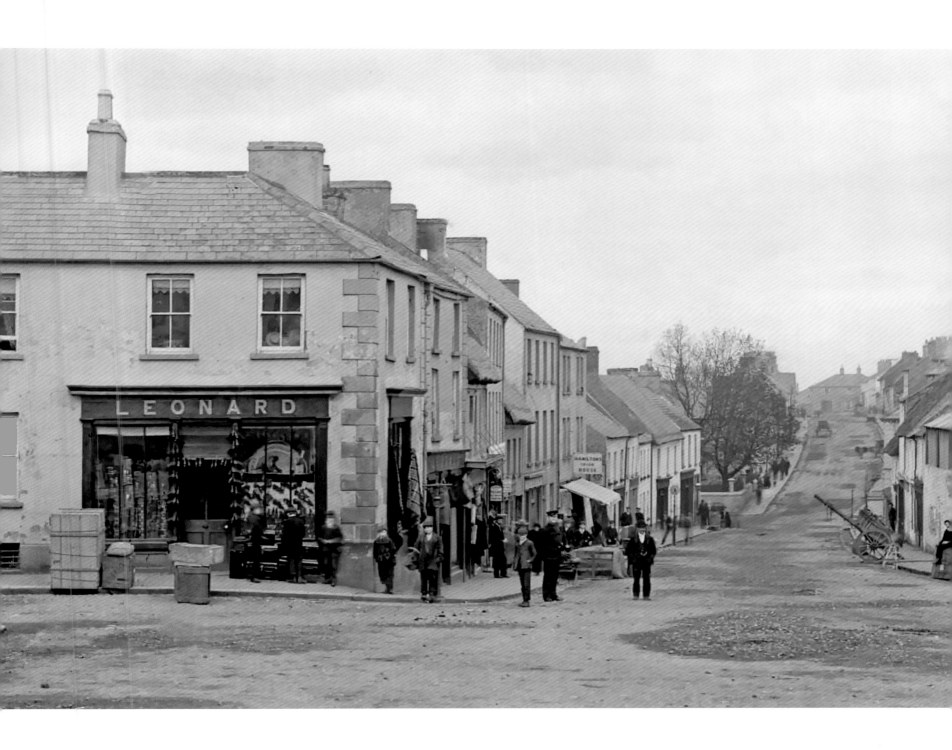

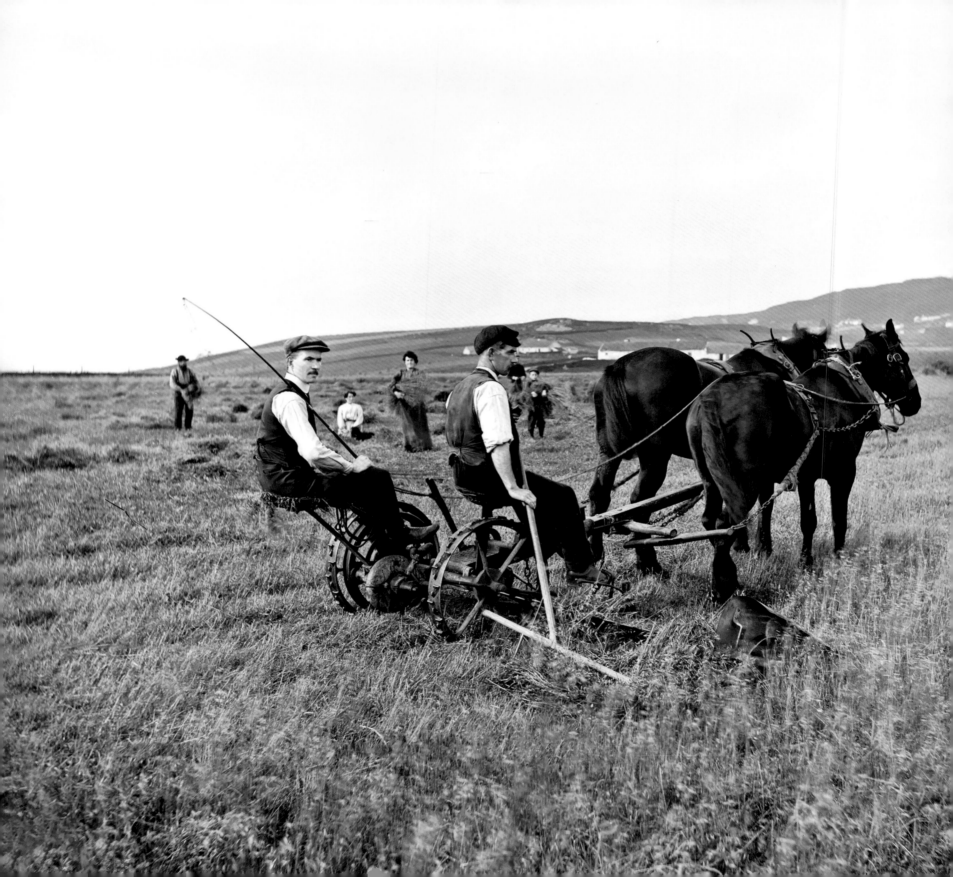

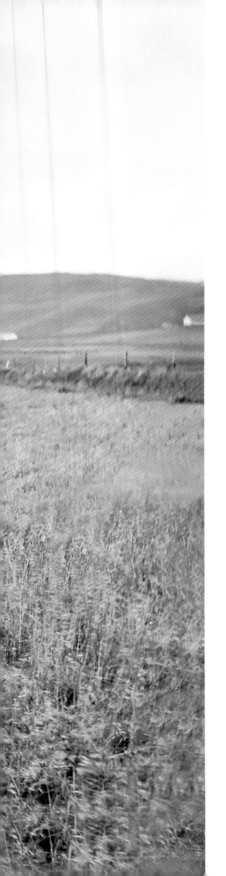

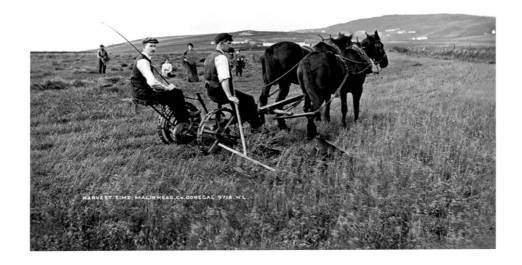

DONEGAL
Malin Head
c.1890s

Harvest time in the townland of Ballygorman in Malin Head, County Donegal. These workers are harvesting oats, which were then cut into small clumps for the people in the background to tie up in sheaves before putting three or four together as a stook.

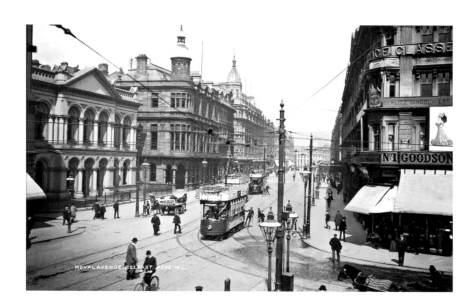

ANTRIM
Royal Avenue, Belfast
c.1906

Royal Avenue viewed from Castle Junction in Belfast City featuring the Provincial Bank of Ireland (now Tesco) and the red sandstone Ulster Reform Club. Belfast City's first trams, from 1872, were horse-drawn and initially owned and operated by the Belfast Street Tramways Company.

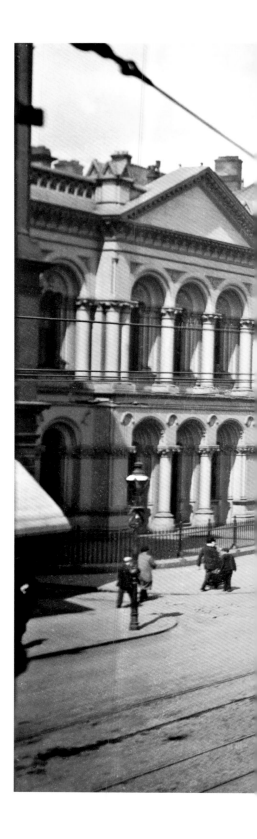

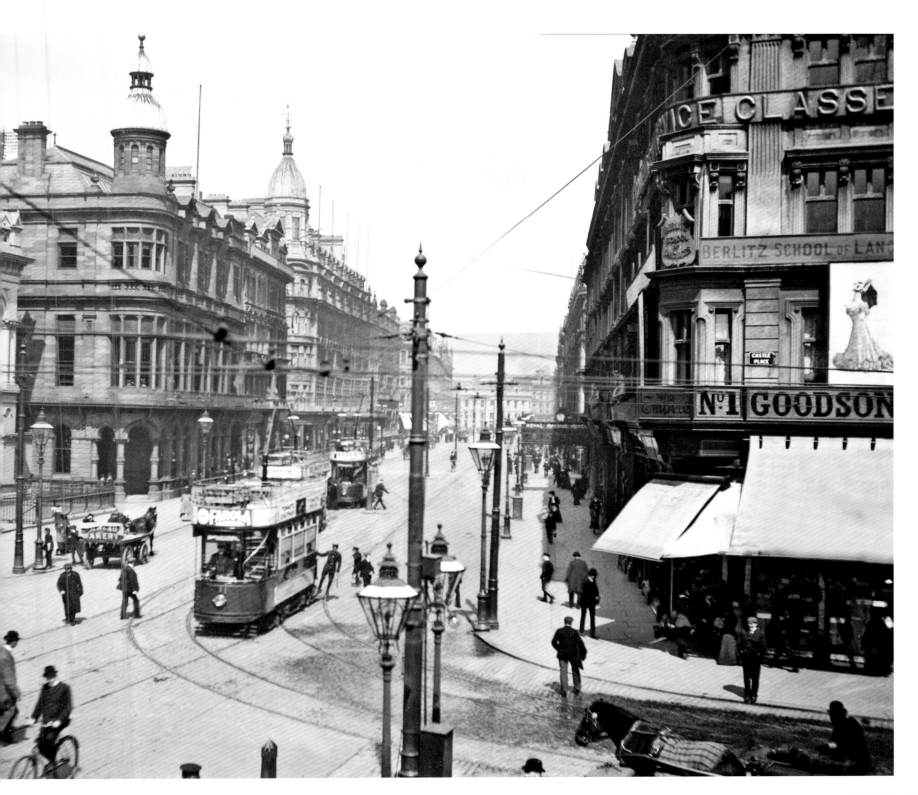

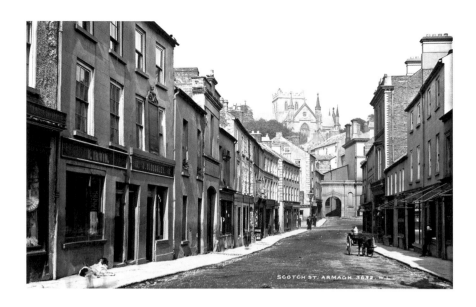

ARMAGH
Scotch Street
c.1900s

Scotch Street, Armagh City in County Armagh, featuring St Patrick's Cathedral which stands on the hill from which the City of Armagh derives its name – Ard Mhacha (the 'Height of Macha'). The photograph features several street traders such as the Ulster Gazette Newspaper and Printers established in 1844, Robert Irwin tailors, Charles Clarke shoe shop and J. Cochran cycles store.

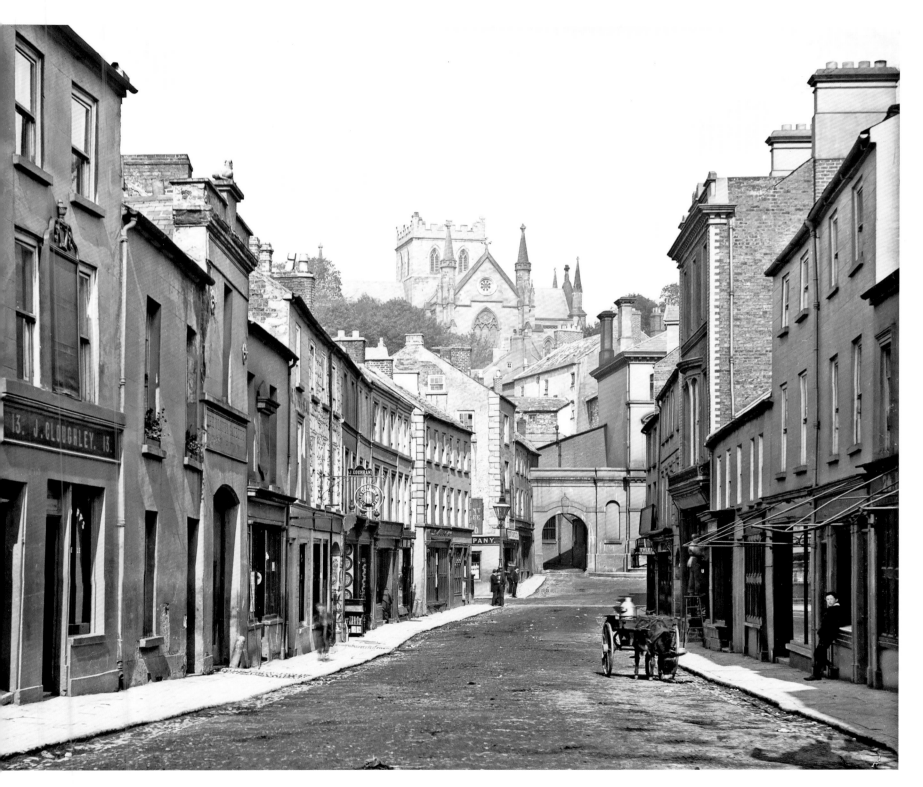

DONEGAL
Ráth Maoláin (Rathmullan)
c.1890

Ráth Maoláin (Rathmullan) village on the Fanad Peninsula in County Donegal. The village is situated on the western shore of Lough Swilly, which was the scene of the Flight of the Earls in 1607.

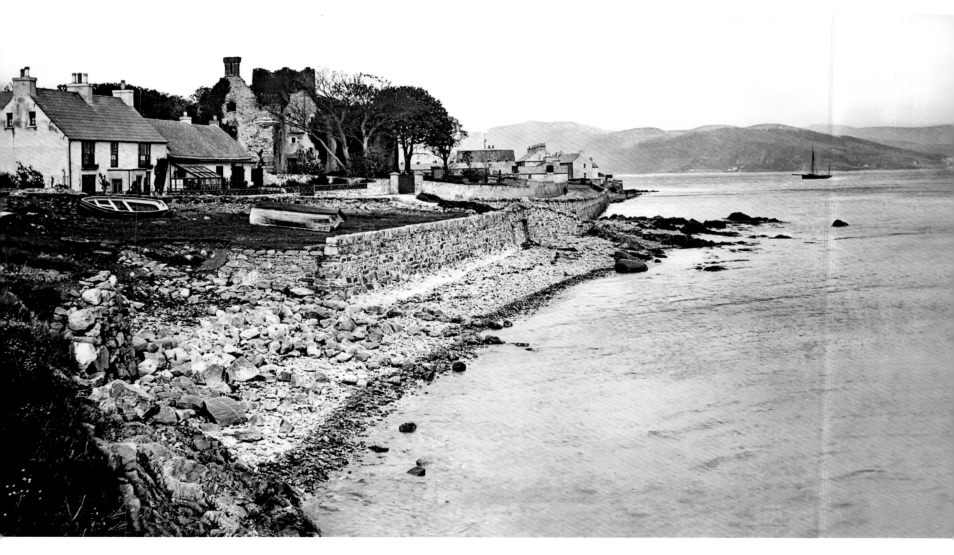

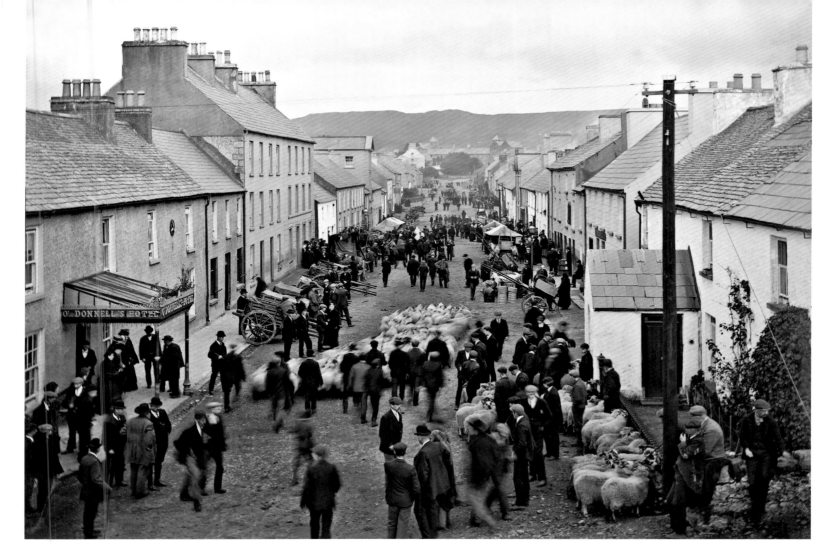

DONEGAL
Glenties
c.1910

Fair Day in Glenties, featuring sheep being herded down the main street, passing O'Donnell's Hotel on the left. In the background is the Glenties Union Workhouse built in 1844–45. The workhouse became Glenties District Hospital. The buildings were demolished in 1960 and the site is now occupied by Glenties comprehensive school.

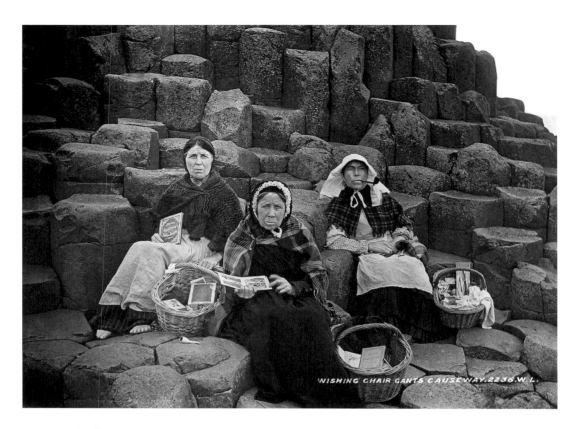

WISHING CHAIR GANTS CAUSEWAY.2236.W.L.

ANTRIM
Giant's Causeway
c.1900

Three women sit on Fionn Mac Cumhaill Wishing Chair, selling tourist trinkets and books containing views of the Giant's Causeway.

The Giant's Causeway is a rock formation made up of over 40,000 interlocking basalt columns – the result of either an ancient volcanic eruption or the hunter-warrior Fionn Mac Cumhaill from Irish mythology, who built the causeway to avoid getting his feet wet.

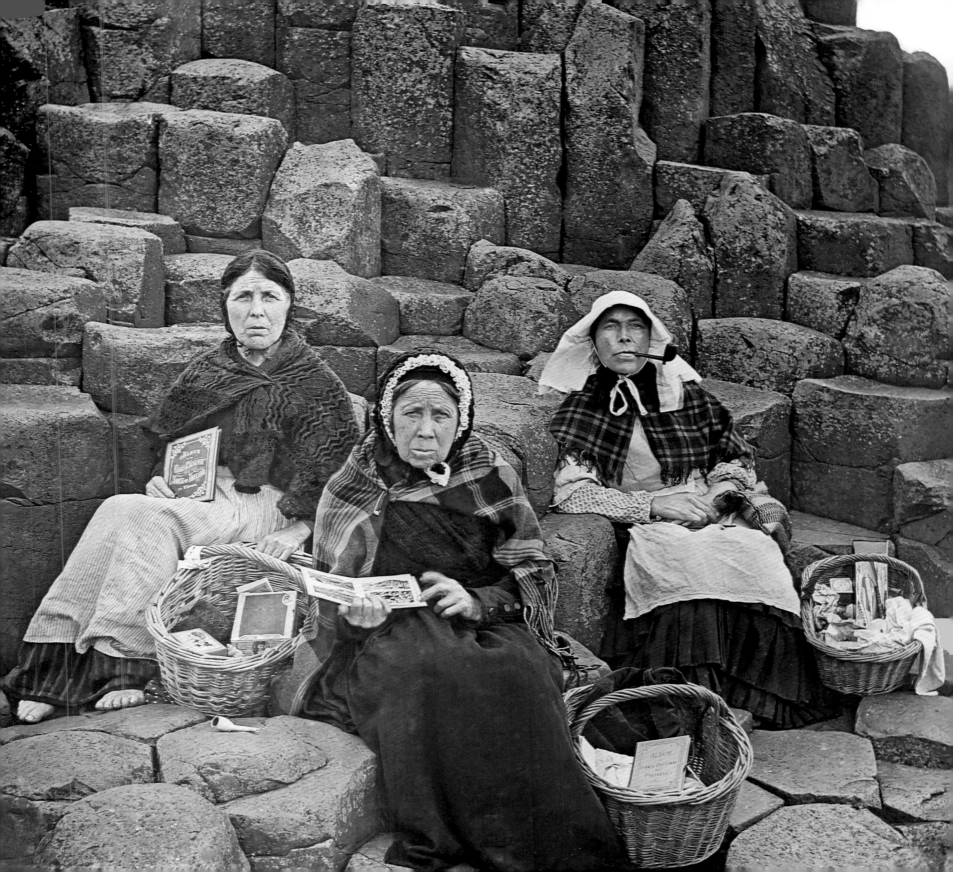

DOWN
Dundrum
c.1900

Dundrum (Dún Droma, 'fort of the ridge'), County Down, featuring St Donard's Church and the dunes of the 1889 Royal County Down Golf Club in Newcastle. St Donard's Church was designed by Sir Thomas Drew between 1885 and 1887. On the right-hand side of the photograph the mill pond can be seen, built by the Marquis of Downshire to power the local flour mill in the 1850s.

FERMANAGH
Enniskillen
c.1900

Enniskillen in County Fermanagh with the 1845 Cole Monument in the the grounds of the Forthill Park in the distance. You can also see the Military Barracks, Enniskillen Distillery, St Macartin's Cathedral and St Michael's Church.

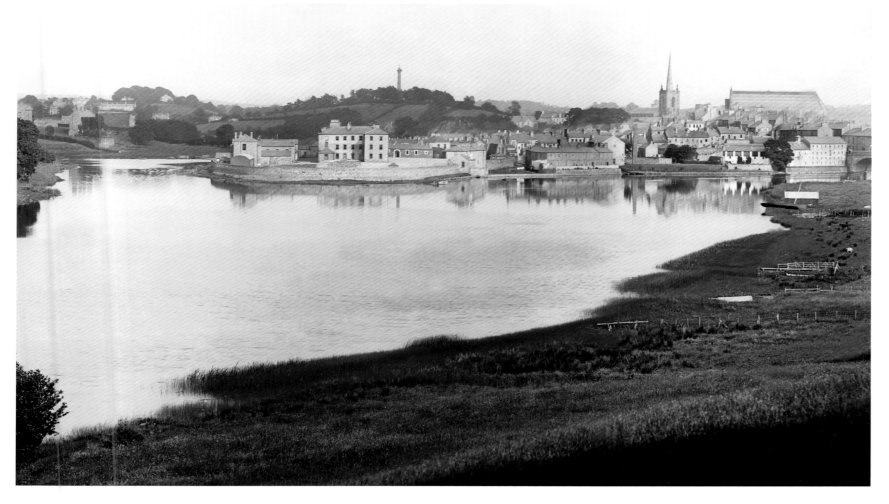

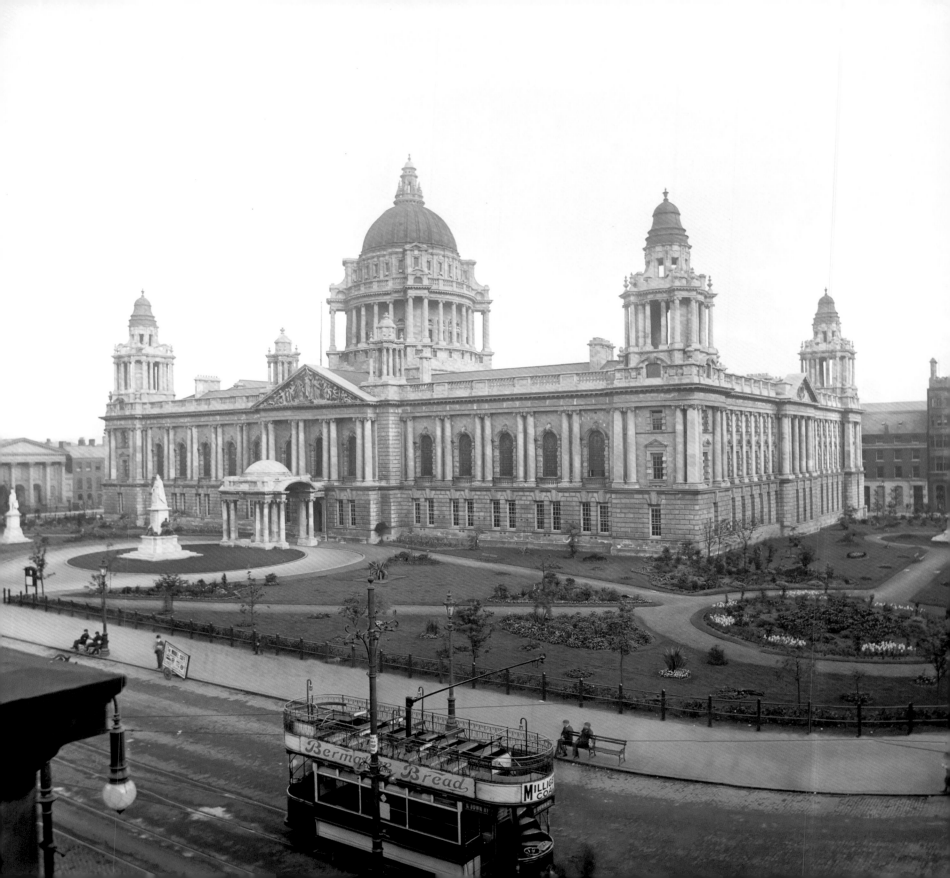

ANTRIM

City Hall, Belfast

c.1906

Belfast City Hall, located in Donegall Square on the former site of the Linen Exchange. Plans for the City Hall began in 1888 when Belfast was awarded city status by Queen Victoria. Designed by Sir Alfred Brumwell Thomas, the building is in the Baroque revival style and is built of Portland stone. The stone alone cost £369,000, the equivalent of €149 million today.

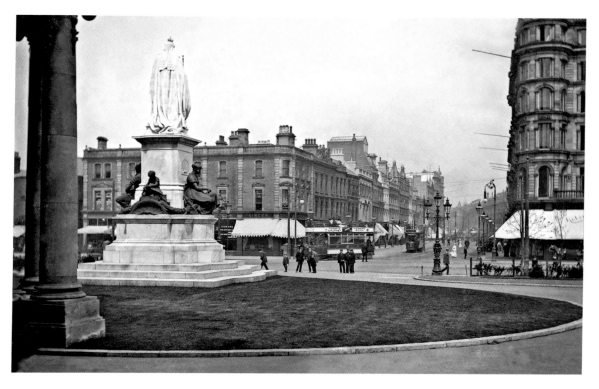

ANTRIM

City Hall, Belfast

c.1906

A view of the Sicilian marble statue of Queen Victoria, by the sculptor Sir Thomas Brock, from Belfast City Hall, Donegall Square North. Facing Belfast City Hall on the right-hand side is the former Robinson & Cleaver store designed by Young & Mackenzie in 1885.

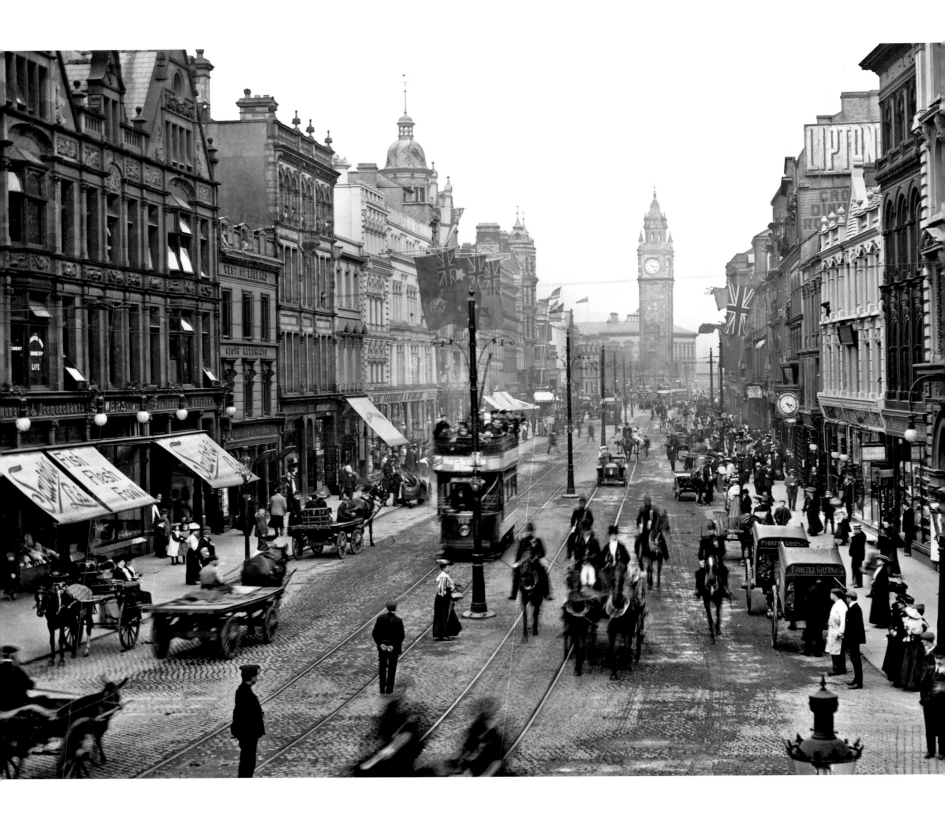

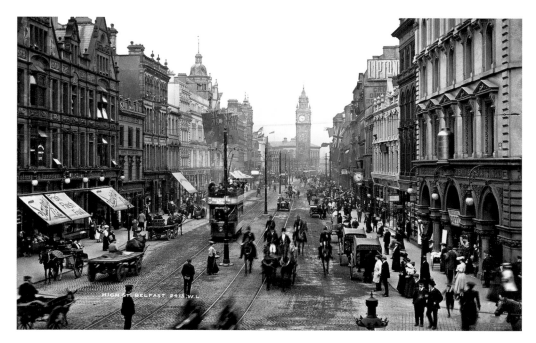

ANTRIM
High Street, Belfast
c.1906

In the background is the sandstone Albert Memorial Clock Tower completed in 1869 and standing at a height of 34.4 metres. The VIP carriage in the foreground is believed to be carrying Anthony Ashley-Cooper, the 9th Earl of Shaftesbury, who was the Lord Lieutenant of Belfast from 1904 to 1911, the Lord Mayor of Belfast in 1907 and the Chancellor of Queen's University Belfast from 1909 to 1923. The photograph also features the long-established grocer and provision merchants Sawers Ltd who were located on 4–10 High Street. The building on the right is the Forster Green & Co tea merchants, designed by architect Thomas Jackson in 1865. During the Belfast Blitz of April and May 1941, the Luftwaffe destroyed most of the High Street and nearby Bridge Street in a set of devastating raids.

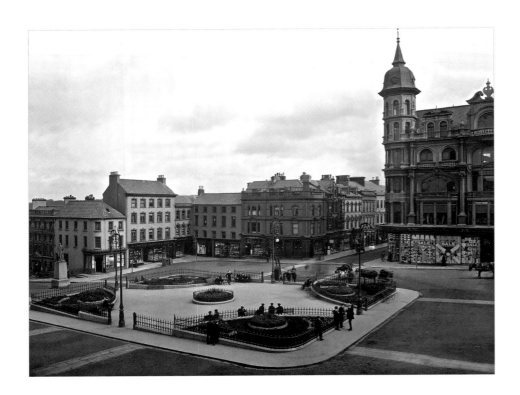

DERRY/LONDONDERRY
The Diamond
c.1907

The Diamond in Derry/Londonderry. The statue of Sir Robert Ferguson by sculptor John E. Jones was erected in 1863. It was relocated to Brooke Park in 1927. On the right-hand side is the Austin's department store, established in 1830 and, until 2016, it remained standing as the world's oldest independent department store.

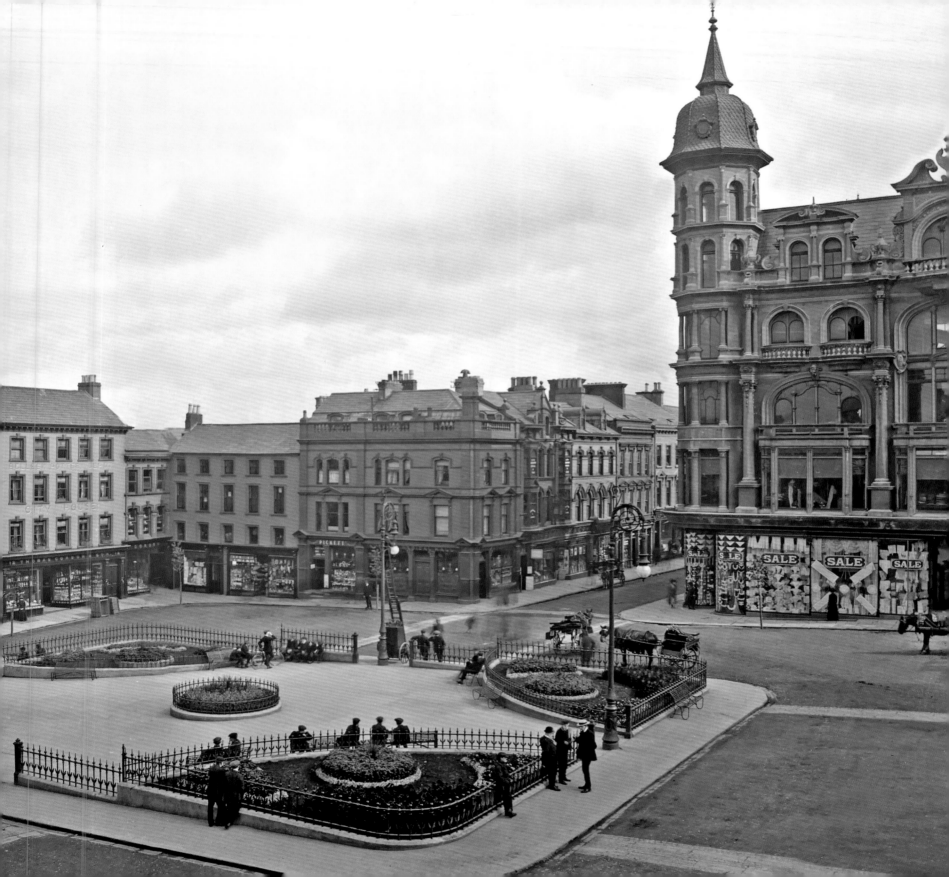

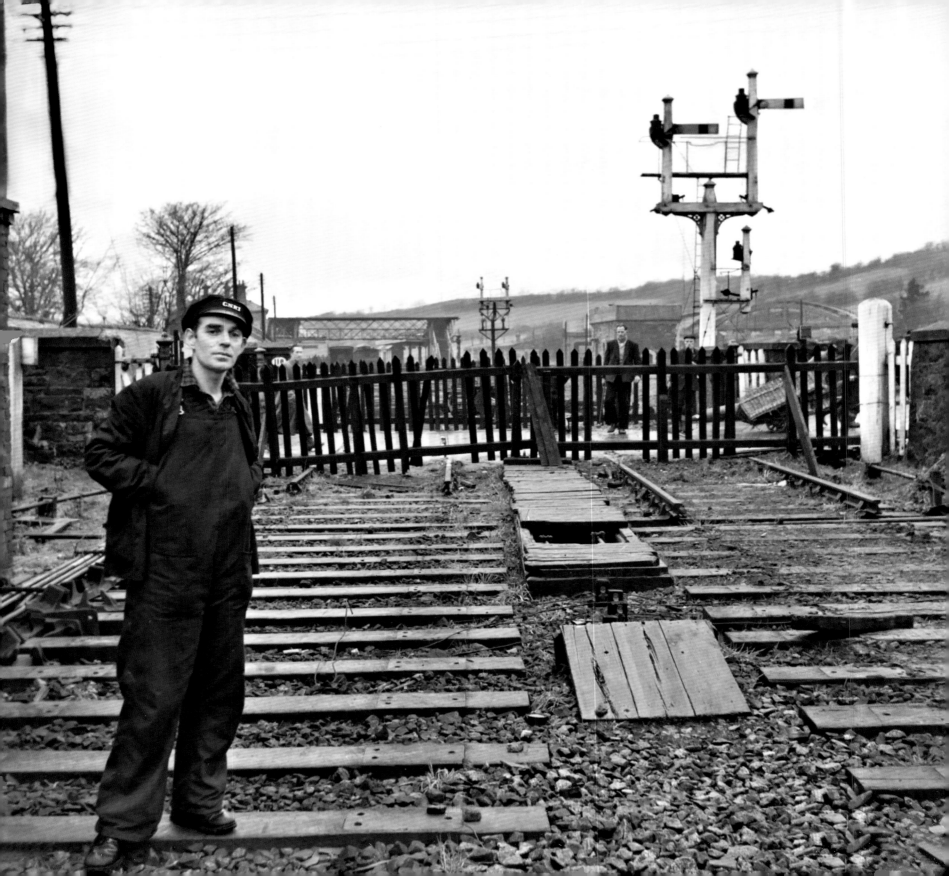

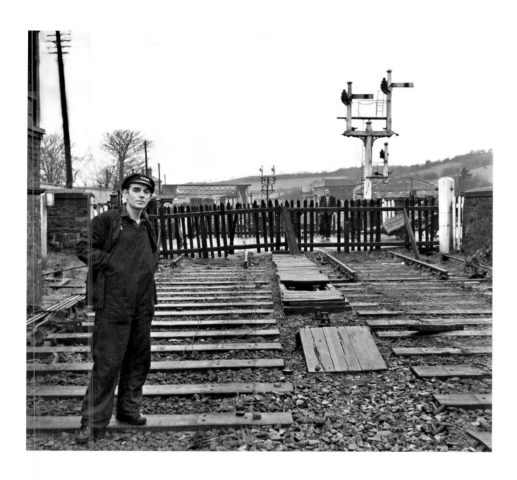

MONAGHAN
Clones
22 November 1960

Séan McPhillips dismantling the railway lines of the GNRI
(Great Northern Railway Ireland) at Clones in Monaghan.
The GNRI closed Clones station to passenger traffic on
14 October 1957.

AI COLOURISATION
IS *not* AN EXACT
SCIENCE

It's worth mentioning that machine deep-learning colourisation models will not find the relevant historical information and rationale for what colours to use for an object in a photo. The machine learning tool also relies on choosing the correct colour from the training set of millions of coloured images in order to decide what colours should be applied to black and white images. Grayscale images lack the crucial data that is embedded in colour images, such as the colour of items which have the same lightness value as greyscale objects, and so machine deep-learning colourisation cannot help but make mistakes.

There are numerous AI colourisation apps on the market. However, these simply colourise black and white images in a way that leaves the colourised images, in my opinion, unfinished with a multitude of incorrect colours and with the photo littered with a host of purple and brown coloured objects. For me, this is lazy, imprecise colourisation and, as such, something that's best avoided.

For me, tremendous, careful work is involved in the post-AI production phase. I use image editing software (such as Photoshop) to colour layer the image to ensure that the colourisation of photos is as realistic as possible. I research the subject thoroughly using historic records and old paintings, and I visit the present-day photo location to source any remaining object colours which I can then incorporate into my colourisation of the photo. The research process also involves sourcing the original colours of clothing such as military uniforms, and seeking out the colours of the current fashions around the time the photo was taken.

PHOTOGRAPHERS

William Mervyn Lawrence and Robert French

In 1865, at the age of twenty-four, Dubliner William Mervyn Lawrence (1840–1931) set up his photographic studio at his mother's toy shop at 7 Upper Sackville Street, right across the road from the General Post Office. After losing his right arm in an accident, Lawrence employed his brother John Fortune Lawrence as an assistant photographer, and he developed the stereo photographs side of the business.

In 1880 the dry plate process arrived and by then William had a team of printers and colourists working for him when he employed Robert French (1841–1917), who had briefly been in the Royal Irish Constabulary stationed in Glenealy, County Wicklow. French first was employed as a printer before working his way up to a colourist before finally becoming William's chief photographer.

The 1890s saw William's business of the colouring of postcards take off. One could argue that this success helped fund French to use his camera to photograph some 30,000 glass plate negatives the length and breadth of Ireland, before his retirement in 1914, images which help document Ireland's history. He didn't know it at the time, but French would become the foremost visual history chronicler of his generation in providing an invaluable visual record of urban and rural Ireland.

Arthur Henri Poole

Originally from Taunton, Somerset, in the south of England, Arthur Henri Poole was born in 1850. In the 1880s he moved to Waterford City where he set up Waterford Photographic Company. Poole produced some 65,000 glass negatives documenting the social and economic life of Waterford and the south east of Ireland from the 1880s onwards. In 1928 Poole left a note saying he was going to Tramore, a popular seaside resort seven miles from Waterford City, after which he disappeared mysteriously.

Herbert Walter Doughty

In 1908 Herbert Walter Doughty was the *Manchester Guardian*'s first staff photographer. He was sent to Cork in December 1920 to document the sheer destruction caused by British forces during the Irish War of Independence following the burning of Cork on 11 December 1920. Later on, Herbert was sent to Dublin to cover the Irish Civil War (1922–23) with a camera he had custom-built for his use.

W. D. Hogan

W. D. Hogan was a commercial and press photographer located in Henry Street in Dublin between 1920 and 1935. Hogan produced 160 photographs between June and July 1922, visually documenting a violent and turbulent period in Dublin during the early stages of the Irish Civil War.

The Dillon Family

The Dillon family were the Barons Clonbrock from Ahascragh in County Galway. As a family of enthusiastic amateur photographers, their glass plate photographs provide an invaluable visual record of urban and rural Ireland over a period spanning the years from 1860 to 1930.

Harry Tempest

The Tempest family of Dundalk in County Louth operated a successful printing and stationery business in the town. Harry Tempest produced 91 glass plates that document life in Dundalk and the surrounding areas in the first decade of the twentieth century.

James P. O'Dea

James P. O'Dea was a devoted railway enthusiast, and his subjects include locomotives, railway stations and bridges, as well as railway staff and passengers. His work documents all aspects of railway transportation in Ireland between 1937 and 1977, where he photographed several railway stations and lines on the extensive Irish rail network before it was unfortunately dismantled at an alarming rate. Ireland's extensive rail network, at its peak in 1920, had 3,500 route miles, but in the 1950s and 1960s large swathes of routes were closed and today the total network is a mere 1,698 route miles.

Father Browne

Frank Browne from County Cork was an Irish Jesuit and prolific photographer. His best-known photographs are those of the RMS *Titanic* and its passengers and crew, which were taken shortly before its sinking in 1912. In 1986 Father Browne's collection of negatives of religious life and country life in Ireland was discovered by chance in a tin trunk by Father E. E. O'Donnell SJ.

RESOURCES

The Irish Times Archives

www.irishtimes.com

Dublin City Library

www.dublincity.ie/residential/libraries

Irish Architectural Forum

www.archiseek.com

National Library of Ireland

www.nli.ie

National Library of Ireland on The Commons

www.flickr.com/photos/nlireland

Dictionary of Irish Architects 1720–1940

www.dia.ie

Ordnance Survey of Ireland Spatial Data Mapping Platform

www.geohive.ie

Web Mapping Platform

earth.google.com

IMAGE CREDITS

Front cover

Image Courtesy of the National Library of Ireland.
The Lawrence Photograph Collection.

Photographer: Robert French
Contributors: William Lawrence

Back cover

Image Courtesy of the National Library of Ireland.
Clonbrock Photographic Collection.

Main Creator: Dillon family

Author photo

© Naoise Culhane

**vi(bottom two), xvi, 6-19, 21-22, 24, 26-32, 34-36,
41-42, 43(left), 84, 88-92, 94-115, 118, 120-127,
130-131, 134-137, 139-141, 143-151, 154-157, 180,
186-210, 211(left), 214, 219(right), 220-221, 224-237,
238(right), 239-247, 249-259**

Image Courtesy of the National Library of Ireland.
The Lawrence Photograph Collection.

Photographer: Robert French
Contributors: William Lawrence

vi(top left), 82-83

Image Courtesy of Dublin City Library and Archive.

vi(top right),128

Image Courtesy of the National Library of Ireland.
Fergus O'Connor Collection.

Contributors: Fergus O'Connor

2, 45-51, 54-55

Image Courtesy of the National Library of Ireland.
Keogh Photographic Collection.

Photographers: Keogh Brothers Ltd

4, 5, 128-129, 184-185, 218, 219(left), 222-223

Image Courtesy of the National Library of Ireland.
Collection: The Stereo Pairs Photograph Collection.

Photographers: Frederick Holland Mares and
James Simonton
Contributors: John Fortune Lawrence and
William Lawrence

20, 25

Image Courtesy of the National Library of Ireland.
Clarke Photographic Collection.

Photographer: J. J. (John J.) Clarke
Contributors: Brian P. Clarke, donor

23, 67, 142

Image Courtesy of the National Library of Ireland.
Mason Photographic Collection.

Photographer: Thomas Holmes Mason
Contributors: Thomas H. Mason & Sons photographers

33, 43(right), 44, 50, 80-81, 138-139

Image Courtesy of the National Library of Ireland.
Eason Photographic Collection.

Contributors: Eason & Son

37-40

Image Courtesy of the National Library of Ireland.
Tempest Photographic Collection.

52-53
Image Courtesy of the National
Library of Ireland.

Political Photographs Collection.

56-57
Image Courtesy of the National
Library of Ireland.

Photographer: W. D. Hogan
Contributors: William Thomas
Cosgrave

58, 68, 69
Image Courtesy of the National
Library of Ireland. Hogan-Wilson
Collection.

Photographer: W. D. Hogan

59
Image Courtesy of the National
Library of Ireland.
Piaras Béaslaí Collection.

Photographer: W. D. Hogan
Contributors: P. S. Béaslaí (Piaras S.)

59, 62-63, 71, 72
Image Courtesy of the National
Library of Ireland.
The Independent Newspapers
(Ireland) Collection.

Main Creator: Independent
Newspapers (Firm)

63
Image Courtesy of the National
Library of Ireland.
Civil War Prints Photographic
Collection.

Photographer: Joseph Cashman
Contributors: Daily Mail

64-65, 171(right)
© Guardian News & Media Ltd 2021.

66, 170, 171(left), 174-175
Image Courtesy of the National
Library of Ireland.

Photographer: W. D. Hogan

70
© Walshe / Stringer

73
© ACC-2019-03, Barry Family,
Military Archives.

74, 75
Image Courtesy of the National
Library of Ireland. Clonbrock
Photographic Collection.

Main Creator: Dillon family

76
Image Courtesy of The Iveagh Trust
and The Irish Times

77, 168, 169
© Hulton Archive / Stringer

78-79, 116-117, 152-153, 158-159, 162-168, 178
Image Courtesy of the National
Library of Ireland. The Poole
Photographic Collection.

Main Creator: A. H. Poole Studio
Photographer

93(top)
William Derham

132-133
Image Courtesy of the National
Library of Ireland. Commissioners of
Irish Lights Photographic Collection.

Main Creator: Ireland. Commissioners
of Irish Lights
Photographer: Robert S. (Robert
Stawell) Ball

160-161
Image Courtesy of the National
Library of Ireland.
Fergus O'Connor Collection.

Contributors: Fergus O'Connor

172, 173(top)
Image Courtesy of the National
Library of Ireland.
Irish Political Figures Photographic
Collection.

173(bottom)
Image Courtesy of the National
Library of Ireland. Kathleen
McKenna-Napoli Photographic
Collection.

176-177, 213
© Historic England.

179
Image Courtesy of the National
Library of Ireland.
The Wiltshire Photographic
Collection.

Photographer: Elinor Wiltshire

212
Image Courtesy of the Irish
Independent

238(left), 248
Image Courtesy of the National
Library of Ireland.
The Eblana Photograph Collection.

Contributors: William Lawrence

260-261
Image Courtesy of the National
Library of Ireland.
O'Dea Photograph Collection.

Photographer: James P. O'Dea

LOCATIONS INDEX

About

ROB CROSS

Rob Cross is originally from Limerick City in Ireland. He has a professional background in the field of architecture and digital technology. After graduating from Edinburgh's Heriot-Watt University, he moved to Dublin City where he works for an award-winning architectural practice.

Rob has a great passion for Irish history, especially the preservation of its architectural heritage and culture. In his Bringing Ireland's History to Life project, Rob faithfully restores and colourises historical photos for future generations to enjoy. What began as a hobby is now captured here in this book. The project also has an international fanbase on Twitter, including politicians, academics, actors and film directors.

@RobCross247 | #TheColourOfIreland
thecolourofireland.com | robcrossphotography.com

THANK YOU TO . . .

Two deep-learning programmers, Jason Antic and Dana Kelley, for creating the DeOldify software and for their encouragement throughout my Bringing Ireland's History to Life project.

All the staff at Black & White Publishing, and at Gill Hess.

The brilliant historians, Diarmaid Ferriter and Donal Fallon, for their introductory essays that begin this book.

The staff at the National Library of Ireland and all the contributors to their Flickr page.

Paul Clerkin and his brilliant Archiseek website.

The staff of *The Irish Times* and all the journalists who supported my project.

All my Twitter followers for their encouragement and support throughout this journey.